Michael Rosenthal
studied at the University of London
and was a Research Fellow at Jesus College, Cambridge,
before taking up a Lectureship in the History of Art at the
University of Warwick. His previous books include *British
Landscape Painting* (1982), and *Constable: The Painter and
his Landscape* (1983).

WORLD OF ART

This famous series
provides the widest available
range of illustrated books on art in all its aspects.
If you would like to receive a complete list
of titles in print please write to:
THAMES AND HUDSON
30 Bloomsbury Street, London WC1B 3QP
In the United States please write to:
THAMES AND HUDSON INC.
500 Fifth Avenue, New York, New York 10110

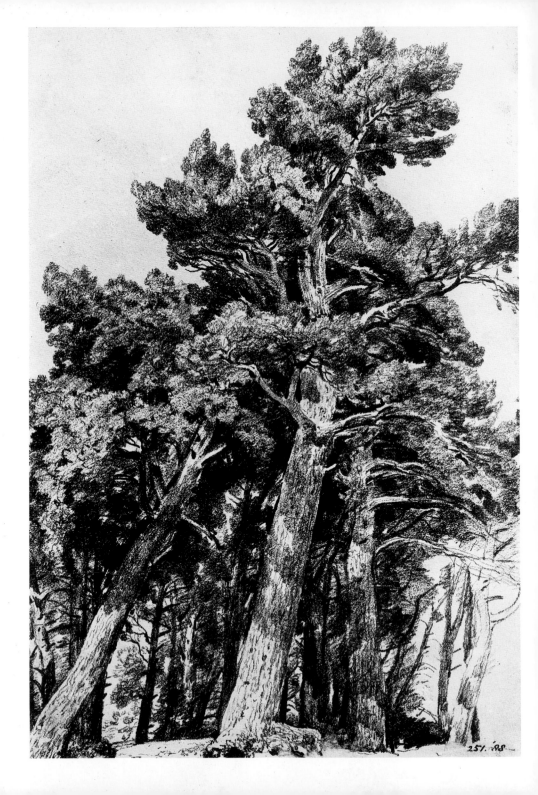

251. 98

MICHAEL ROSENTHAL

Constable

191 illustrations, 48 in color

THAMES AND HUDSON

Frontispiece: Fir Trees at Hampstead, 1820. Inscribed
'Wedding day, Hampstead Octr. 2 1820'

© 1987 Thames and Hudson Ltd, London

First published in the United States in 1987 by
Thames and Hudson Inc., 500 Fifth Avenue,
New York, New York 10110

Library of Congress Catalog Card Number 86-50221

Printed and bound in Japan by Dai Nippon

Contents

Preface

Certain of Constable's paintings – *The Hay Wain*, or *The Cornfield* – are unusual in being known to a wide public, and for having been instrumental in forming the popular image of the 'essential' English countryside. This book shows that to be thought of as an 'English' painter was partly Constable's aim, but that he would have conceived of this in different ways from us. It is vital to make the attempt to understand Constable's art in terms of its own time. This can involve, at one level, elucidating the artistic procedures by which he was able to achieve so brilliant an illusion of the look of a summer's landscape, and, on another, unravelling what the subjects of these paintings were supposed to be. Constable believed that painters were valuable and important within society: we shall read how he dedicated his career to living up to this ideal, and how he had to adjust this ambition as his life took its course.

Constable worked at a period when landscape was unprecedentedly popular in Britain, and his responses to fashions in aesthetics, or to the works of his rivals, are charted here. Among the latter was, pre-eminently, J. M. W. Turner, but the group also included men, like William Collins, whose landscapes were held in the highest esteem in the early nineteenth century but who are practically forgotten today. Any introduction to the life and works of John Constable must concern itself first and foremost with the salient works, but it must never forget that neither they nor the contemporary public were ever sealed off from a vast range of stimuli, emotional, artistic and historical. We do not see *The Hay Wain* as it was perceived in 1821, when it was first exposed to public view at the annual exhibition of the Royal Academy at Somerset House.

The Life

John Constable was born in 1776, at East Bergholt in Suffolk. His family background was instrumental in directing the forms his landscapes would take, and provided an income sufficient to allow him to paint free from the worry of having to rely on this for his living. Just as it is unusual for an artist to establish an imagery so potent that advertisers still exploit it, so they seldom give their names to particular regions. What Constable's pictures established as 'Constable Country' was where his family lived. The painter's father, Golding Constable, inherited Flatford Mill, on the lower reaches of the Suffolk Stour, which was then navigable for barge traffic as far upstream as Sudbury. He came eventually to have an interest in Dedham Mill, a mile or so upstream, and also bought the windmill at East Bergholt which features in several of Constable's pictures. It was to East Bergholt (a mile or so above Flatford) that Golding Constable had removed in 1774, to a newly built and substantial mansion, the reward for his astute and prudent management. This house was impressive enough for a fellow-miller to record in 1775 that not only was Bergholt 'one of the handsomest villages in England', but that 'a Mr. Constable, a man of fortune and a miller, has a very elegant house in the street and lives in the style of a country squire'.

Golding had diversified his business into shipping grain out of Mistley (on the Stour estuary) in his own vessels, and importing coal, which he stored at Cattawade (downstream from Flatford) and shipped up the river in his own barges, which he constructed at Flatford. He was a Commissioner of the River Stour Navigation, those gentlemen who met to arrange tolls and to ensure that the river remained navigable, and a man of moment in the locality: in more general terms he can be perceived to have belonged to an entrepreneurial and enterprising rural middle class.

John Constable described the estate attached to East Bergholt House (which Golding farmed for recreation rather than the relatively small profit it produced) in various works, pre-eminently *Golding*

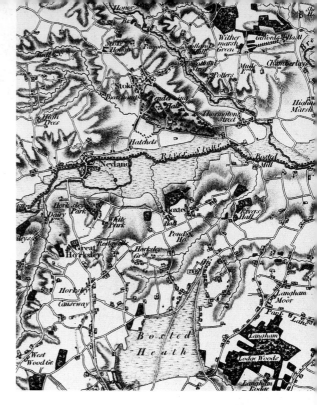

1 'Constable Country'
from the 1805
Ordnance Survey Map

74 *Constable's Kitchen Garden* of 1815. This may be set besides the 1817 East Bergholt Enclosure Map and the Constable holdings identified. Both painting and map delineate the relation of their estate to the village itself and the holdings of their neighbours, and we can gauge the real connection between the social harmony, signified by the houses and neat gardens, the activity in these and the fields, and the economic wealth represented by the rich harvest-scenes. There was a pride to be taken in this sight, and the pleasure it provided was as much the countryman's as the painter's. It is worth emphasizing that Constable's order of knowledge was extremely refined. He knew his landscape subjects in three dimensions, understood their histories and the significance of details, whether agricultural or botanical, and particular landscape features would have carried personal associations.

Constable generally depicted subjects from regions not favoured by other artists – Hampstead and its Heath is the exception – and this was eccentric enough for his first biographer, Charles Robert Leslie, to stress that 'the subjects of his works form a history of his affections'.

8

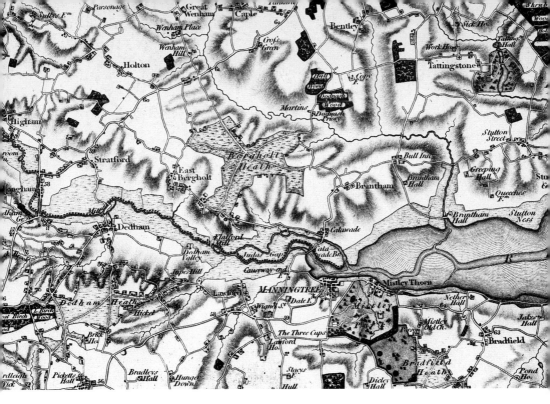

There were localities – the Lake District, Scotland, North Wales, or the Peak District – which were judged to contain terrain entirely suited to landscape painting, and Constable twice made tours to such regions, to Derbyshire and the Peak District in 1801, and to the Lake District in 1806. But after three years of unsuccessfully exhibiting Lake District scenes, in 1810 he began to show landscapes of East Anglian motifs. He was one of the very few to have discovered anything worth painting in the Stour Valley. The connoisseur and collector Sir George Beaumont, whose mother kept a house at Dedham, and the landscape-painter Joseph Farington, who would tutor the young Constable in landscape, had made studies there. But they are more typically remembered from Thomas Hearne's watercolour of them perched with easels, canvases and umbrellas amongst rocks, painting a vertiginous waterfall in the Lake District. Constable's choice of this area to paint was therefore idiosyncratic, and almost provocatively anti-fashionable, for, along the Orwell valley, but a few miles from East Bergholt, lay scenes of proven beauty

18, 19
36, 41–2

which had the benefit of a powerful association with the name of Thomas Gainsborough. Pictures of 'Constable Country', though, were crucial to his practice from first to last.

It would probably have come as a shock to Golding Constable to discover a would-be artist in the son whom he had intended to take over his business. Golding's was a practical temperament – in 1811 he counselled John against getting married at that time because 'as a single man I fear your rent and outgoing, on the most frugal plan, will be found quite equal to the produce of your profits', recommending instead 'a close application to your profession & to such parts as pay best'. Painting was another business, at which John Constable, despite admonitions from his family, was proving far from adept. When rebuked by her brother that she was 'wordly in my wishes & views for my son', Contable's mother replied that, 'whilst we are on this Earth, our plans & ideas must be worldly'. The Protestant materialism which infuses the frequent letters she sent John must have been characteristic of the mores of the Constable household, and, as in 1811 Constable had yet to achieve any professional success, Golding Constable showed rare tolerance of his eccentricity by continuing to fund it: indeed, income from the family business would allow Constable a varying degree of financial independence throughout his life.

It is said that John Constable was inspired to attempt art in 1795, when, aged nineteen, he was introduced to Sir George Beaumont who was then staying at Dedham, and who showed him the small Claude, *Landscape with Hagar and the Angel*. The taste this inspired grew to gluttonous proportions when, in 1796, at his uncle's house in Edmonton, Constable met John Thomas Smith, artist, connoisseur, and antiquarian, who was at that time earning a living as a drawing-master in that village. Smith must have appeared an extremely glamorous figure, and over the next few years Constable sent him letters of pressing earnestness in which he expressed his growing devotion to art with a naive candour. For the moment, however, he had to rest content with following painting as an amateur. Constable's mother wrote in 1797 to Smith (who had in fact pre-empted her by advising John earlier in the year to attend to his father's business) that she and her husband were looking forward to precisely this, 'by which means he will please his Father, and ensure his own respectibility, comfort, & accommodation'. For a while Constable settled to this, and contented himself with studying art-theory, copying, and going

2

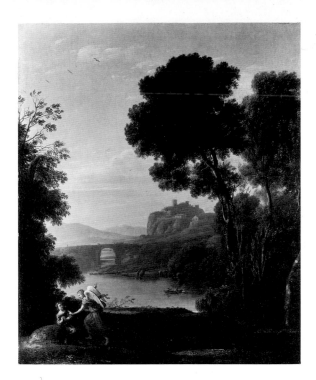

2 Claude, *Landscape with Hagar and the Angel*, 1646

out sketching with John Dunthorne, the local plumber and glazier, and occasional painter of inn signs, who was to remain a good friend. It was not until 1799 that he won permission to study art. He arrived on the doorstep of Joseph Farington (better known to posterity as a diarist and influential figure in the affairs of the Royal Academy than as a landscape painter) armed with a letter of introduction, on 25 February. The next day Farington recorded that Constable's father had now 'consented that C. shall devote his time to the study of Art. Wishes to be in the Academy'. This was the Academy Schools, where 14, 15 Constable would study for many years: Wilkie (some nine years his junior) records drawing from the life there in his company in 1808, and he was still attending life classes in 1811.

Constable was tardy in making the transition from student to full-time artist, and although he made some notable landscape paintings in the 1800s, professional success was imperceptible: yet this had to be his aim. When, in 1802, he had declined the offer of a post as drawing-master to the Military Academy at High Wycombe, having taken the advice of, among others, Sir George Beaumont, and Benjamin West,

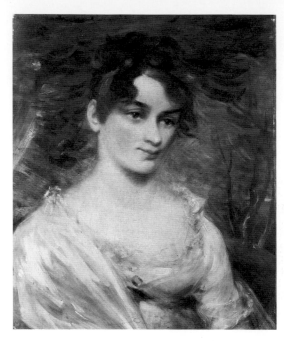

3 *Susannah Lloyd*, 1806

4 *Malvern Hall*, 1809

the King's Painter and President of the Royal Academy, this was because to accept it would have scotched his chances as a fine artist. Pretensions and performance were some way apart. In 1804 he was turning out extremely cheap life-size portraits (with a hand 3 guineas, without 2) at East Bergholt during the mornings while devoting the afternoons to landscape painting. He enjoyed some success. *The Bridges Family* of 1804 (Tate) is a tolerably competent (and value-for-money: it contains ten figures) group portrait of a family with which his own was connected. *Susannah Lloyd* dates from 1806. Constable's maternal uncle, David Pike Watts, probably financed a tour of the Lake District during which Constable stayed with the Hardens of Brathay Hall. Here he met the poet Charles Lloyd (son of a Birmingham banker, also Charles) and this contact led to commissions: Susannah was a daughter-in-law of Charles senior. The portrait reveals some study of Reynolds, and the painter's incompetence in handling the interrelationships of planes on the sitter's face. Constable would have recourse to portraiture for money for many years to come, and his later work is usually of high quality.

 In 1807 a business associate of Golding Constable's, the Dedham attorney Peter Firmin, contrived an introduction to the Dysarts of

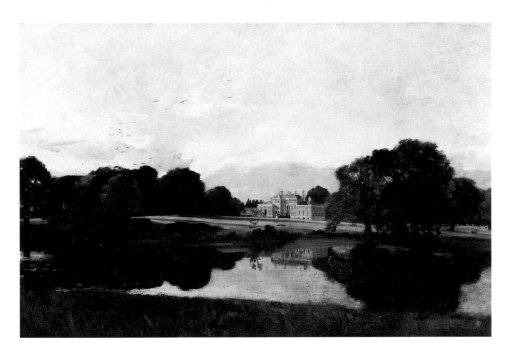

Helmingham Hall, and this led to work. In late November Farington reported that his pupil attended 'the Life Academy every evening, and has for 3 months past been employed by Lord Dysart in copying pictures & painting original portraits', so that he now not only felt 'completely settled' in his profession, but furthermore, his father, 'finding he is getting on is reconciled to it'. Constable had first come into contact with the Dysarts (the Tollemache family) in 1800 when he had studied landscape 'amongst the oaks and solitude of Helmingham' (where he had previously copied a picture) and this had 17 made it easier for Firmin to avail himself of 'so favourable an opportunity of recommending You as an artist of considerable Merit'.

The association with the Tollemache family was to be long-lived, with Constable throughout consulted to advise on the state of pictures, or to repair or copy them, but getting relatively little work in the way of original commissions. There are the 'original portraits' Farington mentioned; in 1808 he made a portrait of one of the lady's maids in the family, and in 1810 the *Ipswich Journal* was pleased to announce that: 'The interesting landscape by Mr. Constable (son of G. Constable Esq. of East Bergholt) in the last exhibition has been purchased by the Right Hon. the Earl of Dysart.' This was a painting

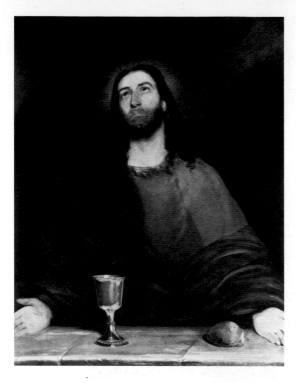

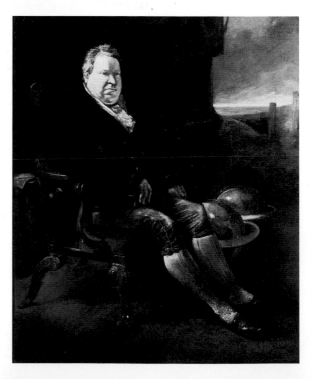

5 *Christ Blessing the Sacraments,*
c. 1809. Nayland Church, Suffolk

6 *Rear-Admiral Thomas Western*
c. 1813

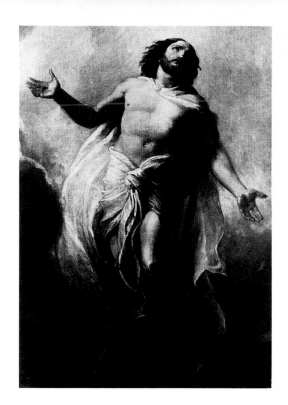

7 *The Risen Christ*, 1822,
for Manningtree Church,
Essex

on a Kit-kat canvas (28 × 36 inches) which Constable told Farington
he was 'overjoyed' to have sold for 30 guineas. In 1821 the Countess of
Dysart was to order two views of her brother Henry Lewis's seat,
Malvern Hall, which Constable had first painted in 1809. Lewis was 4
himself forthcoming with commissions, ranging from portraits to a
figure of his putative Norman ancestor, Humphri de Grousewolde,
and even to a mermaid for an inn sign in Warwickshire in 1828.

Other work did come in: in 1810 Constable's aunt paid for the
altarpiece at Nayland, but his fortunes fluctuated, and in this year he 5
could tell Farington that his father still considered him to be 'pursuing
a shadow', and thought that 'what employment He has he owes to the
kindness of friends', which was near the truth and remained so. A
portrait painted in July 1812 of William Godfrey, son of Peter
Godfrey the local Squire, was accounted so great a success that Mrs
Godfrey cajoled a neighbour, Rear-Admiral Thomas Western of 6
Tattingstone Hall, to sit for his own likeness. In the meantime
Constable had painted his father's friend Major-General Rebow at

15

Wivenhoe Park, outside Colchester. Good reviews in the press did not accelerate his sales, and in 1813 Mrs Constable took him to task on the occasion of the Reynolds retrospective exhibition at the British Institution: 'See what has been done by one bright genius & one pair of hands, – who can then be satisfied with one landscape, a few sketches & some unfinished portraits, for an annual employment?' By now Constable was at least making his way in portrait. He was charging 15 guineas for a head, and that summer would leave London 'for the only time in my life with my pockets full of money'. Yet despite local commissions for landscapes as well as portraits (the Godfreys had persuaded their prospective son-in-law Thomas Fitzhugh to commis-

65 sion a view of the Stour Valley as a souvenir for their daughter, and in

83 1816 General Rebow requested the painting of *Wivenhoe Park* plus a smaller view of *The Quarters* at Alresford Hall), and sporadic public sales (James Carpenter the bookseller gave 20 guineas and books

57 above that for *Landscape, Boys Fishing* at the 1814 British Institution, and the next year John Allnutt bought the original version of

63 *Landscape, Ploughing Scene in Suffolk*), Constable generally earned too little to live on, and in June 1815 was reduced to painting the background to George Dawe's portrait of the actress Eliza O'Neill.

Outside pressure to remedy this had been building up from 1809–1810, when Constable had fallen in love with Maria Bicknell, grand-daughter of the Reverend Dr Durand Rhudde, Rector of East Bergholt. The marriage Constable longed for had to be postponed after Rhudde had come to oppose the association because of Constable's obstinacy in refusing to abandon art and earn his living, and probably because of his public friendship with John Dunthorne, who was reputed to be an atheist. As the Bicknell family had expectations from Rhudde, they gave way to him and the affair became clandestine.

Apart from anything else, Constable would have needed to improve his circumstances because Maria expected to live in some style. In June 1814 she had been bothered that 'people cannot now live upon four hundred a year', while Norman Gash writes that from '£100 to £200 a year represented comfort; and it was on this kind of income that the bulk of the middle classes supported themselves' during this period. Evidently Maria aspired to a superior level of comfort. This was to be expected. Her father was Solicitor to the Admiralty: the family was situated in the upper ranks of the middle

16

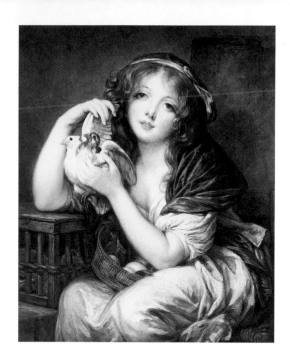

8 *Girl with Doves*, after Greuze, 1831

class. In 1813 Constable's mother, who was acutely sensitive to any real or imagined social slight, was dismayed because 'your virtuous & honourable love is so sadly requited as not to obtain for you the admittance of a Gentleman to her Father's house'.

It was only after the death of Golding Constable in 1816 had guaranteed his son a private income that John was able to marry. The ceremony was performed by Archdeacon John Fisher, nephew of the Bishop of Salisbury, whom he had first met in 1811 on a visit to that city, made at the Bishop's invitation (Constable had come to know him in 1798 when he had been titular rector of Langham, near Dedham). The honeymoon was taken, at the younger John Fisher's suggestion, in Wiltshire and Dorset. Constable was again being led to the places he painted through personal ties, and neither Salisbury and its environs, nor the scenery in Dorset and Wiltshire, were popularly favoured by other landscape artists. Constable can indeed be singled out for having usually allowed his affections to lead him to the places he pictured. Hampstead (in 1819) and Brighton (in 1824) would enter 97–9, 138 his repertoire of subjects because Maria's consumption inspired their residences there. Hampstead was a healthy village within easy commuting distance of London; Brighton (which, unlike the nearby

Hastings, was not favoured by landscapists) was a fashionable resort, blessed with sea breezes.

In the later 1810s Constable's career began progressing. He exhibited the large *White Horse* at the 1819 Royal Academy, and its successful reception was influential in persuading the Academicians to elect him Associate, although he still had to wait until 1829 before he became a full Academician. His professional income increased, although his private means (his brother Abram would send him £400 in 1825 for instance) permitted him on occasion to paint, albeit somewhat precariously, independent of the market. At other times he would take on any work offered. It was Abram who informed his brother of the altarpiece commission for Manningtree Church which Constable conceived as *The Risen Christ*. It must have been on hand while work was proceeding on *A View on the Stour near Dedham*, which gives us some idea of how far Constable could deviate from his public practice if necessity demanded it. By the 1820s he had already become a highly skilled portraitist, and at least made drawings for the Mermaid Inn sign proposed by Lewis in 1828. In 1831 he copied Greuze's *Girl with Doves* for a lady who found it the 'exact image' of a daughter snatched from her by her estranged husband.

The death of Maria Constable in 1828 was an emotional blow from which he is reported never to have fully recovered. We learn the extent of his grief from Charles Robert Leslie, the young American painter whom Constable had met in the late 1810s and with whom he had developed a close friendship, and who would in due course be his first biographer; and Henry Trimmer remarked on the 'gloom' which the loss 'threw . . . over his life'. In 1832 the deaths of John Fisher, and of John Dunthorne Junior, who had for some time been his studio assistant, left him feeling increasingly lonely. Constable continued to exhibit, and was active in the Artists' General Benevolent Institution, and at the Royal Academy, where he was popular amongst the students as Visitor at the Life Schools. He remained interested in East Anglia, investing with his sister in a property near East Bergholt in the 1830s. His death at the age of sixty-one was unexpected. He woke in great pain on the night of 31 March 1837 and died within half an hour. The sudden onset of pain is suggestive of angina, a symptom of an acute coronary attack (Constable was later in his life exceptionally prone to fits of anxiety), and it seems most likely that this caused his death in so short a time.

18

The Art Student

On their first meeting in 1795 John Constable is said to have impressed
Sir George Beaumont with laborious pen and wash copies of 9
Dorigny's engravings after Raphael's cartoons. They may have
demonstrated little precocious talent, but at least they were pains-
taking, and they represented a single concession to the orthodoxy of
learning painting by copying from the best masters in the highest
walks of art. After this, though, Constable stayed almost wholly with
landscape. His taste was probably confirmed when he met John
Thomas Smith, for in 1796 Smith was preparing to espouse the
fashionable Picturesque with an illustrated book, *Remarks on Rural
Scenery* (1797). This directed landscape-enthusiasts towards run-down
hovels and dilapidated cottages, subjects which were less unusual than
Smith claimed; cottage scenes in general were associated with
Gainsborough, and more kempt dwellings were familiar in media
ranging from Wheatley's paintings to designs on ceramics. Smith's

9 *Christ's Charge to Peter*, copy after Dorigny's engraving after Raphael, *c.* 1795

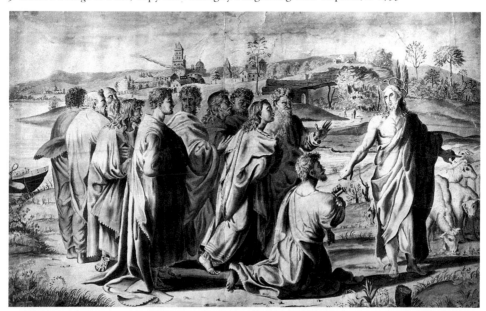

book inspired Constable to ape the former's etching style in various pen and ink drawings. He here demonstrated his understanding of picturesque essentials: decay was considered to blend objects harmoniously with their surroundings. But as yet he was ignorant of perspective or chiaroscuro. The note on the place's history is an antiquarian touch: such interests were traceable to Smith and his circle, who keenly recorded inscriptions or interesting anecdotes pertaining to their subjects.

The Picturesque (which had originated in the Italian *pittoresco*, meaning 'after the manner of painters') was an aesthetic category popularized by the Rev. William Gilpin in his various published *Tours*, beginning with his *Observations on the River Wye . . . relative chiefly to Picturesque Beauty*, of 1782. He aimed, as he proposed here, to give touring a point, to introduce the excitement of the chase as people covered the country in search of picturesque scenes. These would arrange themselves into a foreground, middle distance and background, and would be characterized by roughness and sudden variation (there was an emphasis on such textural qualities), and a colouring which was never strident and usually variegated. An appreciation of these features was to be developed from the study of landscape painting, which would allow the perception of terrain (often with some imaginative modification) as scenery.

Expertise in the Picturesque permitted those with no prior knowledge of a place to make a visual appropriation of it, and it involved a distancing of content from form which, as Gilpin acknowledged elsewhere, opposed the conventional aesthetics of judging scenery:

. . . all I mean is, to investigate the *sources of beauty*; to limit the *different modes* of pleasure and pain; to separate *causes*, and *effects*; and to evince that a scene, tho' it abounds with circumstances of *horror*, may be very *picturesque*; tho' another may be entirely the *reverse*, tho' replete with incidents, that produce joy and happiness.

The normal reaction to a mountainous gorge would be, at least, to feel uneasy; but judging it in terms of the paintings of Salvator Rosa could make it afford pleasure, and this activity would, moreover, reveal a degree of real cultivation in whoever carried it out. While Gilpin formulated the popular notion of the Picturesque, by the mid-1790s other writers, Humphrey Repton, Richard Payne Knight and

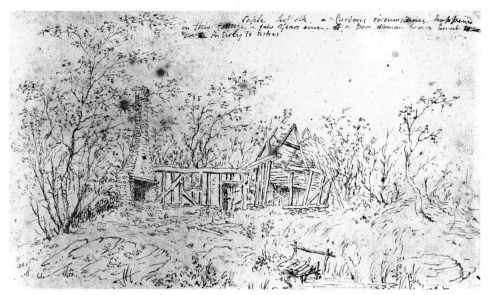

10 *A Ruined Cottage at Capel, Suffolk*, 1796. Inscribed 'Caple Suffolk, a curious circumstance happened in this cottage a few years since of a poor woman being burnt intirely to ashes . . .' [the rest erased]

Uvedale Price, were publishing on it and related subjects, with Price, who placed his Picturesque between Burke's sublime and beautiful, proving eventually the most significant of these writers. Hussey has termed his a 'practical aesthetic'. He sought to establish a 'mode of study which will best enable a man of a liberal and intelligent mind to judge of the forms, colours, effects, and combinations of visible objects either in single compositions or else as parts of scenery'. Price wished the knowledge of pictures to be natural in the cultivated man and to be exploited in literally enlarging his horizons; inducing the awareness that a fine oak, grown for timber, certainly denoted good management, but was also shown by the paintings of Ruisdael or Gainsborough to be picturesque. Such an act of discrimination evidenced a proper cultivation of the intellectual faculties. Gilpin's was more a system for viewing landscape as a recreation and probably better suited to those who themselves wished to make drawings (a polite enough accomplishment in itself) rather than to manage estates.

The young Constable was eager to learn and to become *au fait* with the latest trends: in 1796 he was approving of Smith's 'landscapes in the style of Gilpin' and had been soliciting subscriptions to *Remarks on*

21

11 *A Dell*, 1796

Rural Scenery. Smith was self-effacing in his claims for the book, which was very complimentary to Gainsborough, thought Reynolds's teaching too abstracted for learners, and cited his phrase 'The Art of seeing Nature' as encapsulating the theory of the Picturesque (as he understood it) in 'a single expression'. He advised artists to go 'into the inmost recesses of forests, and the most obscure and unfrequented villages', to find 'the happiest choice and combinations of *natural colouring*', and Constable depicted both deserted corners of woodland and obscure cottages. The latter, drawn in pencil with a grey wash in *c.* 1799, used his own rather than Smith's artistic vocabulary, although he was learning other things from him. Smith thought Gainsborough's early works 'as exactly *imitative* as possible',

11,12

22

12 *A Cottage among Trees, c. 1798–9*

13 *East Bergholt Church from the South West, c. 1796–9*

and on meeting Farington Constable volunteered the opinion that the 'first pictures of Gainsborough' were 'his best, latter so wide of nature'. It would be interesting to know what Smith would have made of the 'high glaring colours, and ... sudden and unqualified sparkles of light' which later became apparent in Constable's oil sketching, for these he censured for 'impropriety'. His greatest influence was probably in directing Constable's attention to the *domestic* scene from very early on, rather than encouraging him to seek subjects elsewhere.

In the later 1790s Constable still saw himself as an amateur. He copied from engravings and casts, studied anatomy, and was regularly requesting books like Gessner's 'Essay [*sic*] on Landscape'. Any drawings were of conventional subjects, nervous to the point of incompetence, and thoroughly unoriginal. The sharply exaggerated perspective of the careful pen and watercolour version of East Bergholt Church suggests that, like other amateurs, Constable used optical aids, which here had not been a great deal of help, although pink and grey washes do give a plausible effect of light and shade on the building itself. It is hard to guess why, in 1799, Constable imagined that he had the aptitude to warrant his becoming an art student.

13

14 Academy study, *c.* 1800

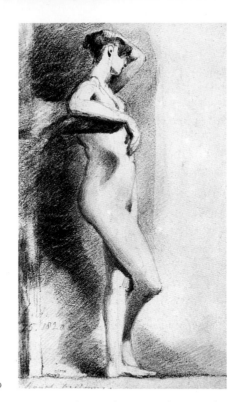

15 Female figure study, 1820

His early training was varied. He made academy studies in the customary materials, chalks on grey paper, and, as we noted, he maintained the discipline of figure drawing through his career. He either refused to correct nature, or was never entirely happy when confronted by the human form. Outside the Academy Schools, Farington put him to copying landscapes by Wyjnants and Wilson, the range extending in 1800 to include Annibale Carracci and Claude's *Landscape with Hagar and the Angel*. The unofficial side of Constable's education was largely directed towards landscape painting in oil. We can only guess at what kind of theoretical instruction he was being given to go along with it.

In 1800 Farington quoted Malchair the drawing-master as saying 'it requires that time shd. be allowed to observe nature & to mark the changes in the appearances of objects at different times of the day', which is reminiscent of Lucas's later note that Constable and Dunthorne studied from a particular motif only until the shadows changed, when they would stop, to resume at the same time the

14

15

2

following day. And Constable would have learned from Smith not to invent figures for a scene from nature, but to wait until some actually appeared, for these would always be more fitting for the subject. Sir George Beaumont would have kept him up-to-date on the latest aesthetic debates.

Constable also attended anatomical lectures, and probably heard Fuseli's near-incomprehensible discourses in 1801 (he knew them well later on), as well as attending picture sales. He reported all this to John Dunthorne back in Bergholt, who, Leslie was pleased to observe, 'possessed more intelligence than is often found in the class of life to which he belonged', and 'devoted all the leisure his business allowed him to painting landscapes from nature'. Constable made few alliances with his fellow-students (he fell in, then out, with his fellow-student, and eventual Royal Academician and forger, Ramsay Richard Reinagle), perhaps so distancing himself from the more experimental developments in landscape, and therefore providing some explanation for the individual character his work assumed almost from the start. He held himself aloof from his peers. He had nothing to do with The Sketching Society to which between 1799 and 1800 variously belonged Thomas Girtin, Paul Sandby Munn and John Varley, and which was engaged in producing historical landscapes (that is, pictures of scenery in which an elevating historical incident

16 *The Stour Valley with Stratford Bridge*, 1800

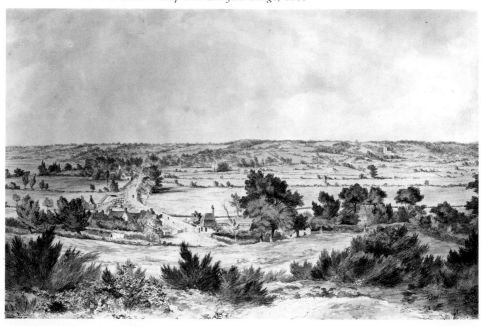

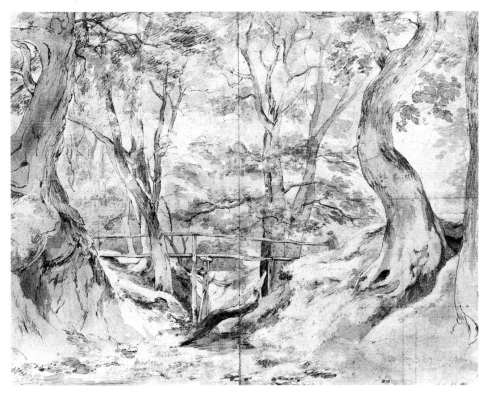

17 *Helmingham Dell*, July 1800

was inserted) as its contribution to closing the academic gap between
landscape and history painting. There appears no trace of any contact
with Dr Munro's Academy, where Girtin and Turner had once made
drawings after various masters, including John Robert Cozens.

Constable was taught, rather, by Joseph Farington, with help from
Sir George Beaumont, who readily made pictures available for
copying (by 1801, Farington thought Constable's painting of trees
virtually indistinguishable from Beaumont's). He was making occa-
sional essays in oil (around 1800 he portrayed the vista over his father's
farm for the first time), but mostly it is drawings and watercolours that
survive, and indicate little besides Constable being eclectic, and of a
moderate ability. *The Stour Valley with Stratford Bridge* was one of the 16
four fairly large watercolour drawings, completing a panorama of the
Stour Valley made as a present for a local friend, Lucy Hurlock. The
colour has badly deteriorated, but we can still attend to the clumsy

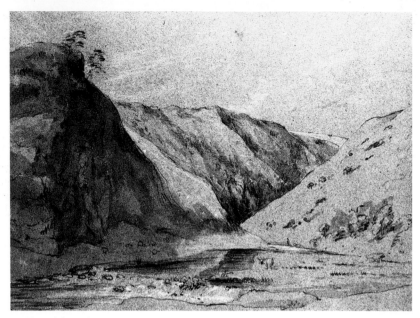

18 *Dovedale*, 1 August 1801

draughtsmanship, foliage like seaweed, and small figures looking as
though they had strayed from Dutch prints. These works nevertheless
impressed the recipient, who, in April 1800, looked forward to
obtaining 'a sight of the gradual production of early genius'. In other
instances Constable made progress. Gainsborough or Wyjnants
would have encouraged him to heed Smith's injunction to take to the
17 woods, and in *Helmingham Dell* he demonstrated his easiness with
picturesque imagery.

The subject might be compared with Turner's 1799 sketches of
woodland. The view into the dell, with its bridge a principal feature,
recalls Thomas Hearne's watercolour *The 'Alpine Bridge' at Downton*
(1785), and complied with a popular compositional formula, which
had been widely broadcast through prints. Constable's technique was
more skilled. The tree-limbs were outlined with some eye to
plausibility of representation, light and shade modulated the perspec-
tive, and there was more of an analysis of the motif in pictorial terms.
Constable maintained this improvement during an 1801 tour of

28

19 *The Entrance to the Village of Edensor*, 18 August 1801

Derbyshire, a region traditionally considered worth the attention of the landscape painter. One drawing in chalks on blue paper (in the tradition of Gainsborough) represents a fairly disciplined rendering of one of the favoured locales, Dovedale. Other pen and wash studies recall Sir George Beaumont's manner in their schematic representation of light and shade, or perspective, constituting work of a kind which one might have expected from any reasonably talented amateur.

18

19

Constable had visited Derbyshire primarily to stay with a relation, Daniel Whalley senior, and this picturesque tour was incidental to that domestic visit. He was not behaving like other landscape painters, and this aloofness can encourage us to study his art mainly in his local contexts. Yet, by exhibiting at the Royal Academy from 1802, Constable was inviting the public to scrutinize his work in terms of the more general prospect of modern landscape painting. And it was in the late May of this year that he finally committed himself to following art as a profession.

Professing Art

The decision to exhibit at the Royal Academy from 1802 was not the only sign that Constable had elected to make the shift from art student to would-be professional painter. His work began to show some awareness of what other artists were doing. Constable's drawn copy 20 after Girtin's *Guisborough Priory* is of uncertain date, but watercolours made at Windsor in May 1802, which are realized as sophisticated systems of washes, suggest that he was aware by then, certainly of Girtin's, and possibly of J.R. Cozens's work. These Windsor drawings were made when he was there to discuss with Bishop Fisher the details of the post the latter had suggested for him as drawing-master at a Military Academy. As we saw, Constable turned it down: 'Had I accepted the situation offered', he wrote to John Dunthorne on 29 May, 'it would have been a death blow to all my prospects of perfection in the Art I love.' He knew that to follow the trade of drawing-master would militate against professional advancement. With hindsight we can appreciate the rightness of that decision in the light, for example, of Cotman's having become nationally an insignificant artist after his leaving London thus to earn his living from 1806.

Constable had made a commitment to landscape painting, and an ambition to become, and be perceived as, a great painter was developed, however improbably, early in his career; and while it sometimes wavered, it nevertheless sustained him till his death. He had written his letter to Dunthorne after 'a visit to Sir George Beaumont's pictures – I am returned with a deep conviction of the truth of Sir Joshua Reynolds's observation that "there is no *easy* way of becoming a good painter"'. In 1803 Constable would reiterate, again to Dunthorne, that 'I feel now, more than ever, a decided conviction that I shall some time or another make some good Pictures. Pictures that shall be valuable to posterity, if I reap not the benefit of them.' The discrepancy between pretension and performance was enormous, and inspired pressure to relinquish painting for a real job, which was

20 Copy after Girtin's *Guisborough Priory*, c. 1800

renewed in 1812 as his parents urged him to abandon landscape for the more lucrative portraiture. He stayed resolute. 'I wish all they tell me about it could make me vain of my portraits – you know I am *"too proud to be vain"*, I am however perverse enough to be vain of some studies Landscapes which I have done – "Landscape which found me poor at first and keep me so."' That last quotation adapted Goldsmith's invocation to 'sweet Poetry', which 'found'st me poor at first and keep'st me so', from *The Deserted Village*. Landscape was one of the polite arts which indicated the health of a culture. Constable would confirm his commitment later that year: 'Landscape is my mistress – 'tis to her I look for fame, and all that the warmth of imagination renders dear to man.' He was claiming for landscape a social value equivalent to that of poetry, which, by inference, accredited the landscape painter with an occupation as worthwhile as any of the very many in which citizens were engaged, as well as justifying the egocentricity of his approach in a society which was

dynamic precisely through its having to respond to the competitive jostling of practitioners of those various specializations.

It was accepted that the fine arts were of value and importance in a society which was understood as cohesive, arranged on a model where disparate interests cooperated in promoting a common end, and where no doubts were entertained that excellence in the liberal arts was the most reliable index to the national condition. George III's foundation of the Royal Academy in 1768 had been, as Reynolds stressed in his opening *Discourse*, recognition enough of this:

We are happy in having a PRINCE, who has conceived the design of such an Institution, according to its true dignity; and who promotes the Arts, as the head of a great, a learned, a polite, and a commercial nation . . .

This traditional concept continued to exercise a powerful hold, and the watercolourist Edward Dayes produced his version of it in an essay 'On the Power and Usefulness of Drawing' (published in 1805).

That man was not intended by nature for purposes base and ignoble, none will deny; and, if arguments were wanted, they might be drawn from that eternal enquiry after whatever is grand, dignified, or exalted; and finally after a state superior to our present terrestrial one. For it is not too much to assert, that we approach the Divinity in nothing so much as in wisdom. Hence, as the arts are connected with wisdom, as men become careless of their culture, they become equally incapable of fulfilling the duties of social beings, for knowledge is what humanises mankind . . .

In 1807 Opie was dogmatic: 'The progress of the arts in every country is the exact and exclusive measure of the progress of refinement . . . and hence we find that the most enlightened, the most envied, and the most interesting periods in the history of mankind are precisely those in which the arts have been most esteemed, most cultivated, and have reached their highest points of elevation.' To neglect the liberal arts indicated moral bankruptcy and social disintegration.

In the early nineteenth century a majority of the concerned classes automatically took this view, believing that material comfort was only a prerequisite for cultural development, and showed a keen interest in the fine arts. If Constable could take a pride in his profession, this was because society equally valued painters. 'In no age and no country perhaps have the fine arts met that public patronage which they happily experience in England in the nineteenth century,' wrote J. B. Pyne in 1815. The public importance of the artist and the Royal

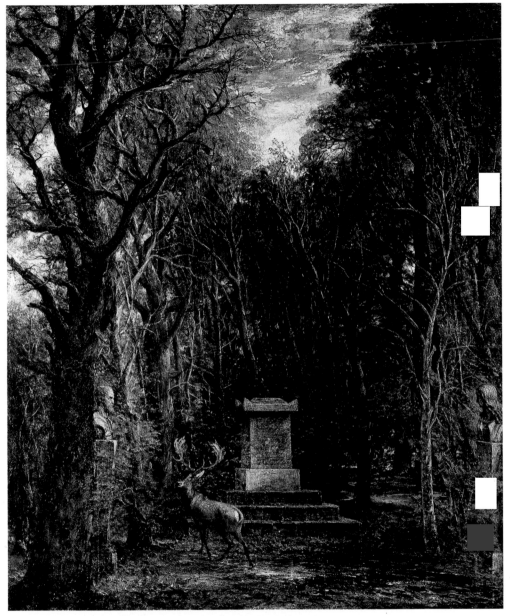

21 *The Cenotaph. (Cenotaph to the memory of Sir Joshua Reynolds, erected in the grounds
of Coleorton Hall, Leicestershire, by the late Sir George Beaumont, Bart.), 1836*

Academy was endorsed by John Fisher in 1819 when he congratulated Constable on his 'honourable election' to Associateship. 'Honourable it is: for the Royal Academy is in the first place an establishment of the great country to be held in great respect.'

In May 1802 Constable's sense of purpose had been fired through the example of Sir Joshua Reynolds, which was coming to assume almost a totemic status in the minds of British painters. Reynolds had moulded the Royal Academy and had laid out an artistic philosophy. He had created a professional identity for artists. His status was confirmed by Fuseli in a lecture of 1801 (printed soon after its delivery) which Constable very probably attended:

> To compare Reynolds with his predecessors would equally disgrace our judgement and impeach our gratitude. His volumes can never be consulted without profit, and should never be quitted by the student's hand, but to embody by exercise the precepts he gives and the means he points out.

Constable acted on this, or on advice like it, and Reynolds always would be of great significance for him. The 'Commemoration' that the British Institution organized to coincide with its Reynolds exhibition in 1813 was, for Constable, 'a moment of exaltation and joy' because it was an 'honor and homage to my own beloved pursuit – it was indeed the triumph of genius and painting'. He went on to write that to see 'two hundred of the highest characters in the country' on such an occasion 'could not fail of exciting the most lively emotions in every one who had a mind capable of appreciating the true value of mental acquirements'. A lecture note of 1835 reads: 'All art in Europe roused into Life by Sir Joshua Reynolds in England', and Constable's last completed Academy exhibit was *Cenotaph to the memory of Sir Joshua Reynolds, erected in the grounds of Coleorton Hall, Leicestershire, by the late Sir George Beaumont, Bart.* Beaumont had died in 1827, and Constable laid aside *Arundel Mill and Castle* to devote himself to the former canvas for the last exhibition to be held at Somerset House: 'I preferred to see Joshua Reynolds's name and Sir George Beaumont's once more in the catalogue, for the last time in the old house.' The painting sets the busts of Raphael and Michelangelo by the Cenotaph: the final *Discourse* had proclaimed: 'I should desire that the last words I should pronounce in this Academy, and from this place, might be the name of – MICHAEL ANGELO.' In his last painting at Somerset House Constable included himself not only with Michelangelo but

21

187

also with Raphael and Reynolds by freezing them in a landscape of his own creation, to stress the pretensions of both the artist and his art.

Constable's admiration for Reynolds seems to have inspired him in 1802 to go to the *Discourses* when seeking to establish a working procedure proper to his ambitions. The letter of May 1802 which accepted Reynolds's dictum that there was no easy way of becoming a good painter contained a unique statement of the programme he had elected to follow.

And however one's mind may be elevated, and kept up to what is excellent, by the works of the Great Masters – still Nature is the fountain's head, the source from whence all originally must spring – and should an artist continue his practice without refering to nature he must soon form a *manner*, & be reduced to the same deplorable situation as the French painter mentioned by Sir J. Reynolds who told him he had long ceased to look at nature for she only put him out.

In the earlier *Discourses* Reynolds insisted upon the importance of studying the art of the Great Masters. While this might never be surpassed, the attempt to surpass, to develop their tradition, was essential. It would impart technical lessons (in the early 1800s Constable was copying Ruisdael, Wilson and Claude, among others) which should then be refined by the direct study of nature. Constable acknowledged his reliance on Reynolds by adapting his language. Nature had been 'the fountain which alone is inexhaustible; and from which all excellencies must originally flow' in the sixth *Discourse*, and 'the fountain head from whence all our ideas are derived' in a note to Mason's translation of Dufresnoy's *De Arte Graphica*. The 'French painter' of the quotation was identified as Boucher in the twelfth *Discourse*, where Reynolds had again insisted that 'you are never to lose sight of nature'.

Having taken this to heart Constable wrote in his letter that he would 'shortly return to Bergholt where I shall make some laborious studies from nature – and I shall endeavour to get a pure and unaffected representation of the scenes that may employ me'. This, then, was to be an ethical endeavour. It would be laborious. It ought to produce pictures which were 'pure and unaffected', to contrast with the current state of affairs:

There is little or nothing in the exhibition worth looking up to – there is

22–4

35

22 *The Stour Valley*, 1802

room enough for a natural painture . . . *Fashion* always had, & will have its day – but *Truth* (in all things) only will last and can have just claims on posterity.

In his seventh *Discourse* Reynolds had written that 'the natural appetite or taste of the human mind is for *Truth*', a relish for which could be acquired by 'the good and virtuous man alone'. This highest of the moral attributes would, for Constable, be attained by developing a 'natural painture'. (Johnson gives 'painture' as an Englishing of the French *peinture*, 'the art of painting'.)

The view that it was imperative to study nature directly remained, or appeared to remain, central to Constable's thinking as he strove to paint for posterity. In 1812 for instance, he described what he had thought a successful campaign of painting from nature:

How much real delight have I had with the study of Landscape this Summer, either I am myself much improved in '*the Art of seeing Nature*' (which Sir

Joshua Reynolds calls painting) or Nature has unveiled her beauties to me with a less fastidious hand.

Constable had originally been directed to Reynolds's formulation by Smith. Reynolds actually defined '*The Art of seeing Nature*' as 'the art of using models' and called it 'the point to which all our studies are directed'; so that by reducing this to 'painting' Constable revealed his loyalty to his own version of this teaching, one which held that it was important to build on what previous painters had demonstrated of the physical appearance of the world – in 1823 Wilson was 'one of the great men who shew to the world what exists in Nature but which was not known till his time' – through direct study.

In 1802 this took the form of 'some laborious studies of nature' which Constable made in the environs of East Bergholt between July and October 1802, in oil, on canvases of around 13 by 17 inches. It is important to stress that these were *studies* (and two may have been exhibited as such in the 1803 Royal Academy) and not sketches. To paint from nature an oil potentially fit for exhibition was to produce something far more pretentious than a watercolour (very finished watercolours were being produced in the early 1800s in reaction to this same constraint), and these oil studies were unexpectedly assertive. Both our examples show Stour Valley landscapes from a high viewpoint (others pictured close views of woodland, or Willy Lott's farm on the Stour). In *The Stour Valley* brown ground mediates the tonal arrangment, fore- and backgrounds vary in finish, and the sky is painted fairly thickly. Commentators have noticed links with Gainsborough: the figure recalls those which lounge around the foregrounds of his Suffolk landscapes, and in each painting Constable's handling had been adapted from the 'exactly descriptive' early paintings of Gainsborough – a proper model for a representational style – leavened through the example of Claude. Sir George Beaumont's *Landscape with a Goatherd and Goats*, thought to have been painted from nature, carefully described wood and indicated foliage with small dabs of paint. Constable was carrying out his plan to regulate what he learned against what he could see: he appears to follow topography, the colouring is descriptive of the local hues.

Both landscapes were carefully composed. The schema of a view framed by a principal and lesser masses of trees was adapted from Claude's *Landscape with Hagar and the Angel*, and the vista stretching from one side of a landscape blocked off with woodland on the other is

very reminiscent of Rubens. Constable was searching out pictures in nature. Claude's landscape had associations of ideal beauty and the Golden Age, but he took over none of these. Rather, he adapted the composition as an armature to support study from nature, and the content of the paintings was abstracted to a 'truth' of appearance. The perceptible Dutch or Gainsbrughian influences parallel the interests of John Crome in Norwich, and it may be that Gainsborough's landscapes were perceived as having set going an East Anglian tradition which, to a greater or a lesser degree, other East Anglian artists (like Frost of Ipswich, of whom Constable knew in 1797) were conscious of maintaining.

These 1802 landscapes were exceptional paintings which, in their concern with actualities, anticipated much later work. Constable painted them not by going on a picturesque tour, but by discovering landscapes around East Bergholt. However, his subsequent work from nature was not developed from these studies. He would next use oil consistently in 1808 to make *sketches*, and until then, seems to have preferred watercolour or graphite to depict landscapes of a similar character to those in the 1802 oil studies. Watercolour, the province of women and the domestic environment, was, despite its development for public exhibition, and the blurring of its role in the paintings of Turner, less appropriate to a public landscape art, although it was this at which Constable continued to aim.

It all *seems* straightforward enough. Constable, deciding to profess art, went to Reynolds to seek a system to help him to develop as a fine artist, and valued member of society. This would suit his conservative temperament, and he respected academic traditions. The system followed in evolving *The Hay Wain* or *The Leaping Horse* relates to 109, 136 that Reynolds described in his first *Discourse* as being used by the masters, in preparing for their compositions via sketches and studies. 110, 113, 134–5 Others also learned from Reynolds. Reynolds's remark: 'that artist who can unite in himself the excellencies of the various great painters will approach nearer to perfection than any one of the masters', might have been laid as a plan of operation for Turner, who maintained in his art, via imitation, pastiche, portraying them, or featuring them in his titles, a continuing dialogue with the old and modern masters.

Yet, both Turner and Constable were landscape painters. The elaborate preparation for *The Leaping Horse* was anomalous: this procedure should have been directed towards the production of

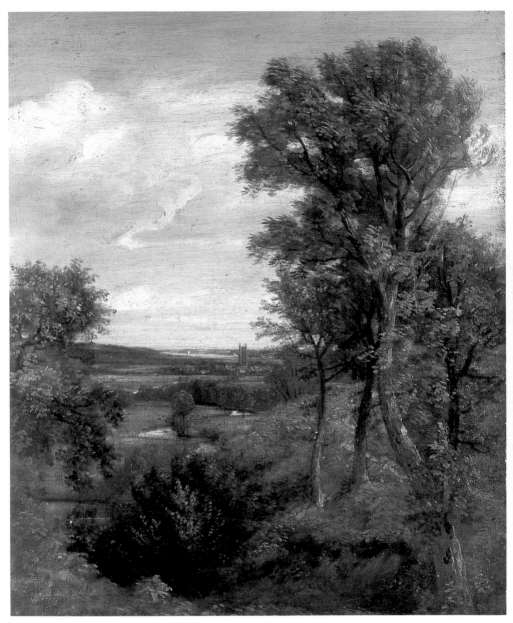

24 *Dedham Vale*, September 1802

history paintings. Landscape, an inferior genre, was one of 'various departments of painting' which did not 'presume to make such high pretensions', and the landscapist was to the history painter what the writer 'of pastorals, or descriptive poetry' was to the epic poet or tragedian. History painting was the most exalted expression of public ideas, those upon which disinterested individuals accepted a degree of consensus. Ideal and practicality might jar. Around 1772 Gainsborough complained that 'Sir Joshua either forgets, or does not chuse to see that his Instruction is all adapted to form the History Painter, which he must know there is no call for in this country.'

The national art which the *Discourses* were bent towards promoting would be expressed in the Great Style, and not as landscape. Students at the Royal Academy Schools were trained in figure drawing as a preliminary to the aim of becoming history painters. Constable never considered this a possibility, and, in different ways throughout his career, appeared untroubled by the academic impossibility of landscape painting fulfilling the requirements of the highest forms of art. When he associated himself with Reynolds, Michelangelo, and Raphael in *The Cenotaph* he ignored the traditional lines of demarcation. Others did not. In May 1808 Constable retailed to Farington a conversation he had had with the history painter Benjamin Robert Haydon. 'Haydon asked Him "Why He was so anxious abt. what He was doing in Art" – "Think"; sd. He "What I am doing" meaning how much greater the object and the effort.' When Constable paid the obligatory call on Lawrence after being elected an Academician, the latter made it clear 'that he considered him particularly fortunate in being chosen an Academician when there were historical painters of great merit on the list of candidates . . . there can be no doubt that he thought the painter of, what he considered the humblest class of landscape was as much surprized at the honour as he was himself'. Constable might have considered his landscape equal to history, and others agree, but the more traditional view retained adherents.

The term 'humblest class of landscape' carried a censure related to style as much as subject. Until *c*.1821 Constable's exhibition canvases were painted in a manner aimed to give the look of the whole by imitating the appearances of the details of his subjects. For Reynolds, such work could communicate only limited and particular ideas, not morally elevating ones: a position which some still maintained. In 1798 Southey censured Wordsworth's *Idiot Boy*:

No tale less deserved the labour that appears to have been bestowed upon this. It resembles a Flemish picture in the worthlessness of its design and the excellence of its execution. From Flemish artists we are satisfied with such pieces: who would not have lamented, if Correggio or Rafaelle had wasted their talents in painting Dutch boors or the humours of a Flemish wake?

The medium and the message it purported to impart could be censured as incompatible. However, while Byron, for instance, would in 1807 agree with Southey, 'when Mr. W. ceases to please, it is by "abandoning" his mind to the most commonplace ideas, at the same time as clothing them in language not simple but puerile', other critics defended Wordsworth's diction as suited to the ambitions of his poetry. 'We think, with him, that the language of poetry ought to be language really used by men, and constructed upon the same principles as the language of prose,' wrote one in 1815.

By then Constable had been engaged in the attempt to paint an imitation of what anyone might see in nature for thirteen years – *Golding Constable's Kitchen Garden* represents the stage the project had reached. The disagreements over Wordsworth parallel disputes about how to receive painting couched in the 'least elevating' style. The existence of this dispute, which would allow the circumstances where some might see it as natural for landscape to serve the same function as history, is in the context of an extremely complicated episode in the history of taste. We need to know far more about art-criticism, its terminology and real effects, and the more general pressures on painters, to understand fully an apparently simple episode of professional pragmatism recorded by Farington in 1811. When he saw the picture of two naked Bacchanalian children intended by William Ward for his Academy Diploma piece he thought it 'much inferior in merit to his pictures of Horses. He said he chose to send this picture, because He did not like to be admitted into the Academy as a *Horse-Painter*.' To the members of the Academy at least, subject-matter could still override considerations like artistic quality. Others, though, were unconcerned with such considerations, and felt able to follow the spirit but not the letter of Reynolds's teaching.

There are various reasons for this. The teaching was distanced by time – Reynolds died in 1792. There was widespread disagreement over what form that elevated art all agreed the British School should strive to paint should take. Ward needed to be considered a figure- rather than a horse-painter. Sir George Beaumont argued violently

with Haydon's contention that a history painting needed to contain figures on the scale of life, rather than on the scale of genre-painting, and Richard Payne Knight, who attempted to wield an equivalent power over public taste, was completely out of sympathy with the Great Style. Painting was an imitative art which should be devoted to 'colour, light and shade and all those harmonious and magical combinations of richness and splendour which form the charm and essence of the art', and therefore the Flemish painters were 'the greatest masters of the art considered abstractedly as the art of painting'. Knight was one of the theorists of the Picturesque, which sought to classify imagery in terms of particular pictorial qualities. Because these might be found in a Brouwer as easily as in a Raphael, there was a tendency to equalize the distinctions between the various genres, to endow landscape with as much value as history, which would suit with Knight's doubts over painting's claim to the status of a liberal art.

While artists themselves thought slightingly of Knight, he and Beaumont were influential in the British Institution, which had been founded 'to encourage and reward the talents of the Artists of the United Kingdom', and which tended to promote a sort of painting at variance with academic ideals. The works lent to the Institution for young artists to copy in 1806 included only one by Annibale Carracci and one by Guido Reni. The remainder included five Rembrandts, and canvases by Ostade, Wouwerman, Teniers, Rubens, Van Dyck and Reynolds. Conversely, after the Reynolds exhibition in 1813, thirteen of the eighteen paintings kept on show for the benefit of aspiring artists were histories and fancy pictures, which themselves would hardly fit their painter's definitions of the Great Style.

The painters themselves, and some critics, while agreeing that art should inspire exalted emotions, differed as to what kind of painting was best suited to do this. In 1794–5 Wilson's pupil William Hodges had attempted to paint a moralized landscape in two canvases, *The Effects of Peace* and *The Effects of War*. In the late 1820s painters like Lawrence, Shee or Phillips still believed history to be superior to any other genre. Given the opportunity for extended study of great historical painting in the Louvre in 1802, Turner seems to have concerned himself with what Farington termed 'the Principles upon which the Great Masters . . . worked'. He thought Poussin's *Gathering of the Manna* 'the grandest system of light and shadow in the

collection', and that Titian's *St Peter Martyr* demonstrated 'great power as to conception and sublimity of intellect', but was also interested in the way that 'the sublimity of the whole lies in the simplicity of the parts and not in the historical color'. He considered it reasonable to learn creatively about composition or 'historical color' from the masters, to develop paintings not necessarily looking like theirs, although derived from common principles.

In 1810 the critic John Britton anticipated Constable in vindicating landscape painting through the example of Richard Wilson:

... we have been told that landscape painting is the lowest branch of the Fine Arts and that those who practice it are little better than 'topographers and map makers' ... It is thus that a prejudice is created, and young minds deceived ... It will not be very difficult to perceive that many of [Wilson's] pictures, which are strictly 'topographical' are replete with merit ... Some of Claude's, Gaspar Poussin's and Ruysdael's are representations of particular scenes, and are certainly not the less interesting or valuable from that circumstance ... excellent painting is calculated to produce intellectual pleasure, and to excite emotions and associations of the most exalted and philanthropic nature.

He was meaning to repudiate Fuseli's denigration of landscape painting as 'the tame delineation of a given spot' in his fourth lecture – yet Fuseli had himself gone on to accord the highest praise to the landscapes of Titian, Mola, Salvator, the Poussins, Claude, Rubens, Elsheimer, Rembrandt and Wilson.

During the 1800s, moreover, Turner went a good way towards challenging the Academic hierarchies on behalf of modern landscape. In 1807 he was elected Professor of Perspective at the Royal Academy, and published the first part of the *Liber Studiorum*. The first involved a landscape painter taking on the most onerous Academic tasks and assuming a mastery of theory equal to that of the history painter. The prints of the *Liber* exemplified the range landscape could have, for Turner classified it under History, Mountains, Pastoral, Marine, Architecture, and Elevated Pastoral. These categories were sufficiently encyclopaedic to allow it to take over the pretensions of history, and Constable may have been half-remembering Turner's categories when he wrote in a lecture note of the 1830s: 'Every walk of landscape – historic, poetic, classic, and pastoral – were familiar to Nicolo Poussin.'

Circumstances did not encourage the slavish adhesion to a

theoretical canon, and when John Cranch introduced Constable to Reynolds in 1796, it was with qualifications:

... be cautious it does not bias you against *Familiar* nature, life and manners, which constitute as proper and genuine a department of imitative art as the *sublime* or the *beautiful* . . . The 'Discourses' are a work of unquestionable genius, and of the highest order of literature; but they go, if I may so express it, to establish an *aristocracy in painting*: they betray . . . many students into a contempt of everything but *grandeur and Michael Angelo*: the force and splendid eloquence, with which the precepts are inculcated, makes us forget, that the truth of Teniers, and the wit and moral purposes of Hogarth, have been, and will for ever be, at least *as* usefull, and diffuse at least as much pleasure as the mere *sublimities* of Julio and Raphael.

Constable appears to have listened to this advice. He proved to be a remarkably insular artist. Numbers of celebrated Italian paintings were entering Britain during the war period, but he appears not to have noticed them much, preferring to copy landscapes from the collections of Beaumont or Farington. And he never made any effort to visit the Continent. Nevertheless, from 1802, he had professedly dedicated himself to evolving a serious and moral landscape painting.

25 *Mill on the Banks of the Stour*, 1802

26 *Landguard Fort near Felixstowe*, 1803 ?

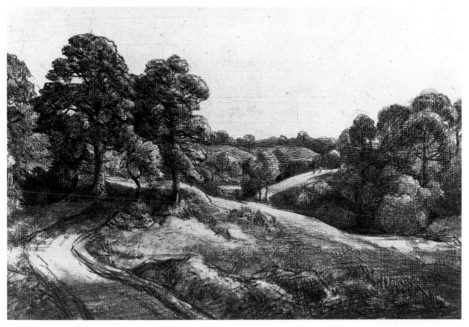

27 *A Wooded Landscape*, *c.* 1805

Finding a Subject

We have mentioned that, after 1802, Constable seems to have laid by oil in favour of graphite and watercolour as his preferred media. By 1803, when they drew side by side at Ipswich Docks, he was collaborating with George Frost, on whose instigation he may have sketched Landguard Fort, Felixtowe (subject of Gainsborough's first 26
commission from his eventual biographer, Philip Thicknesse). Despite his London training, Constable was so content with the crude style which Frost had evolved from Gainsborough's chalk drawings that only recently have Leslie Parris and Ian Fleming-Williams shown how to distinguish their hands. Constable's *Mill on the Banks of the* 25
Stour of October 1802 is such a work. A later study of woodland 27
develops the technique. Tonal relations are set up between chalk and paper, stump creating a half-tone, and white chalk the highlights. This technique describes and interrelates landscape forms – comparing tellingly with that 1801 *Edensor*. Constable often washed watercolour 19
over a graphite underdrawing to realize broad landscape-forms as blots of colour (often now much faded) and is here expressing the 28
effects of a late summer's evening, when intense shadow contrasts with startling light.

With the increase in competence went a certain variety – not *all* the drawings of the period look like the illustration. Constable drew subjects of antiquarian interest, like the front of St Botolph's Priory in 32
Colchester, uneasy in its perspective, and interesting in translating architectural form as patterns of chiaroscuro. This was a personal variant on convention. Church fronts, as the copy after Girtin 20
showed, were popular motifs, and Cotman viewed St Botolph's from a similar angle to Constable's for a print published in 1811.

A brief coasting trip with his father's friend Captain Torin in 1803 resulted in studies of shipping, following the formulae originated by 29
the Van de Veldes. The few surviving oils are too exeptional to reveal much. Here colours ranging through light browns, greens and blues 30
defined a sketchy view of the Stour Valley.

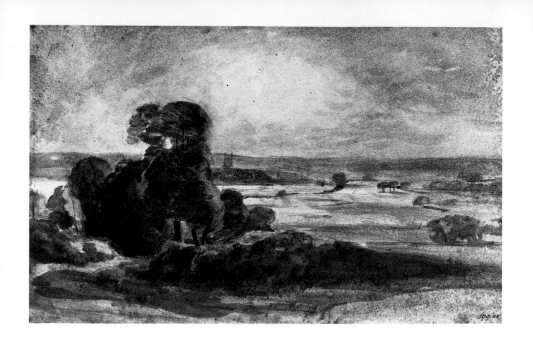

28 *Dedham Vale, c.* 1805

29 *Shipping in the Thames,* 1803

30 *The Stour Estuary,* 1804

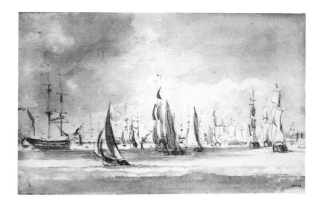

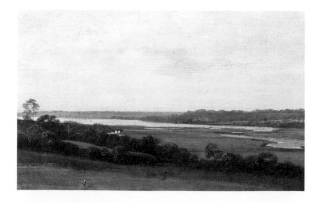

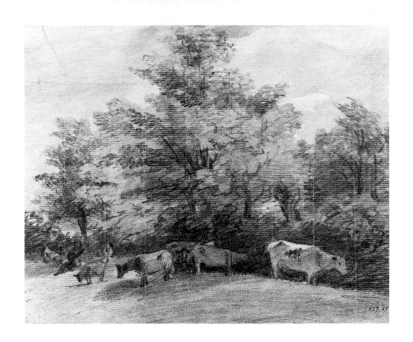

31 *Landscape with Cows and Trees*. Inscribed 'Tuesday Noon 28 June 1803'

32 *Ruins of St Botolph's Priory, Colchester, c.* 1803–7

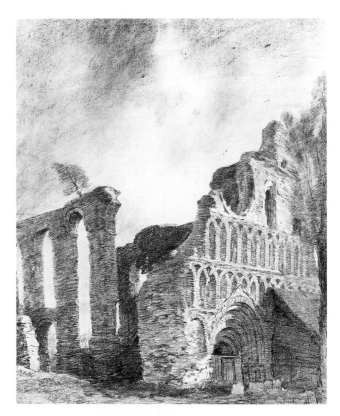

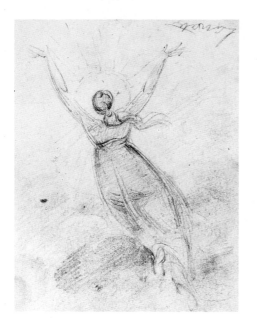

33 (left) *Laura Hobson of Markfield*, 1806

34 (above) *Joshua and Laura*, 1806

We cannot gauge the place of such work in Constable's more general landscape study. He was continuing systematically to depict his native region, and had learned to exploit different media to different ends, but we do not know if any significant landscape painting was resulting from this. He would be genuinely affronted when others deviated from his own criteria of naturalism – in 1803 he felt that Turner was becoming 'more and more extravagant and less attentive to nature'. But despite his feeling qualified to criticize other artists on these terms, his own public career had so far been dismal.

He painted an altarpiece for Brantham Church in 1805, and was slowly building up a local portrait practice. Drawings of 1806 suggest
33–4 the systematic study of humanity in its domestic habitat, and could take unexpected forms, as in the Blakean visualization of Laura Hobson (of Markfield, Tottenham), leaping, arms aloft, into the sun, to invite speculation as to whether some angelic association was intended. To the exhibitions Constable sent landscapes, to demonstrate his independent capabilities. His watercolour of the Battle of
35 Trafalgar in the 1806 Royal Academy Exhibition (reliant on those
29 earlier nautical studies), like other attempts at cashing in on the great

50

victory, had its ambitions put in the shade by Turner's large and dramatic visualization of Nelson's death. It was, as far as we know, important as a first try at competing with other painters: in 1804 Constable had thought of not exhibiting at all.

The Trafalgar watercolour suggested a greater determination to play a public role as a landscape artist, and sustained study in the Lake District in 1806 may also have been aimed towards this. By the start of the nineteenth century the Lake District was vying with North Wales as the most frequently toured and represented region in Britain. Many painted or drew its abundant beautiful or sublime landscapes (engravings of which were widely disseminated), and not only the poets, but painters like Julius Caesar Ibbetson were taking up residence there. The region inspired many memorable images, from Francis Towne's precise watercolour drawings to Turner's sublime canvases. Constable, conscious of the fashionable character of his tour, was not motivated by modishness alone, for again a family connection directed his movements; but he nevertheless reacted to the scenery positively.

Constable, supplied with introductions from his uncle, was in the Lake District for September and much of October. He appears particularly to have liked Borrowdale. He worked mostly in graphite

35 *His Majesty's Ship Victory, Capt. E. Harvey, in the memorable battle of Trafalgar, between two French Ships of the Line*, 1806

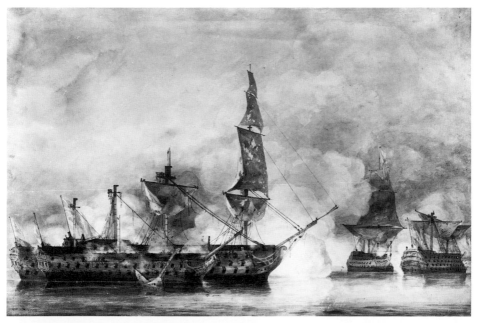

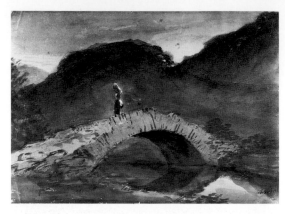

36 *A Bridge, Borrowdale.* Inscribed 'Borrowdale Oct. 2. 1806 – twylight after a very fine day'

37 Sir George Beaumont, *Landscape with a Bridge*

36, 38 and watercolour, but made a few oil sketches too. But as we are largely ignorant of the finished oil paintings based on this study and exhibited between 1807 and 1809, one half of the equation is missing. The latter did receive favourable press notice, in the *St James's Chronicle* in 1807, but, as far as we know, did not sell.

 The studies covered many motifs and effects. Watercolours caught the transient metereological effects typical to the region, drawing often discriminated landscape structures and morphology. The

42 watercolour of *Langdale Pikes* concerns itself with tonal and colouristic
41 reactions to weather, the drawing notes both these, and other aspects of landscape, including a fair amount of apparent detail, often suggested with a few outlines (a technique possibly adapted from studying Wilson's painted background). These studies often include notes of the time of day and weather, or the shortcomings of paint in transmitting

52

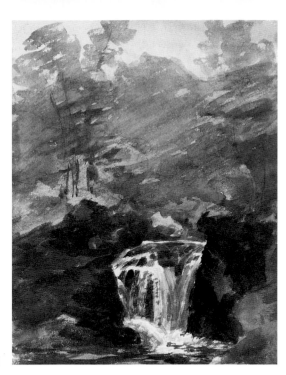

38 *A Waterfall*, 1806

what he saw – 'tone more blooming that [?than] this' – or matching this
with his knowledge of art: 'tone very mellow like – the mildest of
Gaspar Poussin and Sir G. B. & on the whole deeper toned than this
drawing'. These studies were complex productions, backed up by
linguistic mnemonics, and involved in a personal dialogue with the old
masters.

They were also sophisticated essays in conventional landscape.
Girtin's watercolour technique (which had also influenced Cotman)
was adapted for generalities, or the foreground was dispensed with in

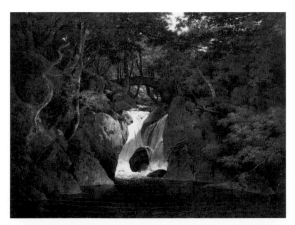

39 Joseph Wright of Derby,
Rydal Waterfall, 1795

a way similar to Francis Towne's in his view of Rydal Water (1786).
The view along and up to a bridge was popularized by drawing
manuals and used by others, like Sir George Beaumont. This
watercolour is now fairly monochrome, and is concerned with tones
and reflections. The solitary figure may or may not be a conspicuously
Wordsworthian point of focus. The waterfall is again shown in a
standard way (compare it with Wright's *Rydal Waterfall* of 1795) and
is technically very deft. Blots of dark green signify rocks, long washes
of both a dilution of this colour and an olive green the flow and fall of
the water, and the white of the paper creates foam and reflections.
There was an increase in executive skill as Constable continued to
develop his 'natural painture'.

In general, Leslie's was a perspicacious summary of these pictures:

> They abound in grand and solemn effects of light, shade, and colour, but
> from these studies he never painted any considerable picture, for his mind was
> formed for a different class of landscape. I have heard him say the solitude of
> mountains oppressed his spirits. His nature was peculiarly social and could
> not feel satisfied with scenery, however grand in itself, that did not abound
> in human associations. He required villages, churches, farmhouses, and
> cottages . . .

As we know so little of the pictures which *were* exhibited we cannot
tell whether or not 'a considerable' one ever was based on the Lake
District studies, although Farington would advise against exhibiting a
five-foot-wide scene in Borrowdale 'as being in appearance only like a
preparation for finishing, wanting variety of colour & effect', in 1809.
Constable was courting public favour with these pictures (a print of
1815 suggests that it took some time to write off the project
completely) and to paint a large picture was a strategy for attracting
notice – one which would eventually pay off in 1819 with *The White
Horse*. There were difficulties in working on that scale (despite
Constable's earlier having made a larger copy of a Reynolds portrait
for the Dysarts), but we do not hear of any aversion for the landscape
itself. In 1814 Constable was keen to visit Wales, and in 1821 showed
that he was sympathetic enough to mountainous scenery to feel put
out by Collins's *Scene in Borrowdale* – 'I thought the subject might be
about the neighbourhood of Bagnage Wells – but he named a scene in
the most romantic glen in Westmorland as the identical spot he had
painted. This I am sure will never do as Landscape painting.'

54

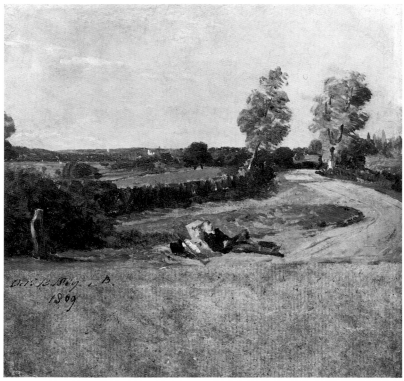

40 *A Lane near East Bergholt with a Man Resting*, 1809

In 1802 Constable had resolved to paint naturally to achieve truth, for '*Truth* (in all things) only will last and can have just claims on posterity.' So far Constable had concentrated on 'truth' of appearance, but truth 'in all things' potentially shifted the natural painture into an ethical realm. The pictorial structures he had been using invited judgment on formal aesthetic grounds, and this limited the scope of his continuing refining of naturalistic observation. It would eventually climax in a truth of representation, truth 'in all things' being left to chance. As a countryman Constable knew that perceiving landscape involved more than formal visual judgements – in 1814 he admitted to Maria Bicknell that 'I can hardly tell you what I feel at the sight from the window where I am now writing of the feilds in which we have so often walked', and if 'the feeling of a country life' came to

constitute 'the essence of landscape', it had to be affected by a range of factors.

Leslie was acute when he mentioned that Constable needed a scenery of 'human associations', transmitted through villages, churches, farmhouses, or cottages, for it was this which distinguished the character of the Stour Valley from that of the Lake District. Rather than a solitary figure on a bridge we meet with a crowd of harvesters. The mixture of enclosures of meadow, arable land, and woodland around East Bergholt had been imposed on a landscape itself adjusted for human convenience. The river, attractive in the middle distance, was also a canal and source of irrigation. The countryside was densely colonized. The physical interrelationships of towns, villages, farms and cottages, connected by roads, lanes or tracks, pointed to the practical interdependence of their inhabitants. Their own relationships were regulated by forms of religion and of law, founded on central authority and administered through systems of delegation originating in Government and ending in the Parish.

Families like the Constables accepted a connection between material and spiritual prosperity: 'man was not made for idleness – or at least incur'd the punishment of labour for disobedience', wrote Ann Constable. Her son favoured Archibald Alison's *Principles of Taste* over Burke *On the Sublime and Beautiful* for considering 'us as endowed with minds capable of comprehending the "beauty and

41 *Langdale Pikes from Elterwater*, 4 September 1806

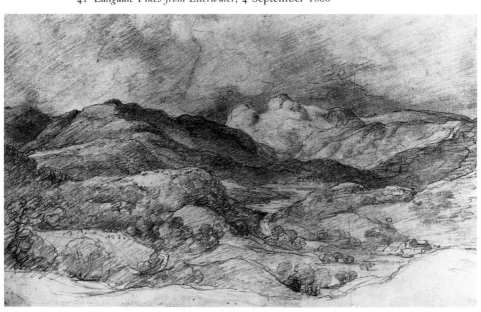

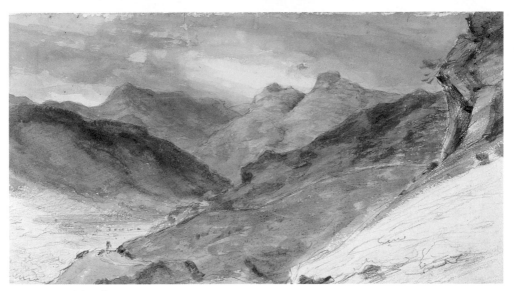

42 *Langdale Pikes*, 1806

sublimity of the material world" only as a means of leading us to *religious sentiment*'. The church tower, so often a compositional accent for Constable, also emphasized God's guiding role in this creation, His word being transmitted via a Church firmly integrated within the political system. If Constable wanted to paint an ethical landscape, he would realize that there were advantages in painting the Stour Valley, of which he had a sophisticated and particular understanding, for the resulting pictures might take on that moral content so necessary to an art aspiring to public status.

As war continued against the French, British scenery had to contain all within itself – Sam Smiles's unpublished researches have shown how Devonian light was an acceptable substitute for Italian – and to represent what stood to be lost. But ways of developing the message needed to be found, if a landscape painting was to exemplify *why* all this was worth defending, which problem began to engage Constable's interest around 1808–10. In 1807 the Dysarts ensured some artistic income, and he began to move more among artists, having become fairly friendly with Wilkie. And there were developments in landscape painting which demanded notice.

Augustus Wall Callcott was being successful with picturesque English landscapes. The eminent collector Sir John Leicester bought

his *Water Mill* for 80 guineas in 1805, and then paid 150 guineas for *Market Day* in 1807. Constable had to balance this acclaim against his own opinion of the latter picture, a highly-finished essay in the manner of Hobbema:

he said it was a fine picture, but treated in a *pedantick manner*, every part seeming to wish to shew itself; that it had not an air of *nature*; that the trees appeared crumbly – as if they might be rubbed in the hand like bread; not loose and waving, but as if the parts if bent would break; the whole not lucid like Wilson's pictures in which the objects appear floating in sunshine.

Constable would have disapproved of the element of pastiche (Wilkie was also doing something like this by referring his imagery to the paintings of Teniers) meant to attract collectors whose tastes had been founded on old art. These modern works appealed to influential connoisseurs, particularly those associated with the recently-founded British Institution: Beaumont had championed Wilkie and was 'decidedly of opinion that the Flemish and Dutch masters are the model for practice and process in painting'. This would encourage an assessment of painting according to how far its formal relationship with old art was distinct and recognizable. Yet, tradition should properly be used as the foundation for a modern painting to be generated from original observation.

The Thames landscapes developed out of Turner's intensive oil sketching along the river and its valley, which he exhibited both in his own gallery and at the Royal Academy from 1806, had exemplified what could be done with native scenery. Oil sketching had more generally seen a resurgence, not just with Varley and his pupils (of whose work Constable probably knew), but among painters like Thomas Hofland and William Delamotte as well. Painting in oil from nature was associated with Wilson's pupils – Thomas Jones and William Hodges – of whom Farington had been one. An awareness of the tradition therefore permitted an analysis of Wilson's grandiose Roman landscapes as being founded on intense study from the motif. These are among the circumstances which may have directed Constable to begin oil sketching around the Stour Valley in 1808.

The small sketch on board (which perhaps absorbed some oil) of East Bergholt Rectory over the fields was realized in broad patches of paint, probably approximating to local colours. Directional brushstrokes defined the distant poplars. In 1809 structure was still

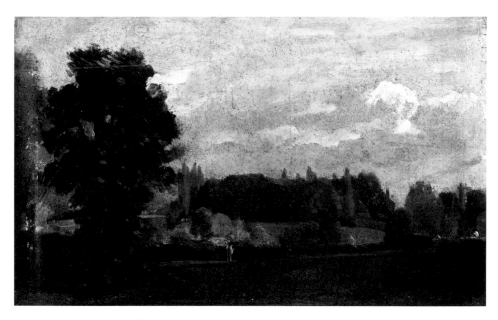

43 *View towards East Bergholt Rectory*, 1808

established by means of patches of paint, but tonal variations were now stressed, and white highlights introduced, to impart information about the lie of the land, and general colouristic interrelationships. The system appears near to what Collins noted of Linnell's in 1814, 'of making studies – without much reference to form – of the way in which colours come up against each other. The sharpness and colour of the shades, as well as the local colour of the objects may be got in this way.'

By 1810 Constable's execution had become refined and dextrous. Another view of East Bergholt Rectory, at dawn, exploits the canvas-weave to enhance effects, and has managed the technically difficult task of keeping the oranges, reds and greys of the sky around the sun relatively unmixed. The sun's rays are suggested by impressions in the paint. In other work he stressed the contrast between shade and bright sunlight, using the brown paper to establish a tonal standard, combined patches of local colour giving a generalized representation of the scene. With the experience of this study behind him, Constable perhaps tried to produce more ambitious pictures painted at least

44

47

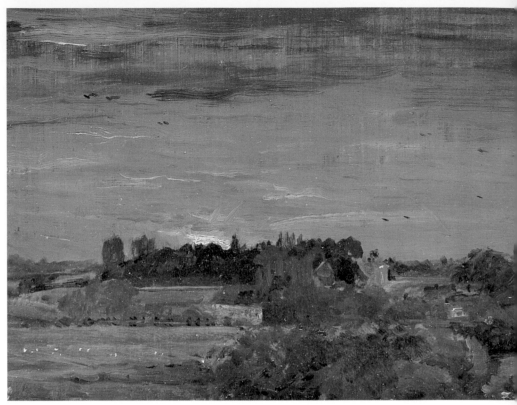

44 *View towards East Bergholt Rectory*, 30 September 1810

4 partly in the open. He was about *Malvern Hall* on a stay there from
 later July 1809, and the trees are unfinished enough to suggest that they
 were painted from the motif.

 Constable's exhibited pictures, however, had so far not even
 qualified as historical landscape – Haydon can be forgiven for his
 incredulity during that conversation in May 1808. Around 1810 he
 moved to rectify matters. Along with the Kit-kat *A Landscape* which
45 Lord Dysart bought, he exhibited *A Church Porch* in the 1810 Royal
 Academy Exhibition. This view of the south side of East Bergholt
 Church on an evening in late summer may have been produced on a
 stay in the village in late August 1809. The figures have been linked to
 a similar group which Constable drew for an engraving of 1806,
 where they ponder a headstone inscribed 'Here rests . . . a Youth' from
 'The Epitaph' which ends Gray's *Elegy*:

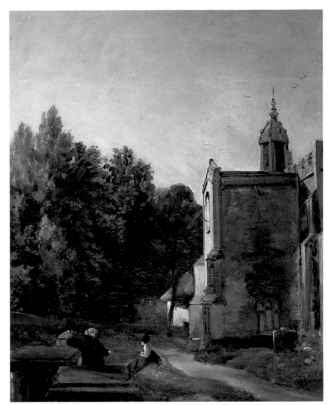

45 *A Church Porch.* Exhibited 1810 ?

Here rests his head upon the lap of earth
 A youth, to fortune and to fame unknown:
Fair science frown'd not on his humble birth,
 And melancholy mark'd him for her own.

The declining sun, the sundial, the figures representing youth, maturity and old age, and this hidden reference, show the picture to invite meditation on the passage of time and the inevitability of death. The church reminds us that only a submission to religion can salve our fears, as Constable's father had found his 'own reliance on a God that shows mercy to all penitent sinners' his best support when he had thought himself to be dying.

The content was reinforced through the group's broad connection with recent derivations of Poussin's *Arcadian Shepherds* (the canonical pictorial exposition of the inevitability of death, even in Arcady) like

61

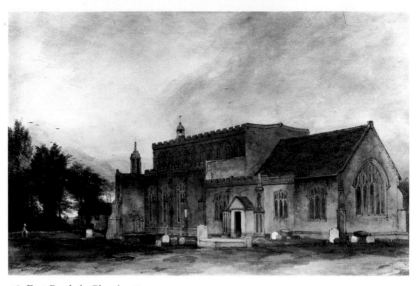

46 *East Bergholt Church*, 1811

Prestal's aquatint after a now-lost Gainsborough, where two lovers contemplate a gravestone as the sun sets, and where the letterpress comprised the first sixteen lines of Gray's *Elegy*. As, in 1809, Constable fell in love with Maria Bicknell, his imagery may privately relate to Gainsborough's, for both were concerned to contemplate religious matters, and Maria's grandfather, Dr Rhudde (whom Constable would try to propitiate with a watercolour of his church in 1811) was the Rector of East Bergholt. *A Church Porch* exhibited the particular reality of its landscape, for the style attempted to represent observable appearances, in a serious moral light: to connect its landscape to the Arcadian was appropriate to Constable's great affection for the place. Imbuing a painting with such exalted content was a departure for the artist, who apparently did not find it incongruous to present his imagery on the small scale and in a sketchy manner. He may have been encouraged to take this step by the example of Turner.

Not only had the *Liber Studiorum* arranged landscapes in categories illustrating the universality of its range, but those recent Thames Valley pictures had demonstrated the heights to which modern painting could aspire. Turner's pastoral lament, *Pope's Villa at*

46

Twickenham, shown in his gallery in 1808, commemorated, according to John Britton in 1810, the 'indiscrete' destruction of 'Pope's Villa, like that of Maecenas in Rome'. He noticed how Turner had emphasized his theme – 'Perfectly in unison with the declining sun, and delapidated Villa, are the trees, plants, and figures: for the vegetable world displays the autumnal hues, or eve of nature, whilst the animals and human figures indicate the time of repose and calm meditation' – approving devices similar to those Constable had adapted.

Constable also revered the contribution of eighteenth-century poets to British culture, and besides the work of Gray and Goldsmith, was intimately familiar with Thomson's *The Seasons* and the writings of Cowper. Of modern writing he favoured Robert Bloomfield's *The Farmer's Boy*. Literary ideas assimilated with others in articulating is own responses. When, in 1812, he explained, 'I have succeeded most with my native scenes they have always charmed me & I hope they always will', he was adapting Cowper, in *The Task*, to give force to his sentiments:

47 *A Lane in Suffolk,*
c. 1810–11

48 *Dedham Vale, Morning*, 1811

> . . . scenes that sooth'd
> Or charm'd me young, no longer young, I find
> Still soothing and of pow'r to charm me still.

On the brink of marriage, he wrote, to reassure a worried Maria Bicknell, 'what is the world to us, "its pomps, its follies & its nonsense all"', expecting her appreciation of the reference to Thomson's description of a pair whose 'hearts, fortunes' and 'beings blend', living in retirement in modest circumstances, for:

> What is the world to them,
> Its pomp, its pleasures, and its nonsense all.

64

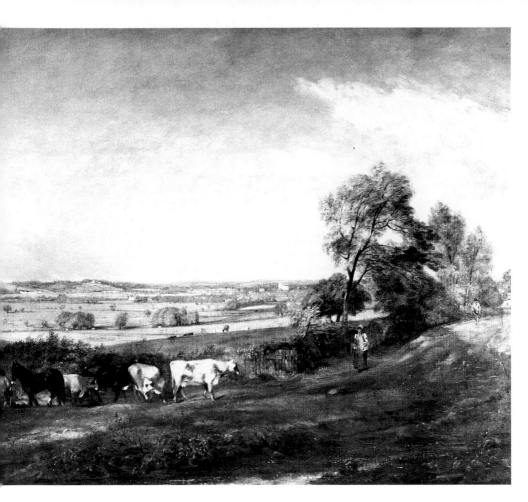

The poets Constable preferred subscribed to a broadly georgic ethic. Virgil's *Georgics*, written as a practical verse explanation of all the operations of agriculture, from the point of view of seeking to encourage a settled rural population into morally right and socially beneficial behaviour, had been translated by Dryden, and were either imitated directly by or very influential on poets throughout the eighteenth century. For Thomson the cultivated landscape resulted from cooperative endeavour: farmers directed labour, produce created wealth, this funded other occupations, from the merchant to the statesman to the artist within an exemplary society. Without industry all would collapse, consequently it was incumbent on all to

discharge their mutual obligations. Employers were expected to be paternal, and labourers honest, sober and industrious. The appearance of a landscape developed from the condition of its inhabitants: wilderness or desert denoted the savage or uncivilized, whereas the order and interconnection apparent in the scenery of, say, the Stour Valley, demonstrated the virtues of its inhabitants.

This outlook denied the validity of the Picturesque, which came about through the absence of husbandry. Constable would have been sympathetic to poetic ideals, and prepared to apply them to actuality, both because his Anglican upbringing saw every action as having a moral consequence, and through the general attitudes of his class. The farming interest was sympathetic to culture. In some 'Strictures on the Useful and Polite Arts' in *The East Anglian Magazine* in 1814, Perry Nursey, a friend both to Constable and Wilkie, wrote not only that 'Agriculture ... claims the first attention in every state', citing the Romans as his authority, but also that 'love of the arts ... proves the possession of a cultivated liberal mind', and even claimed that 'the fine arts have in view the ornament and elegance of life, and feed the mind with noble, useful, and elevated ideas ... The husbandman, after his useful labours, rejoices to see his house adorned with the work of the fine arts.' We can begin to see how Constable could grow to view his artistic ideals and more general attitudes as indissolubly linked.

Pope's Villa might have shown how he might marry his ethical with his painterly concerns, and *Thomson's Aeolian Harp*, which Turner exhibited in 1809, could have provided further help. This landscape of the Thames from Richmond Hill has the dimensions of a history painting (it is ten feet broad). From a foreground where, to the right, nymphs dance around the Aeolian Harp amongst classical ruins, and to the left a shepherd pipes to his flock (thus identifying modern Britain with Antiquity), we survey the river with its barges, running past houses set on banks where flocks graze. Turner governs the terrain with a Claudian composition, to invoke those associations of Claude's landscape with a Golden Age where, in Gessner's words:

every object presents the idea of peace and prosperity; we continually behold a happy soil that pours its bounteous gifts on the inhabitants; a sky serene and bright, under which all things spring forth, and all things flourish.

Constable would have known the description of the view from Richmond Hill (one of the few landscape painted by Reynolds) from

Thomson's *Summer*, which had inspired Turner's composition. Thomson presented the prospect as a microcosm of 'happy Britannia', where:

> . . . the Queen of Arts,
> Inspiring vigour, Liberty abroad
> Walks unconfin'd, e'en to thy farthest cots,
> And scatters plenty with unsparing hand.

This introduces a paean to this land of 'rich' soil and 'merciful' climate, miraculously profuse in produce and livestock, which 'property assures . . . to the swain'.

Both these sentiments and Turner's painting must have had a striking appeal at a time of war with the French, who had demonstrated what horrors followed the destruction of private property, and the institution of democracy. *Thomson's Aeolian Harp* is a symbolic landscape. Constable, understanding both its pictorial structures and literary bases, would have approved of Turner's exaltation of the countryside as the foundation of everything in British culture. The painting worked exactly as had pictures in the Great Style in their own time and circumstances.

There was an urgent need to consolidate the advances of *A Church* 45 *Porch* as pressure increased on Constable to make a success of painting. Although he was earning a little money – there had been that sale to Lord Dysart and his aunt had commissioned the altarpiece for Nayland Church – and although the press was beginning to notice 5 him, this hardly amounted to professional recognition. Constable appears to have been easily discouraged. In 1807 Farington had advised him against standing for election to Associate of the Royal Academy, but in late March 1810 was having to spur him 'to imitate nature & not be affected by loose remarks of critics'.

The exhibition of *Dedham Vale, Morning* in 1811 constituted a 48 major bid for public recognition. Constable confided to Lucas that the painting had 'cost him more anxiety than any work of His before or since that period in which it was painted. That he had even said his prayers before it', and after he had despatched it to the Royal Academy he visited Farington 'in much uneasiness of mind, having herd that His picture – a landscape "A View near Dedham, Essex" was hung very low in the Anti-room of the Royal Academy. He apprehended that it was a proof that He had fallen in the opinion of the Members of the

Academy. I encouraged Him & told Him Lawrence had twice noticed His picture with approbation.' As Constable was habitually nervous before an exhibition, the experience of 1811 must have been exceptional to have stood out from the other years. He staked a great deal on *Dedham Vale, Morning*, and lost.

It was probably Constable's largest exhibited Stour Valley landscape so far, and was on a scale more appropriate to its pretensions. As did *Thomson's Aeolian Harp*, it portrayed an actual country in terms of a Claude pastoral. The picture was developed from a topographically accurate oil sketch of 1809, with the viewpoint angled more to the south to subtend a wider span of ground. The tree on the left established a 'Claudian' *repoussoir*, with the vista being managed in ways adapted from Claude's compositional formulae. In preparing for the painting Constable now adopted the procedures Reynolds ascribed to the masters: the subject originated in and was developed through sketches and studies and was realized in the London studio. The picture emphasized that the beauty of this landscape was not some insulated aesthetic phenomenon, but resulted from what the landscape represents; the use of the ground for cultivation or feeding beasts, the industriousness (no figure rests) and piety of the inhabitants (in June 1813 Constable called the act of painting 'performing a moral duty'). Here he communicated general effects rather than specific details, probably because of working from sketches. The colouring, in a light key to suit the time of day, the representation of topography, and the intimation of cloud gathering in the west, constituted an unprecedented advance in his 'naturalism'. Constable demonstrated that this painting was a milestone in his production to date by inscribing 'Dedham Vale', on an actual milestone by way of a pun, but the public missed the point.

40

'The endless beauties of this happy country'

The disappointment over the reception of *Dedham Vale, Morning* is likely to have been exacerbated by a downturn in Constable's personal affairs. Rhudde's disapproval meant that from 1812 meetings with Maria had to be clandestine. This caused extreme emotional stress. In May that year Constable could not 'go to Bergholt without being at least sixty miles farther from you and seeing a thousand objects to remind me of those happy hours when we *could* meet'. By May 1813 the village had transformed itself into a refuge – 'I hope to be as much as I can at Bergholt – for to that dear Spot I always turn as a safe and calm retreat.'

Dedham Vale, Morning had evolved from Turner's demonstration of how paintings of landscapes could take on an exalted patriotic content, and despite Reynolds's censure of particularities, Constable now began to move towards an increasingly detailed landscape, for the data of that landscape, while always fluctuating, were always recognizably of that place, and were the matter of that moral iconography which allowed him to believe his art to be serious in the terms Reynolds had defined. Problems over finish meant exhibition pictures could be perceived as too sketchy for their intended function, and Constable would work on remedying this in 1814.

In September 1811 the Bishop of Salisbury invited him to stay. Constable appreciated 'the great kindness (I may almost say affection)' of the Bishop and Mrs Fisher. The Bishop ordered a portrait, and they visited sites like Stourhead, where Constable assumed the correct station to take the view over the lake to the Pantheon: a gentleman's park had yet to become his aversion. At Salisbury he preferred to use graphite for a smaller sketchbook and chalks on a larger size of paper. Here, the paper set the tonal standard, and white chalk emphasized the carefully-drawn architecture, while the trees were depicted with a variety of hatchings. He would return to this view when completing another commission from the Bishop in 1823.

48

49

50

49 *Stourhead*, 1811

50 *Salisbury Cathedral from the South West,*
11 and 12 September 1811

51 *Stratford Mill*, August 1811

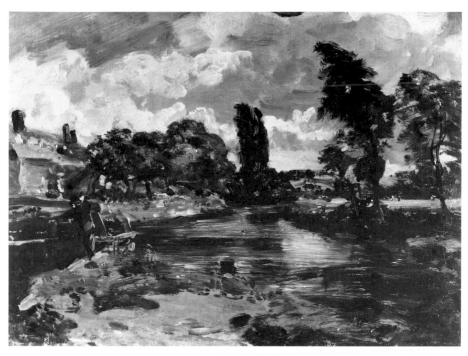

52 *Flatford Mill from the Lock, c.* 1810–11

53 *A Water-Mill,* 1812

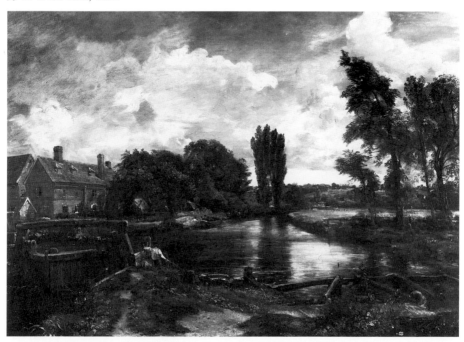

54 *Dedham from Langham, c.* 1812

51 In East Anglia Stratford Mill was rendered as a mosaic of patches in
colour in August, and in November Constable wrote of having 'tried
52 Flatford Mill again, from the lock' as well as 'a view of Mrs. Roberts's
lawn, by the summer's evening'. The latter was probably the *Summer
Evening* exhibited in the 1812 Royal Academy along with a view of
53 Salisbury, and *A Water-Mill*, the view of Flatford Mill towards which
study had also been directed. Constable again developed this
composition through sketches and studies, and at least one drawing
and several oil sketches survive. The latter fixed ratios of tone and
colour, and the steely reflections along the axial perspective of the

55 *Willy Lott's Farm,
c.* 1812

56 *Dedham from Langham*, July 1812

57 *Landscape, Boys Fishing*, 1813

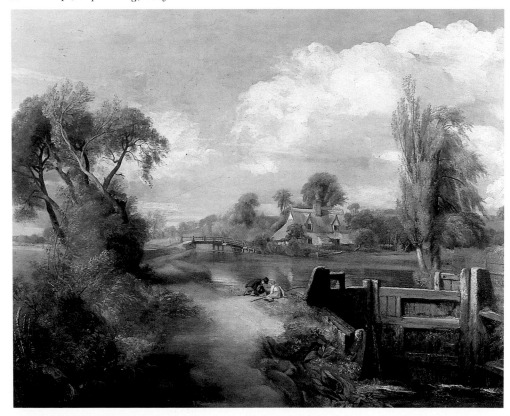

river. In the painting Constable tried to marry his ability to recreate general effects with – in particular in the area about the mill – his awareness of how the subject looked in detail, the scene being bathed in a harsh light. The return to a more 'picturesque' subject may have been meant as a salve to that public which had failed to appreciate *Dedham Vale, Morning.*

Constable was consistent in his practice into 1812. Statements like 'I am still looking towards Suffolk where I hope to pass the greater part of the summer, as much for the sake of pursueing my favorite Study as any other account. You know I have succeeded most with my native scenes' (in May 1812) are self-explanatory, although he could find most scenery interesting. In June he drew the famous vista from Richmond Hill while on a walk with Thomas Stothard. He was reading Cowper ('the poet of Religion and Nature'), particularly his letters – 'He is an author I prefer to almost any other.'

Once in Suffolk, Constable's life was 'hermit-like ... though always with my pencil in my hand'. Superb studies of sunsets captured

56 elusive effects of silhouettes: *Dedham from Langham* alternatively recreates the glare a partly-overcast sky spreads in mid-summer. It is one of several oil sketches of this view, which, with a meticulous

54 drawing, suggest an aborted project, perhaps for the 1813 Royal
55 Academy. The drawing of Willy Lott's farm (usually dated 1812) itself connects with two oil sketches of a motif pictured first in 1802

189 and eventually in 1835 as *The Valley Farm*, and which may have been study towards 'a large picture of Willy Lott's house', intended for exhibition in 1814. In 1813 Constable's principal exhibit was

57 *Landscape, Boys Fishing*, which in July 1812 he had described as 'another very promising subject at *Flatford Mill*'.

This painting was again developed out of drawings and oil sketches. Basing the lock gates or trees to the left on careful pencil studies resulted in their relative finish jarring with more generalized areas of painting. This was a picturesque subject of a popular sort – Mulready and Linnell were painting comparable landscapes – which was well received at the Royal Academy. John Fisher was encouraging:

I have just heard your great picture spoken of here by no inferior judge as one of the best in the exhibition. It is a great thing for *one* man to say this. It is by units that popularity is gained – I only like one better & that is a picture of pictures – the Frost of Turner. But then you need not repine at this decision of mine; you are a great man like Buonaparte & are only beat by a frost –

58 Sketchbook, 1813. A ploughman

59 Sketchbook, 1813. A horse and barges inscribed 'Augst 11 1813'. Flatford Lock, inscribed 'Augt 12 1813' and 'Lock'

60 Sketchbook, 1813. A post. A mill inscribed '22 Octr 1813 friday The Martin Cats – shot – by G. C.'

Robert Hunt, art critic of *The Examiner*, who was consistent in praising Constable, thought *Landscape, Boys Fishing* too undefined, against *Frosty Morning*, which was 'among the nearest imitations of common nature', while the *Morning Chronicle* thought Turner the equal of Claude or Cuyp, and marvelled at 'how much he has made of material so scanty'. Turner was being praised on terms which accorded with Constable's aims, and there are reasons for thinking that Constable took notice of this, for he was alive to comparisons between his and Turner's exhibits the following year (see p. 78).

In May 1813, though, he was anxious to spend as much time as possible at Bergholt, 'a safe and calm retreat'. To work from rural retreat (a convention poets had taken over from the classical authors) permitted the detachment necessary to that disinterested view which alone could perceive the true portrait of a country. Constable's own intense and objective study over a particularly fine summer was realized in oil sketches and in a small sketchbook which in 1814 he would term a 'journal', and dismiss as showing 'how I amused my leisure walks – picking up little scraps of trees – plants – ferns –
58–60 distances &c. &c.'. The subjects actually extend to buildings, animals, landscapes, or labourers, sometimes in outline only, sometimes as pictures in miniature; and the draughtsmanship is exceptionally skilled. These drawings display Constable's interests in landscape in whole or part, and came to supply a repository of motifs for later paintings.

In the short term, both the landscape and ploughman for *Landscape, Ploughing Scene in Suffolk*, exhibited in the 1814 Royal Academy, came
63 from the book. He would write about the painting to John Dunthorne in February 1814:

61 *The Mill Stream*, c. 1810–13

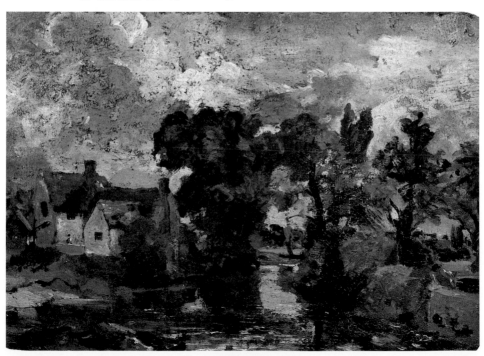

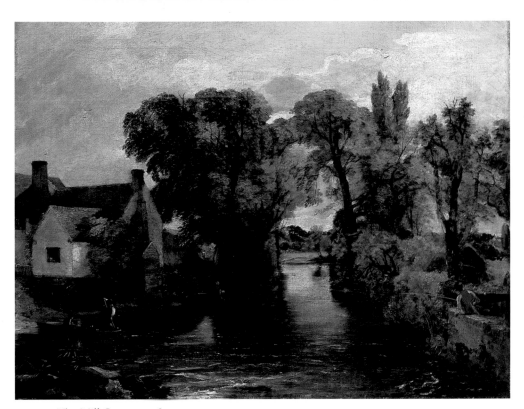

62 *The Mill Stream, c.* 1814

I am anxious about the large picture of Willy Lott's house, which Mr Nursey says promises uncommonly well in masses &c., and tones – but I am determined to detail it but not retail it out.

I have added some ploughmen to the landscape from the park pales which is a great help, but I must try and warm the picture a little more if I can. But it will be difficult as 'tis now all of a piece – it is bleak and looks as if there would be a shower of sleet, and that you know is too much the case with my things. I dread these feilds falling into Coleman's hands ...

I have much to say to you about finishing of my studies more in future – but I look to do a great deal better in future. I am determined to finish a small picture on the spot for every one I intend to make in future. But this I have always talked about but never yet done.

Constable agreed with some critics that his landscapes wanted finish. *The Mill Stream*, for instance, does illustrate how a picture could 62 promise in masses and tones but want detail, because of its reliance on

61 an oil sketch. This problem seriously affected the credibility of
 exhibited work, and Constable's proposed solution, to work from
 finished studies, was logical.

63 The landscape with the ploughmen was, for Constable, an
 extremely serious painting. To walk from a room of large, golden,
 Italianate landscapes by Turner in the Tate Gallery in London to the
 Constable room can make the paintings there initially seem small-
 scale, almost drab, but Constable was not afraid of the comparison.
 After his first sight of the 1814 exhibition he wrote that 'a large
 Landscape of Turners seems to attract much attention', but that 'my
 own opinion was decided the instant I saw it – which I find differs
 from that of Lawrence and many others entirely – but I may tell you
 (because you know I am not a vain fool) that I would rather be the
 author of my Landscape with the ploughmen than the picture in
 question.' The Turner, *Dido and Aeneas*, was an ambitious historical
 landscape, arranged to a Claudian format, showing a busy Carthage
 glimmering in a declining light, on the scale of 4 feet $9\frac{1}{2}$ inches by 8 feet
 $9\frac{3}{8}$ inches. Constable was preferring his naturalistic portrayal of a small
 section of the Stour Valley, on a canvas a quarter the size. If he was
 sincere when making the comparison this reveals the strength of his
 belief in his own kind of landscape.

 While the ploughmen might have been a 'great help' for this vista
 of the valley from the border of Squire Godfrey's park (and
 Constable's real affection for the place itself came out in the way his
 thoughts went from the painting to what Coleman might do to 'these
 feilds') and turned it into a working scene of the kind which the 1813
58 sketchbook shows to have interested him, they also returned the
 iconography to the georgic, as the artist indicated by printing a
 couplet from Bloomfield's *The Farmer's Boy* in the Royal Academy
 Catalogue:

 But unassisted through each toilsome day,
 With smiling brow the ploughman cleaves his way.

 Agricultural landscapes had enjoyed a resurgence after 1800, and
 Turner, with *Ploughing up Turnips near Slough* of 1809 (a view of
 Windsor Castle meant as a celebration of the benefits of the
 Constitution), or *Frosty Morning*, created the immediate precedent for
 Constable. Although Napoleon's blockade was never wholly effec-
 tive, a drive to self-sufficiency spurred unprecedentedly intensive

78

cultivation over Britain, with the exceptionally high prices encouraging the cultivation of poor land, while the demands of the armed forces had reduced the labouring classes to numbers which had full employment at reasonable wages. The ploughman was symbolically important – Thomson's 'Ye generous Britons! venerate the plough' was inscribed on a print dedicated to the Board of Agriculture in 1801 – and Constable pointed to this with his couplet. *The Farmer's Boy*, set in Suffolk, meshed a superficially conventional treatment of the farming calendar with detail of the country 'Where noble GRAFTON spreads his rich domains./ Round *Euston's* water'd vale, and sloping plains.' Bloomfield makes frequent moral interjections – 'THE FARMER'S Life' displays 'A moral lesson to the sensual heart', and the appreciation we accord ripe cornfields compared with that given buildings; and where we praise the 'Architect' of the latter, with the former 'the veriest clown that treats the sod,/ Without one scruple gives the praise to GOD.'

The *Landscape, Ploughing Scene in Suffolk* also relates to a passage Constable liked from Cowper's *The Task* (he had once quoted from the poem as fitting his and Maria's circumstances) in which Cowper and Mary survey the Ouse Valley. The poet describes a ploughman working in the middle distance, and concludes with an encomium on the beauty of familiar scenes which Constable would have found extremely sympathetic. When, later in 1814, he wrote of his preference of Alison to Burke (p. 56), he was rejecting any formalist aesthetic, for Alison derived his theories from the potential objects had to stimulate chains of associated ideas, although to enjoy this stimulation was given only to those 'in the higher stations . . . or in the liberal professions of life'. We can begin to understand why Constable felt able to make that bizarre comparison of his *Ploughing Scene* with *Dido and Aeneas*.

Apprehension of the beauty Constable perceived in landscape was possible only from a particular station, not only that from which the view was taken, but also the one which permitted that perception of its values. This viewpoint was not necessarily the ploughman's, and Bloomfield's poem periodically contradicts its traditional themes. Although 'each new duty brought its share of joy', the boy Giles's life was one of 'constant cheerful servitude'; and Bloomfield overturns his conventional account of the communal pleasure of harvest home by interjecting:

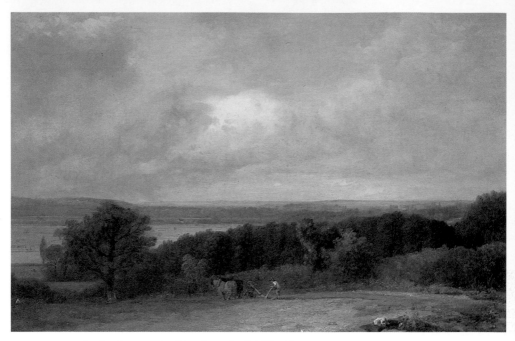

63 *Landscape, Ploughing Scene in Suffolk*, 1814

Such were the days ... of days long past I sing,
When Pride gave place to mirth without a sting;
Ere tyrant customs strength sufficient bore
To violate the feelings of the poor ...

He then curses the new wealth which has tempted farmers to unwarranted ostentation, and has begun to destroy 'the social plan/ That rank to rank cements as man to man'. This was not a specifically proletarian complaint. Arthur Young bemoaned the farmers' wives and daughters who put on airs and neglected their duties, while some others still maintained the 'social plan' which Bloomfield saw as threatened. Thomas Ruggles thought that 'there is a tacit contract between men ... that to him whose only patrimony is his strength, and ability to labour, that patrimony should be equal to his comfortable existence in society'. At the beginning of his last illness Constable's father asked his aged clerk 'if he could recollect an instance in which he had dealt unfairly or taken advantage of the necessities of the poor, the widow or the fatherless that he might make compensation whilst he had the power', and the clerk could not. Comfortable

coexistence between the classes depended on the poor appearing to accept this social contract, and the tensions Bloomfield described, although genuine enough, could be forgotten in the general prosperity. Constable's ploughmen worked 'unassisted through each toilsome day', and their brows – not mouths – smiled, furrowed either with concentration or strain.

In June 1814 Constable visited an old friend of his father's, the Rev. Driffield at Feering in Essex, where, among other subjects, he drew Hadleigh Castle, near Southend, which was 'a really fine place – it commands a view of the Kent hills and the Nore and North Foreland & looking many miles to sea'. Before getting to Bergholt he returned to London, partly to gauge his chances of election as Associate of the Royal Academy, and discovered that his work was thought too unfinished. Farington advised him to study Claude 'to attend to the admirable manner in which all the parts of his pictures are completed', which he duly did at Angerstein's, before leaving London. Returning on 5 November he told Farington that he had been 'long occupied in painting Landscapes from Nature'.

64 *Hadleigh Castle, near Southend,* 1814

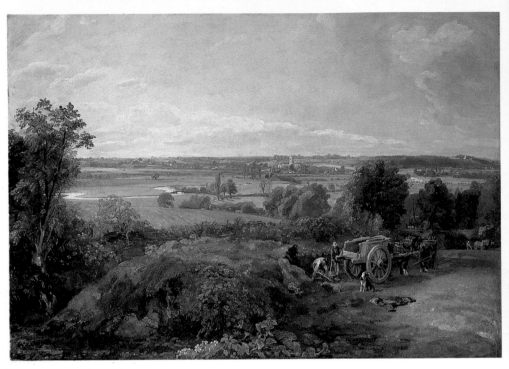

65 *View of Dedham*, 1814

66 Sketch for *View of Dedham*, 5 September 1814

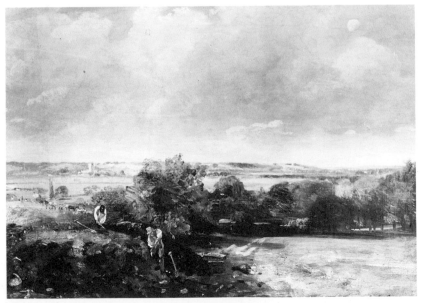

67 Sketchbook, 1814. Labourers

68 Sketchbook, 1814. Dedham Vale, inscribed '9th Octr'

69 *View of Dedham*, 1814, detail (see Ill. 65)

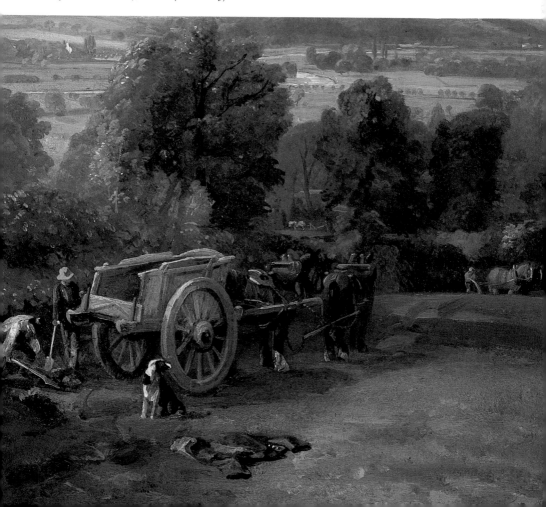

Among these landscapes painted from nature were *Boat Building* (Leslie said so), and the *View of Dedham*. They were prepared mainly with drawings rather than with the usual sequences of oil sketches, and working directly from nature obviated any need to finish a small

65–6 picture on the spot. The one oil sketch for the *View of Dedham* is dated 5 September, and the picture was 'almost done' by 25 October. They show the progression of an agricultural sequence: the sketch contains a harvest-scene, a large dunghill and no ploughmen; the painting shows stubble, and the manure being ploughed in to prepare for wheat-

67–8 sowing. Preparatory work was conspicuously in pencil, with oil studies of particular items, like the cart; and shadows in the painting and related works are consistent with early morning, and with Constable's habit of working from a subject only until the shadows changed. The painting's handling is varied and controlled, with brushstrokes adjusted to the character of what is meant to be represented so as to avoid that worrying sketchiness and achieve a new

69, 71–2 descriptive precision. *Boat Building*, also worked out in drawings, is similarly careful, the figures reduced in number to clarify this pictorial account of barge-construction. The 'natural painture' which Constable was beginning to achieve here would be of an accuracy and discipline exceptional in British painting of this period.

With both these paintings a high viewpoint enforces a command over the scene shown, allowing us a perceptual control analagous to the actual one exercised over them by the landowner, or by Constable himself in representing them. The study of Angerstein's Claudes was put to good use. The *View of Dedham* reverses the composition of *The Marriage of Isaac and Rebekah*, and Charles Rhyne has connected *A Seaport* with *Boat Building*. This again endowed East Anglian reality with the exalted connotations of Claudian landscape. The *View of Dedham*, a souvenir of home for the Squire's daughter, presented its subject, manure and its spreading, as, in Bloomfield's words, 'A promis'd nutriment for Autumn's seed', which would provide the following year's harvest. This, spurred by the sight of Dedham Church, inspires associations of the Resurrection, and the religious iconography underpins the secular one of georgic labour. *Boat Building*'s demonstration of how – looking from left to right – to build a barge, naturalized in the landscape by the very high viewpoint, shows the interaction between man and nature as something we must value. These pictures, which compare in subject and handling with

84

70 *View over Golding Constable's Farm*, 1814

what Linnell, and later Lewis and De Wint were to paint, showed how Constable had solved his technical problems and developed a morally serious landscape. He wrote that 'It is many years since I have pursued my studies so calmly – or worked with so much steadiness & confidence. I hope you will see me an artist some time or another.'

Until 1817 Constable's practice would centre around East Bergholt and develop the techniques and subjects of 1814. The sixty-eight-year-old Farington thought the summer of 1815 'finer . . . than any other I remember', and the *Ipswich Journal* called the harvest 'the finest . . . in remembrance'. Cornfields are conspicuous in the works datable to 1815. *Golding Constable's Kitchen Garden* and *Flower Garden* split the 73–4
vista of East Bergholt and the Constable farm seen in a fine drawing of 70
1814. They are small, disciplined and beautiful, and containing a vast amount of detail – we can see the thresher's flail bent in mid-swing in the *Flower Garden*, for instance. This picture was probably begun first, 73
before harvesting began, for the *Kitchen Garden* contains a populous reaping-scene near the windmill.

71 Sketchbook, 1814. Study for *Boat Building*, inscribed 'Sepr. 7. 1814. Wednesday'

72 *Boat Building*, 1814

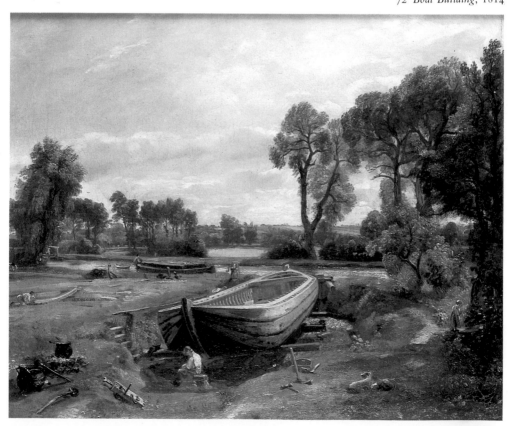

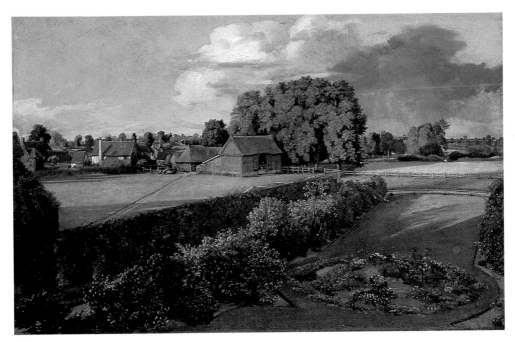

73 *Golding Constable's Flower Garden*, 1815

74 *Golding Constable's Kitchen Garden*, 1815

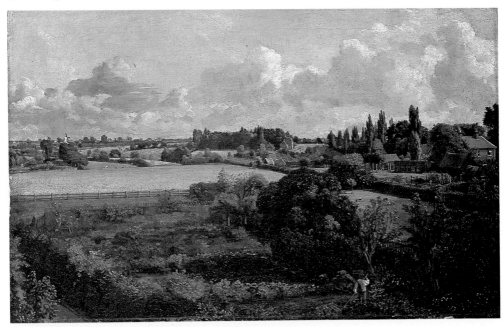

75 The large *Cottage in a Cornfield* may have been painted in July before harvest, but left unfinished, for the right-hand tree is more in
76 the style of 1833, its year of exhibition. The smaller one may date to 1816 when harvest was late and the weather poor: the high corn would fit a wet season. The former may have been left uncompleted because on 31 July Constable travelled to carry out a commission at
81 Brightwell, east of Ipswich. He sketched as he went. Drawings of
80 gleaners done later were probably related either to *The Wheatfield* exhibited in the 1816 Royal Academy Exhibition, or *A Harvest Field, Reapers, Gleaners* in the British Institution of 1817. The oil of Dedham
79, 82 Mill is also dated *c*.1815. This view up a sluice to the river on which is a barge, with mill buildings to the left and Dedham Church beyond those dominating poplars, is technically brilliant. The shift from the sunlit foreground into the meadows has been regulated tonally and colouristically, the foreground stressed by impasted paint to contrast with the near distance, where the canvas–weave can be seen through the colour.

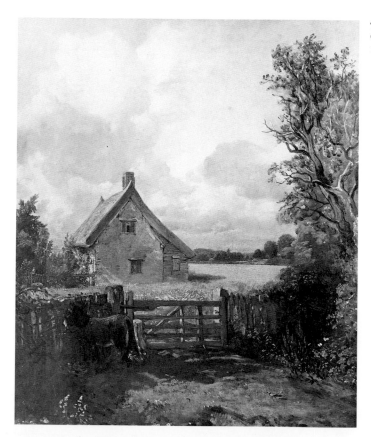

75 *A Cottage in a Cornfield*, 1815 and 1833 ?

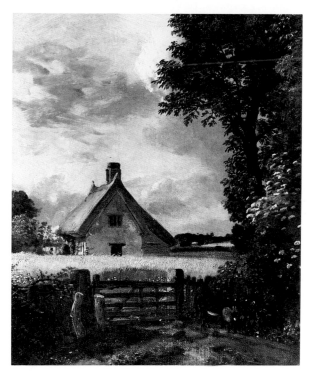

76 *A Cottage in a Cornfield*, 1815–17

Among the now-vanished pictures done over the autumn and into the winter was a 'larger landscape' than any previous one, and Constable, almost permanently resident in Bergholt (his father being ill), evolved his landscape a stage further in 1816. *Flatford Mill*, a large 77–8
painting which has survived, was the first river scene for three years. The high viewpoint commands a landscape displaying how nature and man interact for man's benefit. It was under way by 21 August, and as Constable wrote in mid-August that they could not get their hay up, that haymaker documents the poor summer. The painting is very informative in other ways. We can tell that the river is navigable, and which way it flows. Not only are the plants around the stream to the right carefully painted, but Constable had become skilful enough to convey an illusion of seeing through the water to the mud piled up on the outside of the curve, which would tally with an exceptional volume of rain. The vertically rising smoke means that it is still weather, and that the gathering clouds portend yet more rain.

89

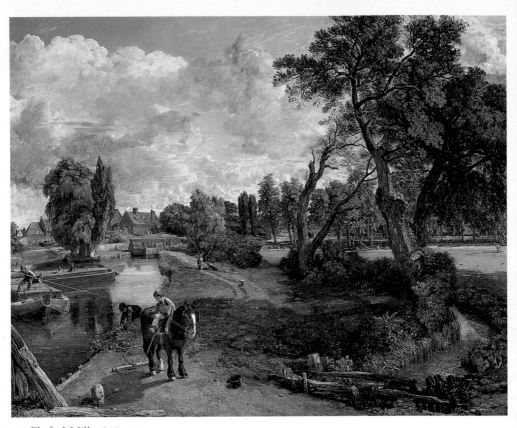

77 *Flatford Mill*, 1816–17

78 *Flatford Mill*, 1816–17, detail

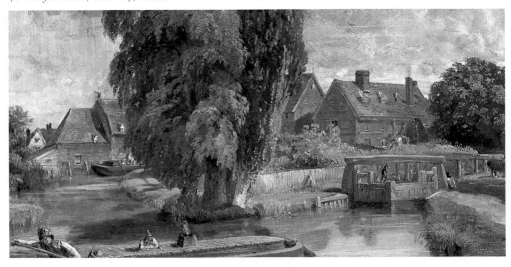

79 *Dedham Mill*, *c.* 1815, detail (see Ill. 82) ▶

80 *Gleaners*, c. 1815

82 *Dedham Mill*, c. 1815
(see also Ill. 79)

81 *Woodbridge*, 3 August 1815

The canvas is large enough to have been cumbersome for outdoor 77 work (and oil sketches might have been meant to circumvent associated problems), yet Sargent pictured Monet working on a comparable scale *en plein air*. While Constable was engaged on this picture, Major-General Rebow commissioned *Wivenhoe Park* and 83 *The Quarters, Alresford Hall*, which, despite their interrupting work on his 'own things', were completed to their mutual satisfaction. *Wivenhoe Park* was almost certainly painted from nature. There were problems in 'getting so much in as they wanted to make them acquainted with the scene' – a grotto to the left of the house and a deer house to the right are shown on strips of canvas which had to be added to the original one. Those were the landmarks that made this *Wivenhoe*, rather than any park in the manner of Capability Brown. The composition, a standard one for country-house paintings, helped to foster a tendency to anonymity, but probably deliberately, for it equated Wivenhoe Park with the seats of those others responsible for

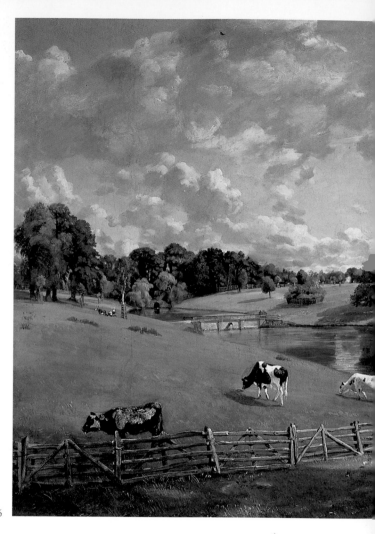

83 *Wivenhoe Park*, 1816

national and local government, and intimated a community of interest between Rebow and his peers. Landscapes like these found their poetic equivalent in Bloomfield's encomium to Euston Hall and the Duke of Grafton (the Lord Lieutenant of Suffolk). Rebow's station was less exalted, but he maintained a proper order over his estate. The sleek cattle and plantations of trees recall Pope's approval for the landlord 'Whose ample lawns are not afraid to feed/ The milky heifer and deserving steed;/ Whose rising Forests, not for pride or

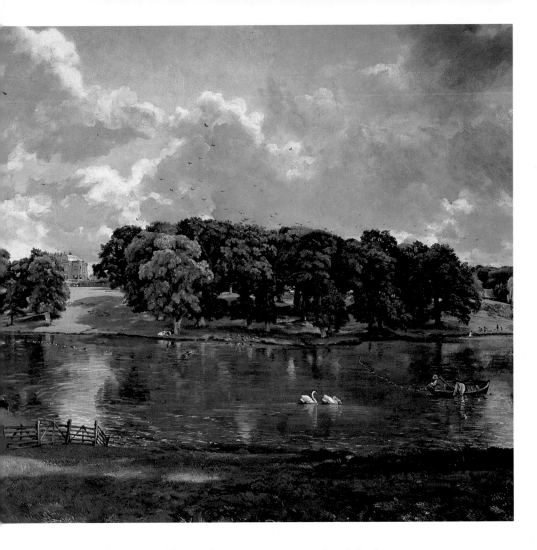

show,/ But future Buildings, future Navies grow', while the netting of fish confirms the traditional iconography of good housekeeping. Juxtaposing labour with the beauty of the swans insists that the landscape is beautiful because it is productive. *Wivenhoe Park* resulted from a conformity of interest between Rebow and Constable, extending, presumably, to a shared approval of the extraordinary amount of nice detail in the painting. Their social compatibility was crucial in permitting this.

Changing Situations

In October 1816 Constable married Maria Bicknell, and, after his
honeymoon, became a Londoner. As the wedding day loomed he
became agitated about leaving his painting, and suggested they
postpone the ceremony. Maria, who had herself suffered during this
protracted courtship, was bitterly hurt; but once he had realized that
life and art must separate, Constable appears to have come to terms
with circumstances. His most recent landscapes were extraordinary in
modern painting. The artist, resident for long periods among the
scenes he depicted, invariably ordered the exalted reality he perceived
77 in the East Anglian landscape from a high viewpoint. His handling
described the appearances of the landscapes and their elements with a
minute precision, sympathetic to that element of documentation
which was so central to his imagery. His pictures celebrated a scenery
of peace and plenty created out of the cooperative endeavour of all
classes. Yet, economic circumstances linked to the post-war agri-
cultural depression were already inducing East Anglian labourers,
mostly in West Suffolk, to riotous acts – Abram Constable had been
disturbed by the actions of the mob in 1815. Rather than question his

84 *Weymouth Bay from the Downs*, 5 November 1816

85 *Weymouth Bay*, 1816 ?

complacent and exalted idea of place, Constable simply transferred it
to the larger scale, and, because his art would respond to comparable
disturbances (albeit affecting East Bergholt) in 1822, this may seem
odd. Constable was, however, in London, preoccupied with domestic
matters, during the principal period of trouble. Furthermore, vision
can be selective, and, having periodically experienced food riots,
Constable probably failed to realize the political significance of the
1816 disturbances, not understanding criminal also to be social acts.

A long holiday in 1817 was Constable's last protracted contact with
East Anglia. He experienced other landscapes, with the honeymoon in
Dorset providing coastal and downland subjects, London, metropoli- 84–5
tan scenes, and Hampstead, heath subjects from 1819. After 1816 his

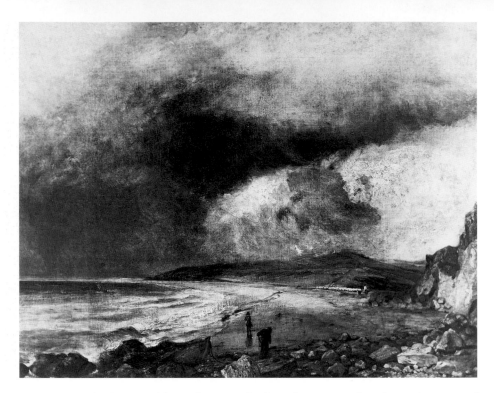

painting could no longer display that exceptional consistency of interest. The trip to Dorset had been recommended by John Fisher, who wrote that:

The country down here is wonderfully wild & sublime and well worth a painters visit. My house commands a singularly beautiful view: & you may study from my very windows ... I have brushes paints & canvass in abundance. My wife is quiet & silent & sits & reads without disturbing a soul & Mrs. Constable may follow her example.

Whether or not Maria Constable succumbed to this regimen, her husband was busy painting and drawing this new country. As in the Lake District, drawings map the terrain by delineating it. Here a ruled horizon line supplies a standard – Portland Island acts as a focus, with the intervening country drawn so as to suggest the marquetry of the walled enclosures and the broad accents of light and shade. Oil studies fixed chiaroscuro and weather-effects, fluttering clothing indicating the breeziness associated with such a sky. The more finished version of this scene may be the *Landscape: Breaking up of a Shower* shown in the

84

86

86 (left) *Weymouth Bay*. Exhibited
1819 ?

87 (right) *Mrs Edwards*, 1818 ?

1818 Royal Academy; the title suits the weather, with the sky clearing from the top right.

East Anglian scenes continued to go to public exhibitions. *A Harvest Field: Reapers, Gleaners* in the British Institution of 1817 was new to the art critic Robert Hunt and therefore probably not *The Wheatfield* of the 1816 Royal Academy. The former was exhibited with another tag from *The Farmer's Boy*:

> No rake takes here what Heaven to all bestows –
> Children of want, for you the bounty flows!

Despite our ignorance of the picture's appearance, we can tell that it was concerned with a traditional theme. Harvesting corn represented an opportunity to reflect on the ties of obligation which joined social classes together. While the propertied few gained from a good harvest, labour had to plough the fields, to sow, and to reap, and Constable was concerned to stress the necessity to be charitable. The painting may have responded to the return of apparent normality

99

88 *Cottage and a Road at East Bergholt*, 3 August 1817

after 1816, and confirmed the traditional values which ensured social harmony in the countryside. The hardship the depression brought was not seen as politically significant. In February 1817 Abram Constable wrote of the 'uncommon fine weather' being 'fortunate for the poor people that their labours are not interrupted', and in 1819 'I don't know how your profession goes on, but mine is nothing to boast of, let's hope patience will bring a good year.' Hard times had to be expected, and would pass. However, Abram had indicated that the East Bergholt poor now found employment in day-labour, not seasonal work, which cost-effective development meant they had to resort to the parish if no work was to be had.

Constable was beginning to sell pictures. He painted very competent portraits and took on other commissions, and in 1818 sold two landscapes for 20 guineas (probably *A Cottage in a Cornfield*) and 45 guineas respectively. He needed the money; and made regular attempts to propitiate Dr Rhudde (who, by 1817, had made provision for any great-grandchildren). At least the press was giving him good notices, and Farington's diary indicates that artists were themselves generating some enthusiasm for his work.

The 1817 visit to Bergholt led to intensive painting and drawing,

87
76

and William Redmore Bigg was to speak 'very favourably' of the studies Constable told Farington he had painted (of which we know one oil sketch). A sketchbook of $4\frac{1}{2}$ by $7\frac{3}{8}$ inches was used to record a variety of scenes: a cornfield with reapers at work under the long shadows of evening, scenes of shipping and the riverside at Mistley. Views at Harwich and Dedham would reappear in paintings. The subjects maintained the concerns of previous work. This drawing, possibly showing the cottage painted in a cornfield from a different 88 angle, is conceived as a complete picture. The lighting indicates that it is late in the evening, and the stooping reaper has something of the air of Gainsborough's faggot-gatherer in the Cincinnati *Cottage Door*. Finished drawings of trees (one of them to circumvent a problem with 89 *Flatford Mill*) display their complicated subjects with remarkable clarity. Constable's later note about the tree being blown down and clear of the ground in 1835, recalls Cowper finding tree-felling saddening because it intimated his own mortality, for aged trees signified an historical continuum within a place, as the two oaks in the middle distance of *Dedham Vale, Morning* still stand. 48

89 *Elm Trees in Old Hall Park, East Bergholt*, October 1817

90 *Richmond Bridge with Barges on the Thames*, 3 September 1818

91 *Fulham Church*, 8 September 1818

92 *Waterloo Bridge from the Left Bank of the Thames*, 1817 ?

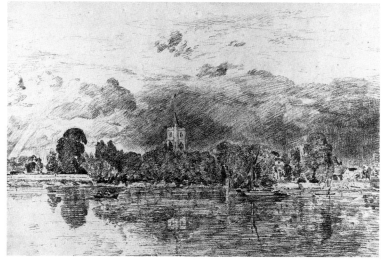

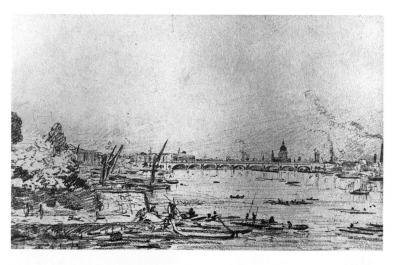

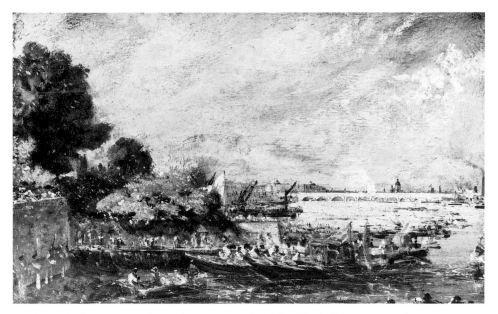

93 Sketch for *The Opening of Waterloo Bridge seen from The Whitehall Stairs, June 18th 1817*, 1819–25

By 1818 Constable was taking a real interest in the scenes the Thames afforded. *Fulham Church* is a sophisticated exercise in chiaroscuro, and *Richmond Bridge* (but a detail in *Thomson's Aeolian Harp*) counterpoises its elegant structure with the river traffic to realize an imagery akin to Turner's Thames paintings of the later 1800s, or Callcott's fine oil sketch of this subject. Constable also drew Waterloo Bridge on its opening by the Prince Regent on 18 June 1817, and by 1819, contemplating this as an exhibition picture, was producing appropriate studies, although, on Farington's advice, he completed *The Hay Wain* and not *The Opening of Waterloo Bridge* for the 1821 Royal Academy. The subject invited a patriotic response: Waterloo represented the triumph of English ideals. The prominent St Paul's Cathedral plus the City church spires may deliberately refer to Canaletto's well-known *The Thames from the Terrace of Somerset House*, and symbolize that alliance of Church, State, and Commerce which made London superior to other capitals, and Britain to other nations. By September 1820, Constable, who was aware of the Thames pictures of Scott and Marlow, was thinking of *Waterloo Bridge* as 'my river Thames', the Thames being to contemporary

London what the Tiber had been to ancient Rome. He might have been stimulated to attempt the composition because of Callcott's massive success with *The Pool of London* at the Royal Academy exhibition of 1816, and *Waterloo Bridge* lies in a tradition of Thames and London paintings. It was completed only in 1832, although Constable worked on it for exhibition in 1824, 1825 and 1826, when Lawrence viewed it, and, Constable wrote, admired it more than anything he had ever seen by himself.

94 The Constables' first child was born late in 1817: the arrival of a family increased Constable's need for public recognition. The

86 probable exhibition of *Weymouth Bay* in 1819 presented him as a painter of one of the most popular sorts of landscape, coastal scenery.

95 *The White Horse* advertised his powers. Robert Hunt was flattering enough to compare Constable with Turner, tempering the remark that 'he does not at all exalt the spectator's mind which Mr. TURNER eminently does' with approval for the artist's 'more approaching to the outward look and lineaments of trees, water, boats, &c. than any of our landscape painters'. The *New Monthly Magazine* thought *The White Horse* 'painted with great breadth and truth of nature: the tone and feeling … are excellent'. Before the exhibition, Farington suggested some alterations, which Constable had found had had 'the best effect' when he visited him 'in high spirits from the approbation

94 *A Child Being Nursed, c.* 1818

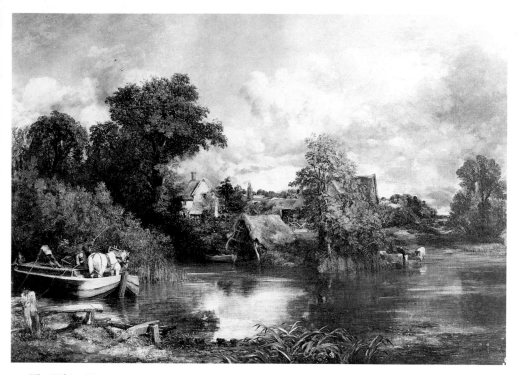

95 *The White Horse*, 1819

96 Sketchbook, 1814.
Willie Lott's Farm

of his picture', although its handling was criticized by some and Farington considered this serious enough to warn him about it.

95 Its size meant that *The White Horse* presented new technical
96 problems. It depended on previous study, and Constable tried out the composition on a canvas of about the same size, to refine that Reynoldsian system of composing by means of varieties of preparatory studies. Because he had had to adjust his handling, the picture
77 lacks the definition, the smoothness of paint surface, of a *Flatford Mill*, and the broader brushwork shows a pragmatic approach to these problems. *The White Horse* communicates an impression of sunlight diffused over a landscape on a calm and hot day. It is exceptional for its apparently randomly-chosen view across the river to Willy Lott's farm to catalogue those things one might typically expect to see — ferrying the horse, or the traces of other activities in the moored boat or the plough and wagon by the barn, which, *in tota*, supply an index to the humane virtues of the region.

97 *Branch Hill Pond, Hampstead*, October 1819

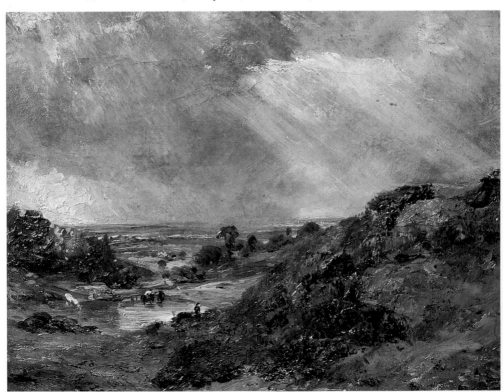

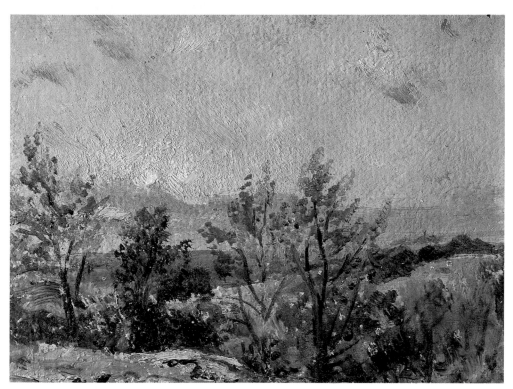

98 *Hampstead: Stormy Sunset*, 1820

From painting this remembered country, in 1819 Constable confronted at Hampstead scenery very different from that he knew so intimately in Suffolk. The rural economy was based on quarrying and gravel, particularly at Branch Hill, and also along Sandy Heath, a dominating extractive industry which unfixed the details of topography. According to Thomas Moule in 1837 the principal attractions of Hampstead were 'the views of the metropolis and of the distant country', and the home landscape which was 'very picturesque', and both sorts of landscape occupied Constable's attention, with the addition of skies. The Hampstead landscape, which had become available incidentally to domestic convenience, was without personal associations, and his view could be detached: he was pleased to picture the same kinds of scene as Hofland, for instance.

100

99 Sketchbook used in 1819. Quarrying on Hampstead Heath

Constable's earlier Hampstead work formed a basis for the later. A
99 sketchbook has studies of animals or landscapes in miniature, which
concentrate on light-effects, or scenes of quarrying of a kind which
would often come to serve to typify the Heath economy in
97 Constable's paintings. *Branch Hill Pond* may be one of the 'studies' he
showed Farington in November 1819. It is less descriptively precise
than comparable East Anglian landscapes, the paint surface evidently
having been built up slowly, over time. Combined work with the
brush and palette knife makes the handling demand notice for itself.
The colouring is sober; a subdued orange or specks of red near the
pond at its brightest: otherwise yellows and ochres in the foreground
and to the right of the pond, and varieties of dark-greens and greys.
White, in an appropriately Newtonian touch, describes light in the
sky or as it reflects on the ground. Landscape-structure is suggested
through light, shade and texture. By 1820 Constable was taking this

100 Thomas Hofland,
Harrow from Hampstead,
1815 ?

101 *A Sandbank at Hampstead*, 1820–2

abstraction of landscape further. In a study of a stormy sunset, the 98
bands of cloud merge with and are coloured similarly to the bands of
ground; only the shrubs and trees in the foreground orientate the
scene.

Pencil was often used for specifically descriptive work, but *frontis*
Constable's concentration in some oil studies on texture, and in others 101
on complex reflected colour, suggests that he did not apprehend the
Heath's topography as being significant in itself: it could be anywhere
for its effects could appear anywhere. This contrasted with the Stour
Valley landscapes which he still continued to exhibit on six-foot
canvases; for, in 1820, *Stratford Mill* (later bought by John Fisher as a
present for his solicitor, Tinney), appeared at the Royal Academy.
Constable again made a large sketch, basing its central section on the 105
one done on-site in 1811, but using it rather as a field for experiment, 51

102 *Harwich Lighthouse*, 1820?

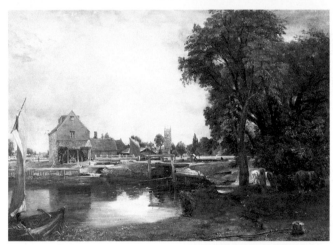

103 *Dedham Lock and Mill.*
Exhibited 1820?

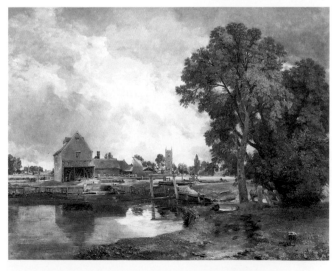

104 *Dedham Lock and Mill.*
Exhibited 1819?

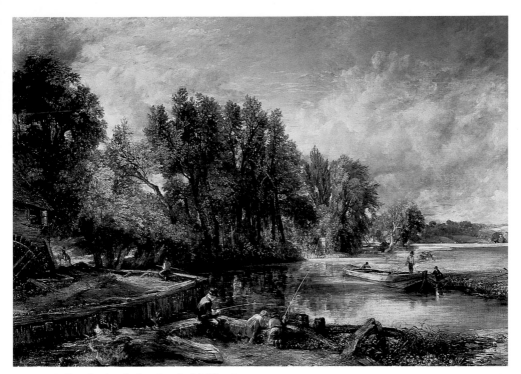

105 Full-scale sketch for *Stratford Mill*, 1820

working on different areas to varying degrees. The sky is loosely painted and the reflected lights have a striking brilliance, imparted by white paint: this interest may well exploit Hampstead study, divorcing the project from direct concern with local nature. There is a new emphasis on chiaroscuro organizing the composition. The exhibited painting had to be, and was, more detailed and more highly finished. Its creation, following a logical progression, was plainly the result of protracted thought and work, and it is pictorially clear and informative. Constable later told Lucas that 'when the water reaches the roots of plants or trees the action on the extremities of their roots is such that they no longer vegetate but die which explains the appearance of the dead tree on the edge of the stream', and that the 'principal group of trees' leant in response to the prevailing wind. As usual we survey the scene from a commanding high viewpoint.

Stratford Mill was exhibited with a *Harwich Lighthouse*, a saleable 102 composition of which several versions exist, all with a closely similar

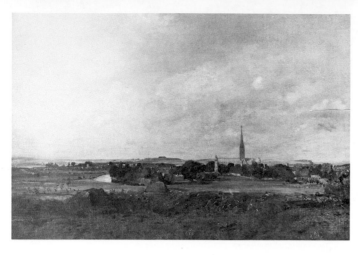

106 *Salisbury from the South,*
1820?

126 sky, which was later adapted to *Yarmouth Jetty*. Repetition of popular
 compositions was a departure in Constable's practice, and occurred
 too with *Dedham Mill*. Of the various versions of this, one was
104 probably at the Royal Academy in 1818 and British Institution in
 1819, and another is dated 1820 (later in the 1820s John Dunthorne
 Junior would help with the groundwork in preparing these replicas of
 successful compositions). This suggests a 'grading' of practice, with
 these pictures perhaps being meant to carry less weight than the six-
 foot canvases, and reminds us that in this decade Constable was often
 having to produce work to order. This work must be distinguished
 from the paintings or study he carried out for his own purposes. In
 summer 1820, for instance, he took a family holiday with the Fishers at
 Salisbury, where his landscapes appear to have developed his concerns

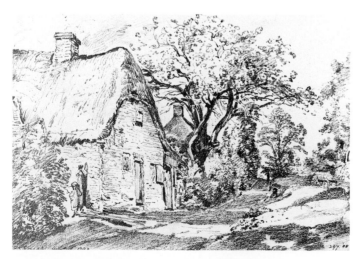

107 *Cottage and Trees in
the New Forest,*
4 August 1820

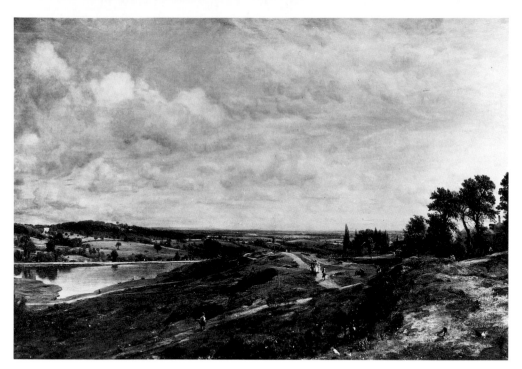

108 *Hampstead Heath*, 1820–1

with the unifying effects of light. Constable's broader handling in 106
drawing from nature was developed in a view in the New Forest. In its 107
subject, and in its stress on light, shade and texture, this demonstrated
how different motifs demanded different pictorial articulation: here it
was conceived in a particularly picturesque manner, suitable to a
cottage in a region associated with Gilpin.

It is testament to this expansion of range that Constable did exhibit
two Hampstead landscapes at the 1821 Royal Academy, and it is
thought that they were of the same type as the painting illustrated. Its 108
subdued handling, which contrasts with work done from nature, 98
reaffirms that Constable was not yet finding at Hampstead, as at
Bergholt, an identity of concern in public and private painting. This
work displays one of the region's noted vistas, and fits, too, with a
seventeenth-century Dutch tradition of panoramic landscapes: Van
Goyen's *Windmill by a River* (National Gallery) similarly has ground
sloping from left to right, populated by isolated figures, and water in
the middle distance supplying repose for the eye.

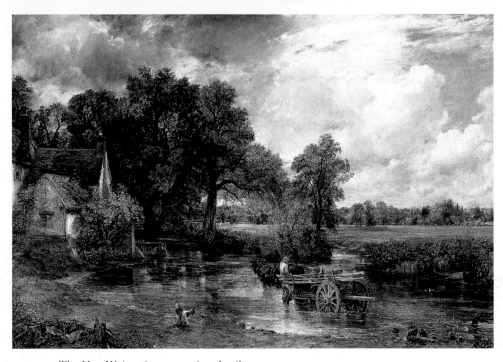

109, 111 *The Hay Wain*, 1821; opposite, detail

110 Full-scale sketch for *The Hay Wain*, 1820–1

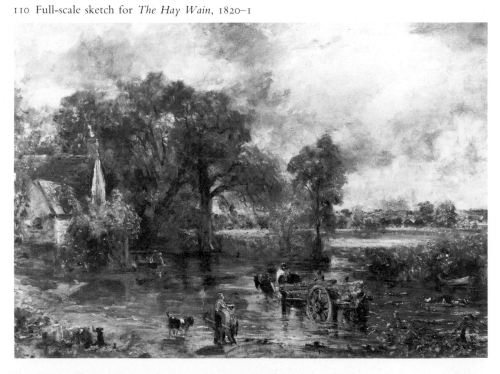

112 *Spring, East Bergholt Common*, 1821?

The Hampstead scenes did not have the pretensions of the work which, on Farington's advice Constable painted as 'more corresponding with his successful picture exhibited last May' – that is, to follow on from *Stratford Mill, The Hay Wain.*

109–11

The Hay Wain represented a place Constable had not studied intensively for three and a half years, although when he went to Bergholt on family business he could find himself moved by the memories of happier times. Visiting there in 1818 (when he made a drawing of his parents' tomb) he found that 'the thoughts of those dear memories almost fill my eyes with tears'. The distancing from the recent past contained the potential for an emotional conflict – 'How sweet and beautifull is every place & I visit my old haunts with renewed delight but filled with many regrets ... How delightfull is the country, but I long to get back to what is still more dear to me' (Easter 1821). Despite his detachment, Constable's pictorial response to the place remained steady.

112

The image of the ploughman in the contemporary *Spring, East Bergholt Common* locks into a venerable tradition. This shows both a Labour of the Month, and that 'Industry' vital to maintaining prosperity, surprisingly major content for so brilliant and sketchy a painting. Constable saw nothing incongruous in his imagery being

applied to a scene of the ploughing of a common after its enclosure. *The Hay Wain* took the georgic on to the larger scale. Its evolution followed the pattern of the two previous 'six-footers'. Oil sketches of Willy Lott's farm were available to form a guide for the configuration of the exhibition picture. The large oil sketch, like its immediate predecessor, was used to try out the composition, and has a variable degree of finish. The painting itself was noticeable in 1821 for a 'certain sparkle' adapted, presumably, from Hampstead studies, and John Thornes has commented on the metereological accuracy of the sky. _{113 110 109}

 The painting received a mixed reception; 'as you say', wrote Abram Constable, 'some are for & some against'. The *Observer* thought it only wanted finishing, and Collins, who approved of the painting, also regretted that Constable had not finished it more accurately. *The Hay Wain* attracted this censure because Constable had had to hurry over painting it, and further work would easily remedy the defect. In the convincing quality of its illusion it blended the lessons learned at Hampstead into the structures of a Stour Valley landscape, making the advances in painting the appearance of nature that were necessary if a 'natural painture' was to remain a goal. Constable retained the high viewpoint, accurate topography and working subject, but also referred to other landscapes (as echoes of some of Turner's Thames scenes can be discerned). The composition has often been linked to Rubens's in the *Château de Steen*, to equate the farm with the centre of a great estate and emphasize such farms' importance in maintaining national prosperity. The haycart on its way to pick up another load reflects Rubens's produce-laden one, Constable's ducks drift safely past an angler, but Rubens's are hunted.

113 *Willy Lott's Farm*, July 1816

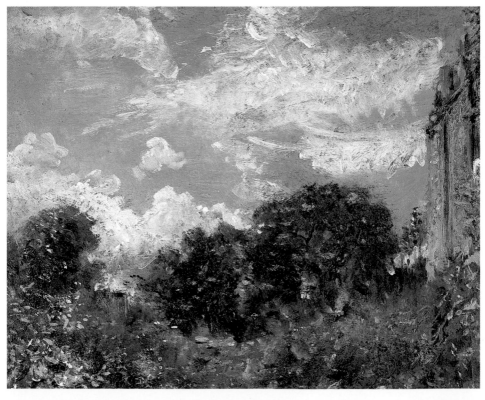

114 *Pond and Cottages, a Storm Approaching*, 1821 ?

115 *Sky and Trees at Hampstead*. Inscribed 'Sepr. 12. 1821. Noon. Wind fresh at West
[3 or 4 words deleted] . . . Sun very Hot. looking southward exceedingly bright vivid
& Glowing. very heavy showers in the Afternoon but a fine evening. High wind in
the night.'

116 *Branch Hill Pond, Evening*, 1821–2

111 While such pictorial paraphrase elevates Constable's imagery, and while *The Hay Wain* evolves from other paintings of haymaking (most recently developed by Gainsborough and Stubbs), the subject is also grounded in a literary tradition. Aikin, in his *Calendar of Nature* (which Constable was 'always giving . . . away'), thought it 'one of the busiest and most agreeable of rural occupations. Both sexes and all ages are engaged in it. The fragrance of the new-mown hay, the gaiety of all surrounding objects, and the genial warmth of the weather, all conspire to render it a season of pleasure and delight to the beholder.' This is implicit in *The Hay Wain*, where incident, in the line of mowers, is absorbed in the landscape. It was in 1821, after a sight of Collins's attempt to paint 'the most romantic glen in Westmoreland', that Constable wrote: 'The Londoners with all their ingenuity as artists know nothing of the feeling of a country life (the essence of Landscape) – any more than a hackney coach horse knows of pasture.' *The Hay Wain* gives a convincing illusion of an actual scene, and still appears to be concerned with transmitting that georgic idea of a country life; but because Constable was no longer painting in East Anglia the harmonious coincidence of public with private interests had become unstable.

 In June 1821, for example, he accompanied Fisher on his visitation of Berkshire and made various drawings and watercolours of a variety

117 of scenes, many of them along the Thames. A ruin near Abingdon was not drawn to create a pictorial record, but because it had interesting shapes which made striking patterns of chiaroscuro. The watercolour

114 of cottages by a pond was painted over a pencil underdrawing (Constable very rarely *painted* in watercolour). The chief effect is that of an oncoming and louring storm; the sky has been saturated with water and rubbed, to freeze effects of light in atmosphere. By

117 *A Ruin near Abingdon,* 7 June 1821

118 *Sky and Trees at Hampstead,* 1821, detail (see Ill. 115)

concentrating on light, shade and reflected colour, Constable had
evolved a means of making consistent study independent of locality.

At Hampstead Constable was most prolific in oil studies and, in
1821, produced many of these showing either a base of massed foliage
and the sky (comparable to some of Turner's of the 1800s), or the sky
alone, on which were frequently inscribed legends detailing the
prevailing weather conditions. Here the white and blue of the sky are
hardly mixed, and touches of yellow, green and some white indicate
light glinting off foliage. The systems of reflections are complex as fit
cloud moving quickly in the fresh breeze.

116
115,118

Cloud studies, as we would expect, display great variety. They could be made anywhere, and Constable's perceptions were not filtered through particular ways of looking at skies save for portending weather, and, to a certain extent, mood. These interests were shared by other artists. Cozens, Malchair and Cornelius Varley preceded Constable, and in 1824 William Mulready would use the full Howard terminology – Cirrus, Cumulus, and so on – and also note weather conditions. Constable, satisfied with descriptions like 'large climbing clouds', was unique, though, in the intensity of his sky study, and as John Thornes has recently demonstrated, Constable's fine paintings of clouds are also descriptively precise. This imagery was not 'scientific' in the way Stubbs's anatomical drawings had been; the study illustrated took an hour to paint under very windy conditions, and must therefore represent an abstracted and typical cloud-formation. And it would be wrong to infer from this phase of Constable's career that his interest in weather was confined to these years – he knew something about it before, and that he was concerned with artistic problems is suggested by the rough copies of skies made in 1823 after Alexander Cozens's *New Method of Assisting the Invention in Drawing Original Compositions of Landscape*.

This Hampstead work prompted a development towards a 'pure' landscape, mostly articulating relationships between light, sky and ground, the latter two connected through the water-cycle of evaporation, condensation and precipitation. Subjects tended to be defined in pure colour, and the widening gap between this study and the studio creation of canal scenes for exhibition was concerning Constable in late October 1821, when he wrote that, although he had 'made more particular and general study than I have ever done in one summer' he was 'most anxious to get into my London painting room, for I do not consider myself at work without I am before a six foot canvas'. He wrote of his 'skying' conquering an 'arduous' difficulty, in a sincere espousal of the pathetic fallacy, for the sky was the '"*key note*" – the *standard of "scale"*, and the chief "*Organ of sentiment*"'. Constable responded to Fisher's description of a day's fishing by writing: 'the sound of water escaping from Mill dams, so do Willows – old rotten Banks, slimy posts, & brickwork. I love such things', which led to: 'But I should paint my own places best – Painting is another word for feeling.' The letter continued: 'My last year's work has got much *together*. This weather has blown & washed the *powder off*. I do not

119 *Cloud Study*. Inscribed '25th Sepr. 1821 about from 2 to 3 afternoon looking to the north – strong Wind at west, bright light coming through the Clouds which were lying one on another.'

know what I shall do with it – but I love my children to well to expose them to the taunts of the Ignorant.'

Here he was writing about working on *The Hay Wain*. That he conceived of paintings as 'children' reveals the nature of his creative relationship with them, yet his timidity about exposing them might appear disingenous in the light of the favourable reception accorded his exhibited landscapes – unless he was unsettled by an apparent lack of consensus among the reviewers, and the clear limits of their critical understanding. They thought pictures looked 'natural', or rivalled the masters. The moral character of Constable's work, which we discern only with the guidance afforded chiefly in Constable's letters, remained hidden.

'The illiterate offspring of grocers'

The reception afforded Constable's landscapes often failed to live up to their pretensions, and while he had been at work on *The Hay Wain*, the imagery of which we have considered as public and historically accessible, Constable wrote to Fisher that 'I now fear (for my family's sake) that I shall never be a popular artist – a Gentleman and Ladies painter – but I am spared making a fool of myself – and your hand stretched forth teaches me to value my own natural dignity of mind (if I may say so) above all things.' When, in February 1822, Fisher dismissed a further failure in an Academy election with: 'You are painting for a name to be remembered hereafter: for the time when men shall talk of Wilson & Vanderneer & Constable in the same breath,' Constable was evidently becoming doubtful of ever receiving what he considered his critical due.

As that letter arrived he would have been working on a painting which he had started in September 1821 for the next year's Royal Academy exhibition. *A View on the Stour near Dedham* represented the scene across the meadows to Dedham from Flatford dry dock, and was again developed from far earlier work. The composition's genesis, however, was beset by uncertainty, as we discover from the artist's account of how, between January and April 1822, the composition was 'almost totally changed':

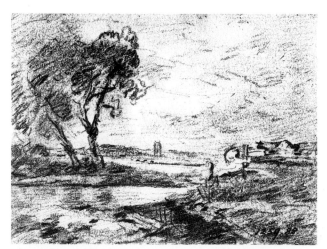

120 Sketchbook, 1814. View on the Stour

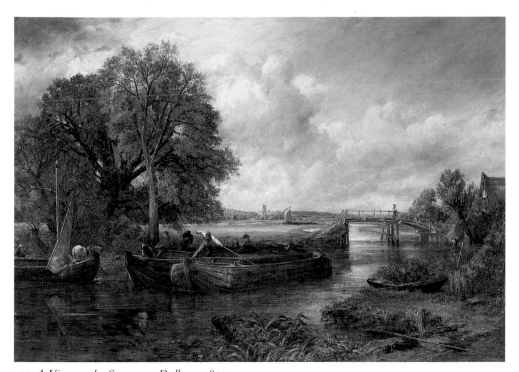

121 *A View on the Stour near Dedham*, 1822

122 *A View on the Stour near Dedham*, 1821–2

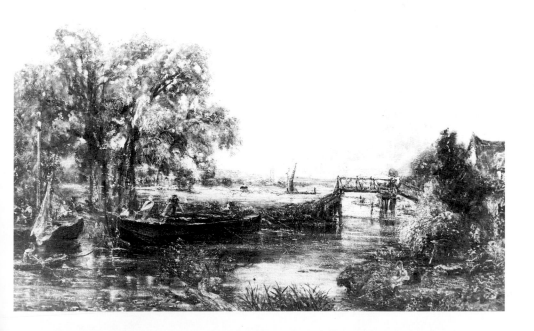

I have taken away the sail, and added another barge in the middle of the picture, with a principal figure, altered the group of trees, and made the bridge entire. The picture now has a rich centre, and the right-hand side becomes only an accessory. I have endeavoured to paint with more delicacy but hardly anyone has seen it.

122
121 The sail is discernible in the Holloway College painting, the barge and principal figure in the other. The former is so heavily painted as to appear a finished painting eventually rejected for exhibition, rather than a full-size sketch. There were also major changes from this to the exhibited picture. The rowing-boat had been manœuvring a barge to shoot a lock, integrated into the landscape by a high viewpoint and put to one side of it as an important but not obtruding element.
121 Establishing a 'rich centre' altered this ratio. There were more and larger barges, to which the eye is directed by (for the first time) a lower viewpoint, or the guiding lines of tree trunks and rakes. Constable was beginning to use his own paintings as a pictorial dictionary – with the
95 barges developing out of the one in *The White Horse*, whence came the rowing-boat, which had also appeared in *The Hay Wain*, which is
109 where the washerwoman originated; the grazing tow-horse came
103 from *Dedham Lock and Mill*. The landscape type was established in *Stratford Mill*, where one side is accented by a mass of trees and the other stretches into a distance. This right-hand side, which located *A*
121 *View on the Stour* at Flatford, with Dedham in the distance, was now 'only an accessory'. As place diminished in centrality, so did pictured incident: the figures on the barges provide an interesting and fitting focus, but this is no longer integral to the landscape. Even the lower viewpoint indicated that the command of scenery in order to assess its components in terms of their whole had become less vital.

These developments were partly due to *A View on the Stour* having to accommodate the more abstracted lessons learned at Hampstead, but there was more to it. This picture no longer presented landscape as *The Hay Wain* had, probably because after 1822 the place pictured no longer accepted such a representation. Continuing agricultural depression meant large-scale rural unemployment, and an alienation of the poor of a kind summarized in a pamphlet of 1824 by the Rev. Anthony Collett of Haveningham in Suffolk. He wrote of a 'bond of union' which had created 'mutual feelings' between farmer and labourer being broken, and that the adoption of day-labour had 'most rapidly effected the total demoralization of the lower orders'.

From late 1821 the East Anglian proletariat expressed its dissatisfactions by assembling riotously, breaking the threshing machines it blamed for its lack of winter employment, and firing stacks and property. February and March 1822 saw an escalation of the disturbances, with troops being brought in on 5 March. Constable knew about these events. On 13 April 1822 he wrote to Fisher that his brother was

... uncomfortable about the state of things in Suffolk. They are as bad as Ireland – "never a night without seeing fires near or at a distance", the *Rector* & his brother the *Squire* (Rowley & Godfrey) have forsaken the village – no abatement of tithes or rents – four of Sir Wm. Rush's tenants distrained next parish – these things are ill timed.

Incendiarism affected East Bergholt, and Constable interpreted the situation as one of prevailing anarchy, illustrated through the dereliction of duty by the Rector and Squire, who should have been using their authority to quell the insurrection.

This state of affairs had been building up gradually. From 1820 there was a new political instability and uncertainty, and we know how both Constable and Fisher reacted to it. Both were ultra-tory and responded violently to anything they saw as radicalism, understanding it correctly as symptomatic of a bid for power by materially powerful but politically disenfranchised classes. The Queen's Affair in 1820 fuelled a political crisis of major proportions; Constable thought 'the Royal Strumpet ... the rallying point (and a very fit one) for all evil-minded persons', and it probably embedded in him his lifetime's detestation both of the Queen's advocate, Henry Brougham, and members of the Low Church denominations, which were associated with political radicalism. That year a correspondent to the *Ipswich Journal* described the Whigs as aiming 'at the subversion of all the most sacred institutions of our hitherto happy country'. Any such subversion undermined the credibility of a landscape which assumed an elevated artistic status through celebrating these 'sacred institutions'.

When the 1822 disturbances took place, it is significant that they came as a surprise to many, and were often interpreted as revolutionary in intent. The Suffolk agriculturalist Samuel Quilter (much admired by Abram Constable) described the acts as 'nearly approaching open revolution' in a letter to Peel, and the Member of Parliament Thomas Sherlock Gooch considered all 'to proceed from great bodies

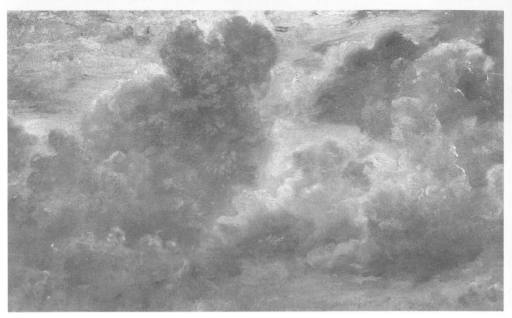

123 *Cumulus Clouds*. Inscribed on label on stretcher; 'Augt 1. 1822 11 o'clock A.M. very hot with large climbing Clouds under the Sun. wind westerly'

of unemployed poor ... *perhaps* urged on to these diabolical acts by *political* incendiaries'. As the demand for labour increased in the summer, the incidents died down.

Constable was unambiguous in the opinion of the lower orders he would express in 1825. The 'mechanick' was 'only made respectable by being kept in solitude ... directly he is *congregated* with his brethren his evil dispositions are fanned and ready to burst into flame – with any plan for the injury of the great – that may be ripe – this – this – remember I know these people well – having seen so many of them at my father's ... '. His incendiary language confirms that his opinions would have accorded with those of the County establishment. Riotous proceedings and arson were Diabolical acts.

It could seem that the world had turned upside down. Labourers were thrown out of work because good harvests depressed corn prices and encouraged employers to economize on wages. They should, as with *A Harvest Field: Reapers, Gleaners*, have been a cause for thanksgiving. John Fisher captured the weird quality of things, writing in a letter from Osmington of 'a strange anomaly Ruin &

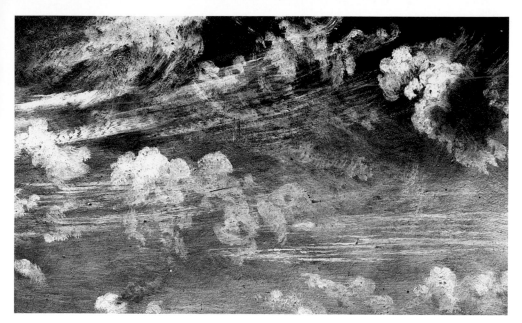

124 *Cirrus Clouds*, 1822 ?

prosperity walking hand in hand', and prophesying a return to 'the little yeoman' and normality. He neatly disclosed the incomprehensibility of the rural economy. It seems possible that the shock of the 1822 disturbances might have led to Constable's abandoning one version of *A View on the Stour* to replace it with another. Conditions had been worsening for some years, but we tend to be very selective in what we choose to see, and Constable's viewpoint had been that of his class: a threshing-machine, (he had drawn one in 1813), or ploughing the common, was of interest to the economically-minded landowner, and Constable's flying visits had not disabused him of his sense of place. With the events of 1822 the content of previous landscapes was no longer credible. 112

A View on the Stour near Dedham, a transitional work which shows little of the stylistic experimentation which becomes noticeable in the canal scenes in 1824, received good notices in the press. Constable himself felt that he had 'dismissed' the painting 'with great calmness and ease of mind'. Notwithstanding this, a few days later he wrote that 'occupation is my sheet anchor – my mind would soon devour me 121

without it. I felt as if I had lost my arms after my picture was gone to the Exhibition.' The painting was an extension of himself, and to be painting, psychologically necessary: to lose his arms deprived him of this release and left him prey to his mind. The art of painting was becoming a means of blocking other perceptions, not of ordering and transmitting them.

During the early 1820s Constable did make money, although he tended from now on to dislike commissions, and during the summer of 1822 he continued to study skies, 'tolerably large to be careful'. Various causes conspired to prevent Constable from having a canal scene for the Royal Academy in 1823, but his *Salisbury Cathedral from the Bishop's Grounds* was widely approved, Constable having removed a 'dark cloud' at the request of his patron, the Bishop of Salisbury. The composition, following that of an 1811 drawing, has the Bishop and Mrs Fisher admire the church, painted in a higher key than its surroundings and framed by an arch of trees. These may acknowledge the common idea that Gothic architecture evolved in imitation of the groves where worship had hitherto been conducted. High Church Anglicanism was thus a natural religion, the pastoral cattle a metaphor for the peace and contentment of Britain under its jurisdiction. Once the canvas was at the Royal Academy Constable joked to Fisher: 'I think you will say when you see it that I have fought a better battle with the Church than old Hume, Brogham [*sic*] and their coadjutors have done.' This referred both to the difficulty of painting the subject and to their correspondence earlier in 1823 about the threat to the Church presented by an attempt to reform the Irish tithe system. Fisher understood this as 'the Vulture of Reform' about to 'fix his talons' in 'the fat of the church' to hasten the disappearance of 'the liberal, literary, & learned body to which I unworthily belong' to allow 'the illiterate offspring of grocers and tallow chandlers' to 'fill the pulpits'. This analysis was perspicacious, but Constable was more sanguine – the 'Vultures' had failed in attacking the State, and this would protect the Church. The Church could appear to stand in need of reform. Norman Gash wrote that its 'organizational defects were notorious: among them nepotism, absenteeism, sinecures, pluralism . . . and the preoccupation of the episcopate with their parliamentary and political functions'. Fisher achieved his own position at Salisbury through nepotism which ensured his enjoyment of various sinecures, while his pluralism necessitated his absenteeism from certain parishes.

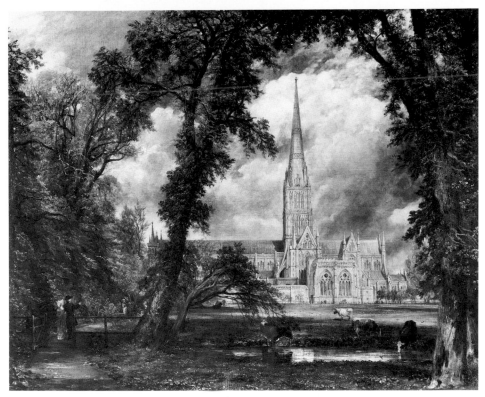

125 *Salisbury Cathedral from the Bishop's Grounds*, 1823

As the union of Church with State rendered any attempt at ecclesiastical reform a constitutional threat, Salisbury Cathedral could easily assume a symbolic importance for both John Fisher and Constable, allowing the latter, by painting a view of it, to demonstrate his own beliefs about the moral inviolability of Church and Constitution. This demonstration was surprising in a commission, hence his tone, 'I got through that job uncommonly well considering how much I dreaded it.'

In the same letter he shed fascinating light on the way painting was becoming an activity of introversion, of retreat – 'though I am here in the midst of the world I am out of it – and am happy – and endeavour to keep myself unspoiled. I have a kingdom of my own both fertile & populous – my landscape and my children.' Landscape was what the artist created, and where his paintings of it had been his children, that

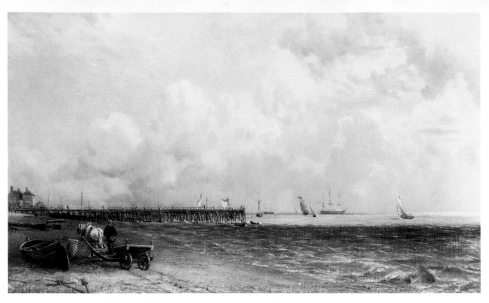

126 *Yarmouth Jetty*, 1822

Constable had loved 'to well to expose them to the taunts of the ignorant', they now became, with his actual children, 'a kingdom of my own'. Rather than existing within and serving society, Constable now felt himself on its periphery. He would say more about this new position – which was the opposite of that he had enjoyed with his public, the Godfreys or the Rebows, in the 1810s when both they and the artist had had an understanding in common of his works – in letters of the mid-1820s. These amplify what had developed *c*. 1822.

 John Tinney, for instance, had offered in 1823 to purchase any six-foot canvas Constable might paint, and had agreed to buy two smaller paintings at 50 guineas. Later, in 1824, Constable would extricate himself from this arrangement, at the same time as seeking to borrow *Stratford Mill* from Tinney for the British Institution exhibition of modern masters scheduled for 1825. He confessed that all his 'indispositions have their source in my mind', referring to the extreme anxiety with which he was sometimes afflicted. And when in November 1825 he again sought to liberate this painting, he wrote that he had 'only the right left of apologizing to him for the past – but if artists (creatures of feeling, visionaries) are to be judged of by every day usage – like pound of butter men – they must always be in scrapes and on the wrong side.' Fisher argued that Constable was exception-

132

ally prone to 'torment' himself with 'imaginary ills', but Constable denied that they were imaginary – 'I live by shadows, to me shadows are realities'. To set these statements in perspective, we may cite Constable's exchange with William Blake, when the latter admired a drawing of fir trees with: 'Why this is not drawing but *inspiration*' – to which Constable had retorted, 'I never knew it before; I meant it for drawing.' From this period then, Constable would, because of his occupation, picture himself outside society to present himself as the visionary; or, as he phrased it when finally deciding to send paintings to France, the prophet who was not known in his own country.

In October 1823 Fisher relayed a suggestion from the painter and engraver F.C. Lewis that Constable had taken to repeating himself, and the latter, having claimed to welcome criticism, went on to write:

When Nat. Hone's malignant picture 'The Conjuror' (meant to ruin Sir Joshua Reynolds 'fair fame') came to the Exhibition the members were for rejecting it. 'No' said Sir Joshua – 'if I deserve this censure it is proper that I should be exposed.'

127 John Crome, *Yarmouth Jetty*, c. 1808–9

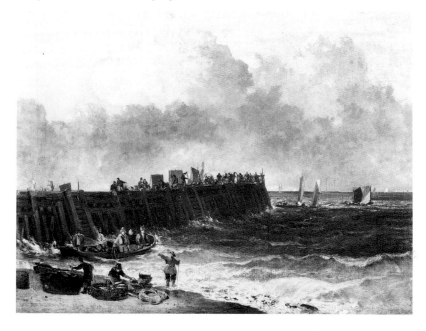

Lewis [is] like most men living in the atmosphere of the Art – followers and attendants upon armies &c. &c. are always great talkers of what *should be* – and this is not always done without malignity – they stroll about the foot of Parnassus only to pull down by the legs those who are laboriously climbing its sides.

Nathaniel Hone had caused an uproar in 1775 with a painting of one of Reynolds's favourite models as a seated magician, waving his wand over a selection of the prints from the Masters which Reynolds had used as sources for his portrait compositions. For Constable, now 'laboriously climbing' the sides of Parnassus, Reynolds remained the great exemplum, and the role he had defined for the artist perhaps the most vital article of Constable's belief. So, while the state of affairs had changed since the 1810s, and those who saw his pictures might no longer assume any community of interest with him, to justify his occupation his alienation had to waver: even as he wrote of shadows and realities, he acknowledged his 'master the publick'.

It is also the case that from 1823 Constable's exhibited pictures began to show considerable variety. The *Yarmouth Jetty* exhibited in the 1823 British Institution was of a subject popular amongst the Norwich artists, who also showed the scene as a place of popular

126
127

128 *Cenotaph to Sir Joshua Reynolds in the Grounds of Coleorton Hall,* 28 November 1823

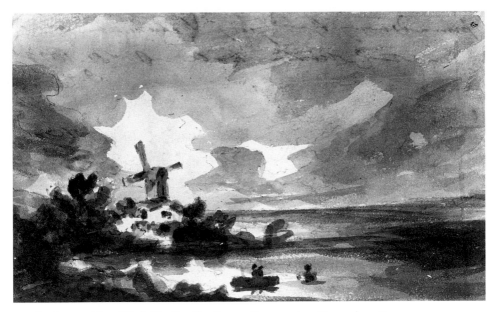

129 *Landscape with a Windmill*, after Sir George Beaumont, 1 November 1823

resort. Promenading on the Jetty itself Constable pictured those who visited the seaside and who themselves might buy such paintings. The colouring was similar to John Crome's painting of the same place, but whereas Crome concentrated on typical activity, Constable catalogued the delights the coast afforded, from the sight of boats to an invigorating atmosphere. Paintings of this kind sold well, and Constable was thrifty in re-using the sky from *Harwich Lighthouse*. 102 Study from nature itself was still done mostly at Hampstead, while an autumn visit to Sir George Beaumont at Coleorton meant an important break in these habits. In the grounds he drew such motifs as the Reynolds Cenotaph, in the house he copied variously, from 128 engravings after Cozens to drawings by Beaumont himself, to 129 Claude's *Landscape with a Goatherd and Goat* which contained 'almost all that I wish to do in landscape'.

The stay was not altogether easy. Despite their long acquaintance Beaumont never patronized Constable (in contrast with other painters, notably Wilkie), and chiefly employed him for picture-repairs. Beaumont's connection with the British Institution created tensions. The artists in general were unhappy about the sway the Institution assumed over their practice – William Owen had felt that

with a Reynolds it would have been 'impossible for Mr. Payne Knight & *the other members of the Committee of Taste* to have obtained the importance they have done and that they should be referred to for decissions as they now are'. In 1823 Constable raised the matter with Beaumont himself – 'I asked Sir G.B. if there was not likely to be a society of noblemen and gentlemen to regulate the offices of the Church – the Horse Guards – the medical world &c – and award prizes to the aspirants.' This is the background to the incident when 'Sir George recommended the colour of an old Cremona fiddle for the prevailing tone of everything, and this Constable answered by laying an old fiddle on the green lawn before the house.'

Expertise in painting was a gentlemanly attribute which should inspire patronage. Yet as the painters were attempting to consolidate their professional autonomy, principally through the Royal Academy, the gentlemen were harming it. Payne Knight (who doubted the quality of the Parthenon sculptures) claimed that 'even the best artists are not always the least fallible judges in their own art', and cited Reynolds; and social status lent weight to opinions like this. Artists were exhibiting pictures of such variety that we can make no formal categorization of the 'British School' of this period: connoisseurs could appear to utter proscriptive opinions on arbitrary grounds.

Constable, under some pressure professionally, was troubled both by their power and by their taste for works which pasticled rather than evolved from the old masters. Their influence did affect the market, and if success in a competitive world depended on whim, not the assessment of merit, then painting became increasingly confused, and success more elusive. Constable's landscapes had variable pretensions. Study was carried out at Hampstead, or, after 1824, Brighton. The irritating burden of commissioned work was often passed on to a greater or lesser extent to John Dunthorne. The large canvases mattered most. In September 1823 Constable exclaimed 'my difficulty lies in what I am to do for the world, next year I must work for myself – and must have a large canvas'.

The Later Canal Scenes

Constable had mentioned 'an excellent subject for a six foot canvas' in
October 1822, and small oil paintings of a boat in a lock with Dedham 130
Church in the background may connect with this project. Here a left-
hand side taken from *Boat Building* is attached to a right from that 72
earlier oil sketch of Dedham Mill. The general arrangement refers to 82
the scheme used in *A View on the Stour near Dedham*: extemporizing on 121
a format where a low viewpoint stresses a central incident in a
landscape where a distance, with Dedham Church prominent, is
blocked off to one side by trees. It recurred in vertical and horizontal
versions of *A Boat Passing a Lock* and *The Leaping Horse*, compositions 131–2, 136
which developed at least one remove from nature.

130 *Dedham Lock, c.* 1822–5

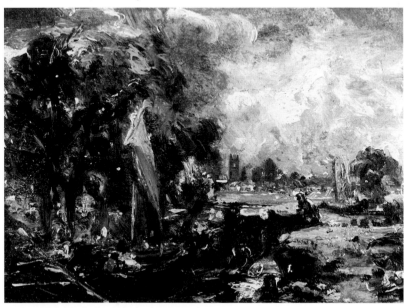

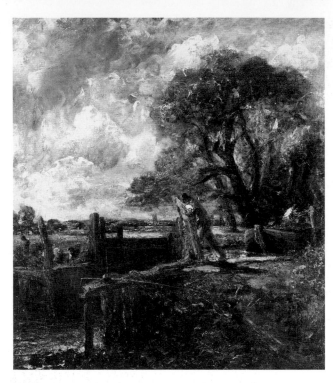

131 *A Boat Passing a Lock*,
1822–4

Conversely, a sketch of Flatford Lock of April 1823 was presumbly
132 done in preparation for *A Boat Passing a Lock*, a canal scene, but not on a
six-foot canvas, which went to the 1824 Royal Academy 'with all its
deficiencies in hand'. Its painter thought it 'a good subject and an
admirable instance of the picturesque' (Constable having moved
151 towards the Picturesque with *Helmingham Dell*, begun in 1823). It
received good notices, and Constable copied out the one from the
Literary Gazette to send to Maria in Brighton. This described him as
the equal of Wilson, and called *The Lock* 'a fine example of the
picturesque – with which its striking and powerful execution
accords', so suggesting that occasionally it was possible to be
understood, for this critic was perceptive in recognizing the pictur-
esque character of both the subject (which relates to Ruisdael's *Sluice in
a Forest*) and its handling, now far less descriptive in manner, to break
dramatically with the controlled naturalism, the concern to paint
appearances, which had been the business of Constable's East Anglian
painting up until 1821–2.

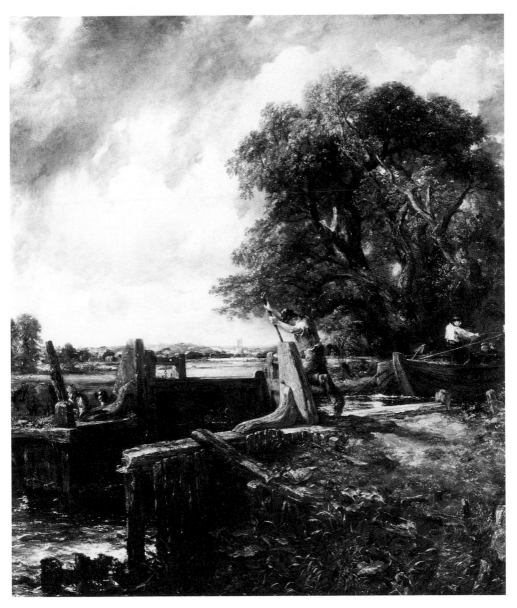

132 *A Boat Passing a Lock*, 1824

131	Constable had tried out the composition in an independent but unexhibitable painting, realizing effects that were necessarily subdued in a picture for public consumption. Surface texture tends to abstraction: the red on the figure reads equally as a patch of colour or a waistcoat. The sky pays scant attention to metereology and is rather a

132	pattern of whites, greys and blues. The exhibited picture, with its almost oppressively low viewpoint, reveals adroit work with the palette knife and has a noticeable textural liveliness, white touches signifying reflected lights, the foreground plants suggested over the canvas ground, rather than described with paint. The subject was 'picturesque' in its pictorial associations with Ruisdael, Gainsborough, and others, and, importantly, in handling. Constable again raided his own painting for his incident: the figure opening the lock was from

104, 121	*Dedham Mill,* and the one on the barge from *A View on the Stour.*

Constable probably adapted something of Gilpin's formalism, but tempered it through the medium of Uvedale Price's writings (Constable owned Price's *Essays* at his death, and would have been apprised of his theories by Farington and Beaumont). Price held that competence in the Picturesque was necessary in those who pretended to cultivation. It would enable 'the man of liberal and intelligent mind' to appraise compositions or parts of scenery 'the arrangement of which must be more or less regulated and restrained by what joins them, and the connection of which with the general scenery must be constantly attended to'. This policing of the landscape constituted it a metaphor for the interdependence of the sections of society, 'regulated and restrained' by the laws and usages which originated in the Church and Constitution.

John Murdoch has characterized Price's as a conservative aesthetic 'based on appreciation of the way things grew naturally through time and benign neglect, in the landscape as in society at large'. 'Time' stated Price, 'turns a beautiful, into a picturesque object.' A picturesque landscape could therefore express a conservative vision of an integrated whole, and Constable may have taken from Price a means of creating a landscape to replace the documenting of what Constable had perceived as reality and which could accommodate an Augustan iconography. The mid-1820s appeared politically stable. The formal regulation of the Picturesque could now provide Constable's content: the landscape became a paradigm, not strictly a representation.

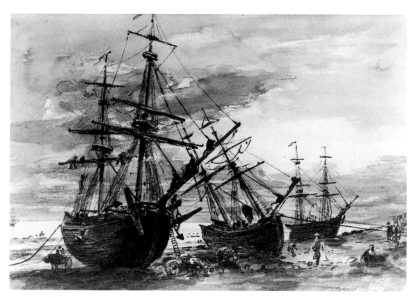

133 *Beached Vessels at Brighton*, 1824?

These shifts in Constable's aesthetic were encapsulated in his account of a visit to the Devil's Dyke in Sussex in August 1824. This presented 'perhaps the most grand & affecting natural landscape in the world', and was

consequently a scene the most unfit for a picture. It is the business of a painter not to contend with nature & put this scene (a valley filled with imagery 50 miles long) on a canvas of a few inches, but to make something out of nothing, in attempting which he must almost of necessity become poetical.

Nevertheless, he did draw the scene. Price had written that 'the picturesque has no connection with dimension of any kind, and is as often found in the smallest as in the largest objects'. A 'nothing' contained within itself that exemplum of scenery 'more or less regulated and restrained' which was then given material form by the artist. Later in 1824 Constable considered it 'the highest *praise*' that the French had criticized his Salon exhibits as like 'rich preludes in musick, and the full harmonious warblings of the Aeolian Lyre, which *mean* nothing', for he was aiming for a significant abstraction, and it would have been gratifying to have had it discovered even in *The Hay Wain*.

Constable thought *A Boat Passing a Lock* had expanded his pictorial range in other ways besides:

... its light cannot be put out, because it is the light of nature – the Mother of all that is valuable in poetry, painting or anything else – where an appeal to the soul is required. The language of the heart is the only one that is universal ... My execution annoys most of them and all the scholastic ones – perhaps the sacrifices I make for *lightness* and *brightness* is too much, but these things are the essence of landscape.

To aim for universals in 'the language of the heart' was to cast off the particular or local, and (in a parallel to Turner) to communicate the decisive power of light in impelling landscape towards that universal. Constable's execution and colouring were themselves meant to be reflective of lightness and brightness, and were now far less concerned with specifics. He might now have been concerned to paint that intellectually discerned general nature which was considered superior to the representation of particularities. 'The general idea constitutes real excellence,' stated Reynolds in the fourth *Discourse*, and in the thirteenth went on to claim that 'painting ... ought to be, in many points of view, no imitation at all of external nature'.

Material success may have encouraged Constable to develop this alternative canal landscape. James Morrison bought *A Boat Passing a Lock* directly from the Academy walls, and he was also selling to the Paris dealer John Arrowsmith. 1824 saw the triumph of *The Hay Wain* at the Salon (Constable had sold Arrowsmith this picture and *A View on the Stour near Dedham*, and threw a 'Yarmouth into the bargain' for £250), and fame brought some fortune. Another dealer, Claude Schroth, ordered three further pictures, and by May Constable was preparing ten landscapes for a total of £180 for France. Collins told him in June that the French spoke only of '"Wilkie, Lawrence, & Constable"'. He was included in the common enthusiasm for British art: Paul Huet found his paintings 'a magnificent lesson'. Although the approbation of the painters led to his paintings moving to more favourable positions on the Salon walls, and eventually won him a gold medal, Constable, of course, was 'still more ambitious of *English* praise'.

Samuel Reynolds prepared to mezzotint the two six-foot canvases, and his plate of *A Boat Passing a Lock* advanced as far as a proof. He also planned to engrave twelve drawings developed out of a Brighton

132
109
121

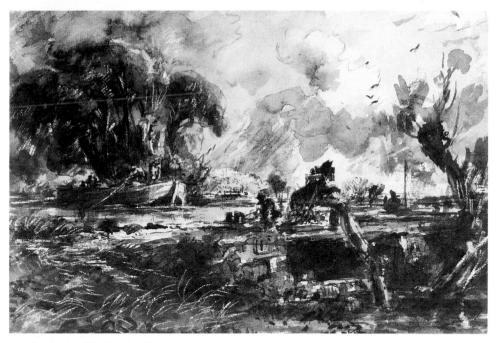

134 Study for *The Leaping Horse*, 1824–5

135 Full-scale study for *The Leaping Horse*, 1824–5

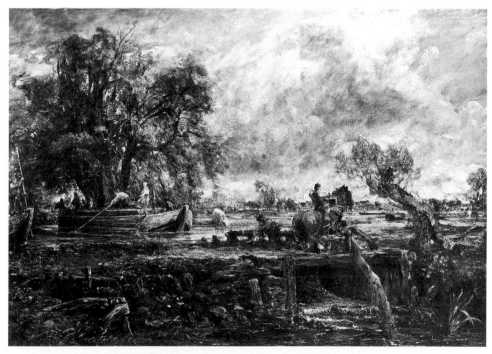

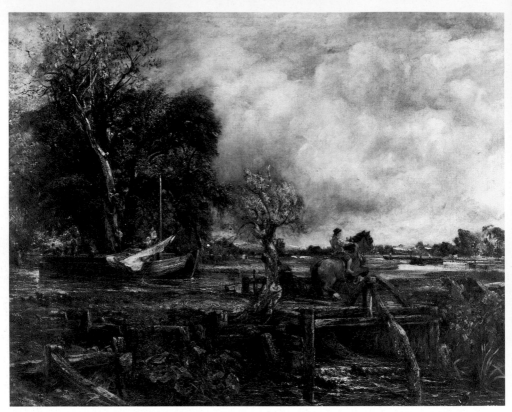

136 *The Leaping Horse*, 1824–5

sketchbook at Arrowsmith's request. The success continued, with commissions coming into 1825, although that November Constable demolished his relationship with Arrowsmith in an angry argument. Schroth received further pictures in 1827, and Constable's French reputation was still high in the 1830s.

He was delighted that French artists were so struck by the 'vivacity and freshness' and '*brightness*' of the earlier landscape – recent work could thus be seen to have developed from it, which perhaps provided 136 an impetus for *The Leaping Horse*, conceived in November 1824. This painting is unique in representing no incontrovertible site, while maintaining the 'canal scene' idiom: Constable's horizontal *Lock* of 1826 (presented to the Royal Academy as his Diploma piece) presents practically a mirror-image of its landscape. There are two variants of

144

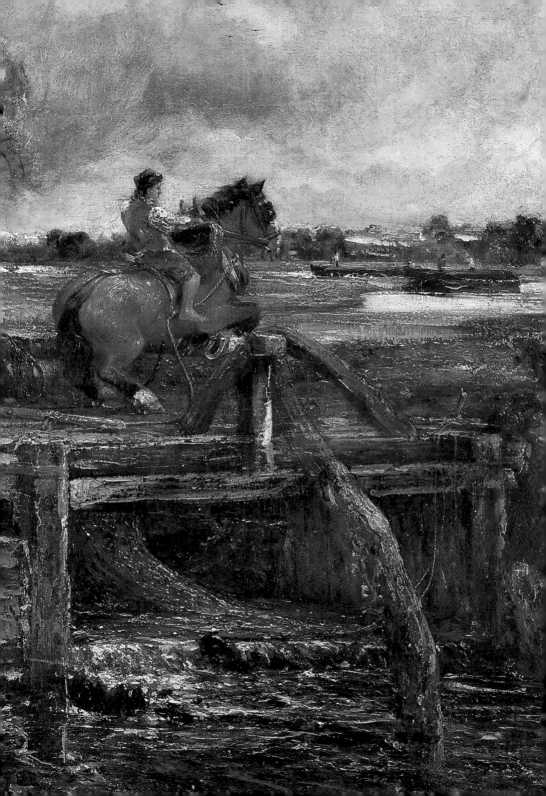

The Leaping Horse, with either one or two barges to the left. In the first edition of his *Memoirs* Leslie wrote that Constable 'made, in the first place, two large sketches, each on a six foot canvas. One was I believe, intended to be the picture, but was afterwards turned into a sketch, not an unusual occurrence with him.' The Victoria and Albert Museum

135
134
canvas became this 'sketch'. Establishing the composition with monochrome wash drawings created a governing structure of chiaroscuro. Constable had retorted to Fisher's objection that mezzotints after his work would fail because they could not reproduce his colour, by arguing that they would catch 'the Chiaroscuro & the details & the taste and with it most of my sentiment'. Chiaroscuro contained all colours and no colours, and therefore in the paintings it was a matter of chromatically embellishing what had already been established through light and shade. The difference in scale between drawings and paintings has no effect if the concern is 'to make something out of nothing', and the division between public and private concerns has been virtually abolished.

137
132
In *The Leaping Horse* a floodgate (reminiscent of the one in those small studies) occupies the place of the lock. A boy on a horse leaps a rail. The horse is towing the barge transporting a mother and child. Constable's handling was more obtrusive than in the *Lock*, and to read the picture surface demands perceptual effort. There is, in detail, some ambiguity between figuration and abstraction, and our expectation that paint will at some level describe phenomena is strained by scrapings of ochres, white and turquoises across ridges of other colours, which we presume to indicate hills, or water and reflections. Since Constable would be castigated for his handling in 1828, it is surprising that this picture, about which he felt anxious on sending it to the Royal Academy, and on which he continued painting later in 1825 (shifting the willow to the other side of the sluice) – and which, on exhibition, was probably more expressionist in character and certainly more brightly coloured – attracted favourable criticisms, criticisms moreover which suggested that Constable's art had now associated itself with a peculiarly English idea of landscape. The *Literary Chronicle* thought it 'a charming specimen of that fresh verdant scenery peculiar to this country', The *European Magazine* noted the 'peculiar and natural style', and claimed that Constable was 'gradually rising to the head of his department. When his pictures receive the mellowing tint of time they will be inestimable.'

That the critics otherwise had little to say affirms Constable's singularity, although there is a paradox in his art inspiring so little verbal analysis: *The Leaping Horse* was meant as an historical landscape (although Constable's definition of artists later in 1825 as 'creatures of feeling, visionaries' rather denies its capacity to serve as this). Constable described *The Leaping Horse* initially as 'a canal and full of the bustle incident to such a scene where four or five boats are passing with dogs, horses, boys & men & women & children, and best of all old timber-props, water plants, willow stumps, sedges, old nets, &c &c &c'. It is immaterial that neither dogs nor nets are visible, for the idea, the 'canal', is all-embracing. On its completion the artist wrote: 'I must say that no one picture ever departed from my easil with more anxiety on my part with it. It is a lovely subject, of the canal kind, – lively – & soothing – calm and exhilarating, fresh – & blowing, but it should have been on my easil a few weeks longer.' His pictorial effects had apparently expanded beyond 'lightness and brightness' to something more synaesthetic, moving on, therefore, from *A Boat Passing a Lock*. Describing *The Leaping Horse* as 'lively – & soothing – calm and exhilarating, fresh – & blowing' implied that it might excite these various opposed responses in a spectator, responses which, being more suited to the experience of actual landscape, allowed the image the potential to contain within itself all natural effect. To conclude this would be to take Constable at his word. But to understand that particular effects may provoke particular sensations, or to see light as so central that to paint 'lightness and brightness' will be to paint essences, is not to say that these reactions to phenomena will necessarily be experienced by all who see the picture.

The Picturesque and the Past

Constable thought his reputation would depend on the canal scenes, hence our focus on them, but he did other work during the mid-1820s. Hampstead Heath landscapes were effective for imparting breeziness or freshness and equally amenable to the Picturesque: a *Branch Hill Pond* was exhibited alongside *The Leaping Horse*. A Henry Hebbert contracted to pay 150 guineas for this and a *Child's Hill, Harrow in the Distance*, but backed out, and a Francis Darby bought them (with Constable producing replicas for Claude Schroth). He described *Branch Hill Pond* as 'A scene on Hampstead Heath, with broken foreground and sand carts, Windsor Castle in the extreme distance on

139

the right of the shower. The fresh greens in the distance ... are the feilds about Harrow, and the villages of Hendon, Kilburn, &c.' It was partly meant, then, as a picture of one of the vistas afforded from Hampstead Heath, and partly to describe weather-effects and typical activity. The paint is less expressive and more richly textured than in *The Leaping Horse*, and the colours warmer than in another *Branch Hill Pond* painted for Hebbert in 1828 but taken back because of Hebbert's objections to it. This version, based closely on the 1819 study, is practically replicated in a further painting probably exhibited at the 1828 Royal Academy, and 1836 saw an extraordinary final manifestation of this composition. This format was apparently meant to stimulate reactions akin to those intended with the canal scenes. Jack Bannister, the actor, who eventually bought yet another *Branch Hill Pond*, had wanted a landscape 'in which he says, he can feel the wind blowing on his face. He says my landscape has something in it beyond freshness, it's life, exhilaration &c.'

140
97

141

138 *Brighton Beach*, 12 June 1824

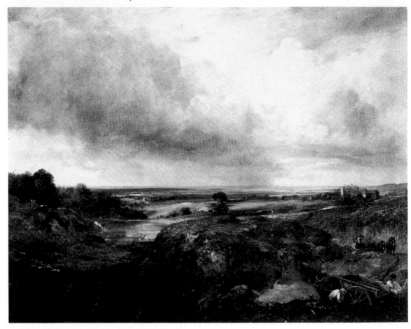

139 *Branch Hill Pond, Hampstead,* 1825

140 *Hampstead Heath, Branch Hill Pond,* 1828

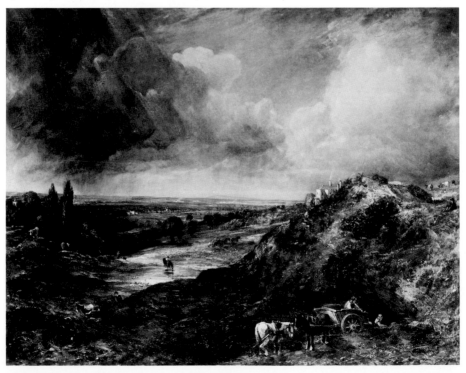

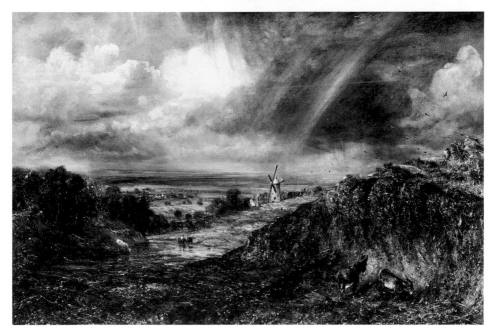

141 *Hampstead Heath and Rainbow*, 1836

By 1824, however, Constable was tending to work from nature at Brighton. In July 1824 he took small commissions there with him, but also drew and painted from nature to an extent which had to be compared to the Hampstead work of the early 1820s. Laborious pen and wash drawings of beach scenes were probably destined to be engraved. Similar subjects are less picturesquely descriptive than intent on silhouette and atmosphere, while other small watercolours capture tremendous effects of storms. Oil sketches, often done with a small palette knife, feature a range of beach and downland subjects, which frequently concentrate on general light effects. Some contain reminiscences of earlier painting: a study of a windmill and rainbow repeats a combination painted in July 1812 in a sketch of Constable's father's windmill. Constable also painted the sea and beach scenes, from 1824 on. An early study shows a flat calm sea under louring skies, with a few small and shadowy vessels and a couple of figures. When attention was fixed on the ocean itself it was usually shown responding to weather. Here the palette was principally of blue-greys and white, and the painting transmits the effects of breeze, with a few tiny accents

133

143

138, 145-6

145

138

146

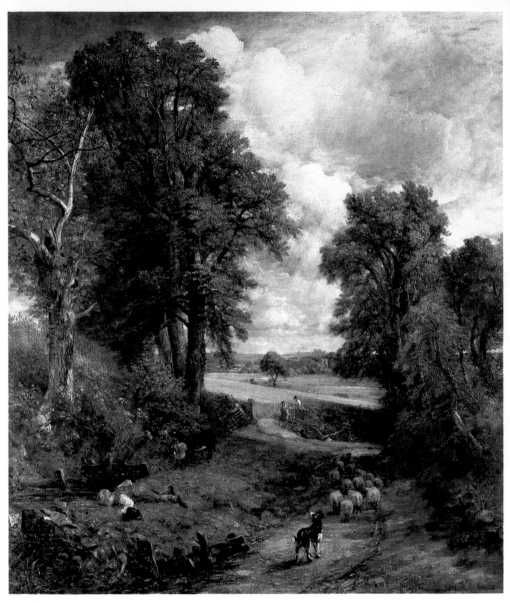

142 *The Cornfield*, 1826

of a brown-red indicating sails: both these studies suggest a sense of desolation, mainly through being depopulated.

Coastal scenes were by no means new to Constable, but at Brighton he was less interested in the place than in the effects to be observed there. As we have seen, seascapes, including Constable's, were popular at this period, and Turner's paintings and engravings must provide the major precedent for Constable, although Turner's was more historical a view of the British coastline. Constable never painted Britain's 'wooden walls' in the same way, and was far less engrossed in the husbandry of the ocean. Only Cotman appears occasionally to share his preoccupation with atmosphere and tone, but this may simply be coincidental. Constable himself felt that coastal scenes were hackneyed, and in a letter of 1824 to Fisher deriding Brighton, wrote that because they were easier than landscape they had 'drawn off many who would have encouraged the growth of a pastoral feel in their own minds', hence 'we have Calcott & Collins – but not Wilson or Gainsborough'.

143 From a sketchbook used at Brighton: a stormy seascape, 1824?

144 *Harwich*, 1825

Persisting with the canal scenes had led to occasional charges of repetitiousness from Lewis in 1823 as already mentioned, and again from Fisher in 1824 with 'I hope that you will a little diversify your subject this year as to *time of day*. Thompson you know wrote, not four Summers but *four Seasons*.' (Constable tended to paint noon scenes.) His friend's reaction was to write:

... subject and change of weather & effect will afford variety in landscape. What if Van de Velde had quitted his sea peices – or Ruisdael his waterfalls – or Hobbema his native woods – would not the world have lost so many features in art? I know that you wish for no material alterations – but I have to combat from high quarters, even Lawrence, the seeming plausible arguments that subject makes the picture.
... I must go on. I imagine myself driving a nail. I have driven it some way – by persevering with this nail I may drive it home ...

He then repeated the point he had made about Callcott and Collins choosing the easier subject in painting coastal scenes, writing that he held 'the genuine – pastoral – feel of landscape to be very rare & difficult of attainment – & by far the most lovely department of painting as well as of poetry', and exemplifying it in Claude, with whose paintings Constable's own would seem to have very little

145 *Windmill among Houses with Rainbow, c.* 1824

146 *The Sea near Brighton,* 1826

direct connection. Apart from the fact that until 1821 subject *had* been important, if it no longer 'makes the picture', then this destabilizes the idea of conventional pastoral. Constable, did, however, begin to introduce an apparently greater variety into his art.

142 *The Cornfield* (exhibited in 1826) was a type of landscape very different from that series of canal scenes, and one which virtually parodied the conventional Picturesque. Adapting the view down a lane to a cornfield from an earlier Stour Valley oil sketch, he added a village and church to the background, taking the drinking boy from another earlier sketch. This was working with pre-existing material, rather than making 'something out of nothing'. The Picturesque here is explicit, with references to Gainsborough's works in particular; the track and pond originated in *Cornard Wood* (owned at one stage by Constable's uncle), for instance, and the unprecedented dead tree also looks to Gainsborough, in whose paintings (as well as in Gaspard Poussin's *Landscape near Albano*) might be found a comparable flock of sheep. The subject, furthermore, is a 'hollow lane' with 'no regular verges of grass ... no distinct lines of separation', where 'even the tracks of the wheels ... contribute to the picturesque of the whole', such as – as these quotes from his *Essays on the Picturesque* suggest – Uvedale Price would have approved.

The painting seems to combine the Picturesque with a cultivated landscape of the type last seen with *The Hay Wain*, but this comparison does not hold. Constable understood farming, and knew wheat would not be sown to the field's edge, and that the dead tree would be felled. A shepherd would not abandon a flock, which looks unshorn at harvest, which is carried out by only two, not the usual crowds of figures. The plough (which would be housed in a barn) is a composite type of the artist's invention, and the gate is off its hinge. Although the handling is superficially less obtrusive, the paint is nevertheless expressively worked, and on looking closely at the picture it can be problematic to distinguish what it is supposed to indicate. The posts and boards in the left-centre foreground recall (along with the Gainsbrughian mallows) the typical foreground litter of the canal scenes: in this respect *The Cornfield* is less decisive a break with them than appears.

Constable needed and hoped to sell this picture, 'as it has certainly got a little more eye-salve than I usually condescend to give to them'. All we can guess about 'eye-salve' is that it was necessary because of his

147 *Cottages at East Bergholt*, 1827

financial state after the break with Arrowsmith, making *The Cornfield* appear to be an attempt to salvage what had actually been rather successful. It denies the validity of the old georgic idea of East Anglia through presenting it as a place where fine crops result from neglect. This was rather more confusing than the fairly humorous application of a tag from *The Seasons* in the 1827 British Institution catalogue: 'A fresher gale/ Begins to wave the woods and stir the stream,/ *Sweeping with shadowy gust the fields of corn*' (Constable's italics). He was offering clues to this picture's being concerned with breezes. While he might simply have required a 'windy' passage, those lines were extracted from a section descriptive of evening, while *The Cornfield* was exhibited as *Landscape, Noon*. Constable was subsequently as sophisticated in taking tags from *The Seasons* as he had been with *The Farmer's Boy*, so the inappropriateness here may be deliberate, in matching a painting which exposes the limitations of the formalist criticism preferred by the connoisseurs by making ridiculous an imagery they should have found more sympathetic than that of recent canal scenes.

With some exceptions, Constable persisted with a picturesque

157

148 *A View on the Stour at Flatford*, 5 October 1827

landscape into which for various reasons a retrospective element now appears to be introduced. At the same time there was a marked falling-off in oil sketching: work was now more often in pencil or ink, sometimes with watercolour washes being added. It includes the fruits of the first long holiday he had taken in 'Constable Country' since 1817, a visit with his two eldest children to Flatford in October 1827. The drawings which he made then often manifest startling fluctuations of control and finishing. A *View on the Stour at Flatford*, concerned to some extent with effects of light and shade in a landscape closely related to A *View on the Stour near Dedham*, is extremely confusing in detail. The pencil work indicates a concern with the material world sharply different from that in even so summary a rendering of this same scene as the pencil sketch of 1814. Other, practically inept or violently expressionistic, drawings contrast markedly with more controlled ones. They tackle much of the imagery of the major paintings of the earlier 1820s, but have rejected any objective concern with representation. *The Cornfield* had intimated that such a perception was no longer possible for an artist who lived by shadows and found them realities. Landscape had secondarily

become a matter of recording alien motifs, like the sea at Brighton, but principally of creating through a process of intuition, and manufacturing from invention, an historical landscape which the public failed to recognize as such: the pretensions of the Picturesque of *A Boat Passing a Lock* or *The Leaping Horse* had gone unacknowledged. This comparative failure may account for the change in Constable's procedures after 1825. His professional status was peculiar – in the Royal Academy elections for 1826 his support was derisory. That Constable's exhibited pictures began to make more obvious connections with other landscapes, and to appear less ostentatiously individualistic, may have been a response to these circumstances.

At the same time, Constable's art might have changed because his perception of England was again under threat. A period of stability had created the environment in which he had felt competent to paint the 'picturesque England' of the later canal scenes. The 1822 Corn Law had seemed to secure the prosperity of the farming interest, but it would come under attack in 1826, as the Government, contemplating unemployment and attendant social disruption in the face of a depression in manufacturing industry, undermined it by releasing bonded corn and allowing some importation. The Corn Law of 1828 eroded still further the absolute protection the farming interest had enjoyed. Abram Constable was, in 1829, a moving spirit behind raising a subscription for a piece of plate for the Suffolk agriculturist Samuel Quilter, who, in his speech of thanks, justified his unceasing support for the Corn Laws as 'protecting agriculture' and thus 'upholding my country'. The Constable business endured financial difficulties at this period, and the family would have seen in the attack on the farming interest an attack on their own property.

But, more crucially, there was also the issue of Catholic Emancipation, which grew to crisis proportions in 1825. Emancipation arrived, preceded by the Repeal of the Test and Corporation Acts, in 1829. Constable was sending Fisher anti-Catholic squibs by 1824, and as committed Ultras, both men comprehended the extent and nature of the threat Emancipation presented. In 1828 Abram Constable would write that 'these Papists are a shocking set, & would set the world on fire, as well as burn the people if they could', and J.C.D. Clark had written of 'George IV's breach of his coronation oath in agreeing to Repeal and Emancipation in 1828–9' as an 'instance of betrayal'. It effectively rent asunder the union of Church and Constitution.

149 *Netley Abbey, the West End*, 1833

150 A. Waterloo (1608/9–1690), *A Water-Mill*

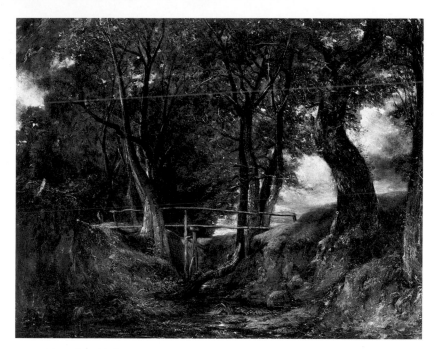

151 *Helmingham Dell*, 1825–6

152 *Gillingham Mill*, 1825

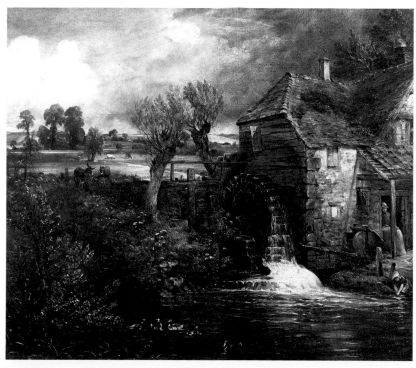

Constable understood attempts at political change as revolutionary and inspired by Satanic agency, and would have perceived the events of the later 1820s as irrevocably destructive. From this period, much of what he did commemorates the world of the earlier painting.

149 A rare attempt at etching, a plate showing Netley Abbey, was based on a honeymoon drawing of 1816. After he saw a painting of Helmingham Dell in 1823, Constable's patron James Pulham of Woodbridge wrote that he 'must have' such a painting. Constable
151 completed it in 1826, and painted further on it in the earlier 1830s.
17 Based on a drawing of 1800, it records the scene as it was. A later repetition is rather darker, and adds deer and cattle. The significance of this retrospective Picturesque can be elucidated through an analysis of other landscapes of the later 1820s.

 Constable depicted *Gillingham Mill* on various occasions. In 1822 he had made an oil sketch there and John Fisher commissioned a picture, which was delivered in 1824. A further painting, also destined for Salisbury, introduced Mere Church in the distance. The site shown held deep personal associations for Constable: this was a 'wonderfully old and romantic' mill on a river, and such places he loved. In 1823 it had become 'that famous mill'. In September 1825, shortly before this
152 painting was begun, Fisher wrote that the mill was 'burnt to the ground, and exists only on your canvas. A huge misshapen, new, bright, brick, modern, improved, patent monster is starting up in its stead.' Constable was 'vexed at the fate of the poor old mill. There will soon be an end to the picturesque in the kingdom.'

 For Constable 'improvement' clearly represented the same kind of threat to the established order as it did for Jane Austen, and the Picturesque stood for the Britain which was being socially and politically transformed at this period. Uvedale Price had frequently mentioned 'with regret' the 'destruction of so many picturesque circumstances by the prevailing passion for levelling', for, 'to level, in a very usual sense of the word, means to take away all distinctions; a principle that, when made general, and brought into action by any determined improver either of grounds or governments, occasions many mischiefs, as time slowly, if ever, repairs.'

 In *Gillingham Mill* 'picturesque' described the mallows, the donkeys, the woodwork, and the mill itself, as well as the colour and handling. The composition, while based on a sketch from nature,
150 recalls that of an engraving by Waterloo, and was of a kind which had

162

153 *The Glebe Farm*, 1827?

been popular with other artists, notably Callcott and Turner. *Gillingham Mill* was, in part, a souvenir of a vanishing world.

In 1827 Constable showed another view of the Mill together with *The Chain Pier, Brighton* at the Royal Academy, and sent a version of *The Glebe Farm* (painted by September 1826) to the British Institution. 153 This refers deliberately to the many precedents for wooded lanes and buildings grouped with churches on hills in Gainsborough's landscapes (as a second version of c.1830 includes a girl with pitcher to 155 recall Gainsborough's *Cottage Girl with Dog and Pitcher*), and was based on an oil sketch of c.1810, with Langham Church, in reality invisible, added to it. But it was, as Constable wrote, important:

My last landscape [is] a cottage scene – with the Church of Langham – the poor bishops first living . . . It is one of my best – very rich in color – & fresh and bright – and I have 'pacified it' – so that it gains much by that in tone and solemnity.

163

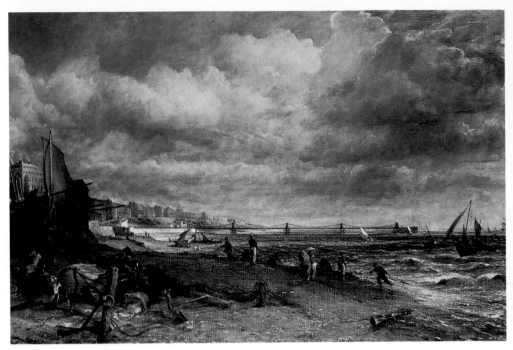

154 *The Chain Pier, Brighton,* 1827

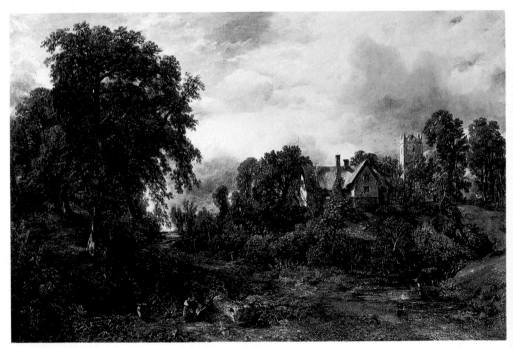

155 *The Glebe Farm, c.* 1830

156 *The Glebe Farm, c.* 1830, detail▶

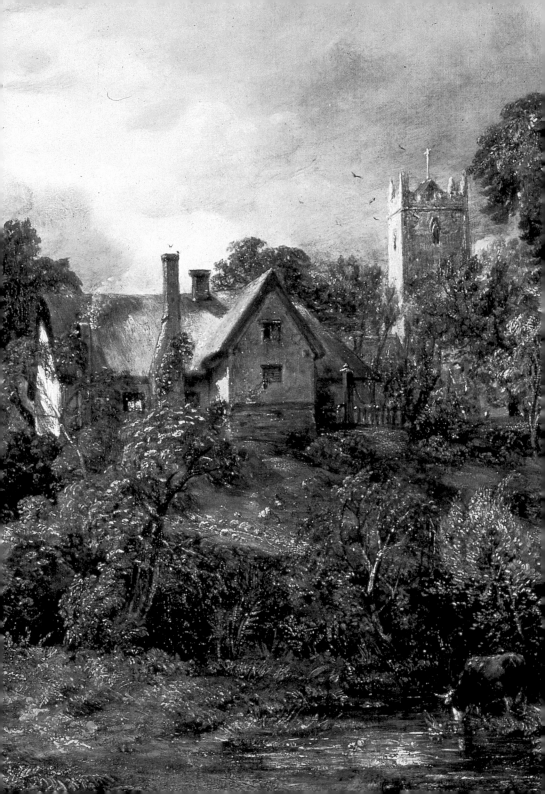

153 The picture was to commemorate Constable's early mentor and eventual patron Bishop Fisher, who had died in 1825. Constable tended to entitle his pictures 'Landscape' or 'Landscape, Noon', but this one was exhibited as *The Glebe Farm* (although the farm was not on glebe land). The pictorial relationship of the church and farm symbolized their actual role in rural government, and this landscape not only remembers Bishop Fisher, but also the values of the world in which he had moved.

154 As we shall see, *The Chain Pier, Brighton* was more concerned with modern coastal landscape. The composition was developed out of
126 *Yarmouth Jetty*, but with a far stronger emphasis on weather. Some vessels are, colouristically, almost lost in the ocean; only the figures marked with patches of red are independent of their background. Fisher's remark that 'Turner, Calcott and Collins will not like it' confirms Constable's rivalry. Constable may have meant to be ironical, as he had with *The Cornfield*. It was a 'stock' subject writ large. It demonstrated both his abilities in another genre of landscape and the fruits of his study around Brighton, by balancing the genre subject with a coastal landscape presented as ground, air and water in various stages of condensation, and where topography carried no burden.

In 1828 he would return to the Picturesque, probably because he preferred it, but perhaps, too, because of the failure of *The Chain Pier*
157-8 to sell. *Dedham Vale*, exhibited in the Royal Academy, retreated from its naturalism. Constable, who usually thought his most recent landscape his 'best', was consistent here, and might have conceived the idea for it on his visit to East Anglia in 1827. In the event, *Dedham Vale*
24 was based on one of the 1802 studies evolved in those first attempts at a
2 'natural painture', and, like it, refers to Claude's *Hagar*. Sir George Beaumont had donated this painting to the National Gallery in 1826 and died in February 1827, so *Dedham Vale* may be another picturesque memorial, albeit a two-edged one, for it relates compositionally to Turner's *Crossing the Brook*, which Beaumont had anathematized in 1815. During early 1828, when this picture must have been in progress, Constable was enduring a traumatic period of canvassing for election to Royal Academician. It was ammunition in this battle, for it referred both to a well-known old master and to an equally well-known modern one, to indicate its formal genealogy straightforwardly enough.

Constable's handling had advanced both in scope and control. It contrasts with the ambivalent detailing in *The Cornfield* by being far more venturesome, with a variegated paint-surface of small lumps, thin trails and ridges, colouristically checked through the pervasive use of ochre and white, with again that tension between the resolution of paint into imagery, and its apprehension for its own material character. The woman and child sitting by a cauldron (perhaps borrowed from one of Gainsborough's gypsy scenes) with their rude shelter claim an exalted lineage in their reference either to the Nativity or to the Rest on the Flight to Egypt, to suggest that at least God's handiwork remains visible in landscape, despite the despoilations of man.

Farington had characterized the 'country about Dedham' as presenting 'a rich English Landscape, the distance towards Harwich particularly beautiful' and it was this combination Constable painted. Rather than look inwards as *The Glebe Farm* does, this view looks outward from Langham over a country which now supports only a few cattle, and a woman and child condemned to vagrancy. The Picturesque was still retrospective, but now on the grander scale, through its obvious connections with the 'historical' landscapes of Claude and Turner. Yet, to understand the intricacies of this picture, we need to know a great deal about Constable himself, with his private view given the pretensions of a grave public statement. *Dedham Vale* inspired Constable's election to Royal Academician, and Lawrence's surprise that a painter of 'the humblest class of landscape' should have been thus honoured may have been due to the lack of explicitness in this, and his other paintings. Constable may have shared with Wordsworth a conviction that his perceptions were of moment, but whereas language could articulate the poet's concerns unambiguously, painting depended on an apprehension of imagery which (as we shall see) contemporary art-criticism shows had scarcely any consistency.

142

157

153

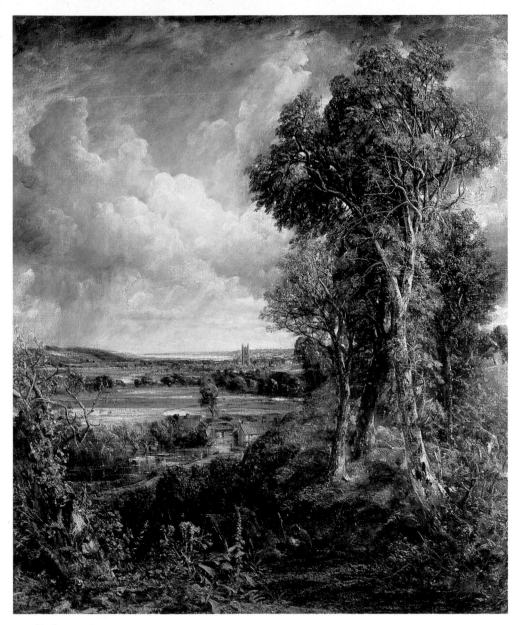

158 *Dedham Vale*, 1828

◄ 157 *Dedham Vale*, 1828, detail

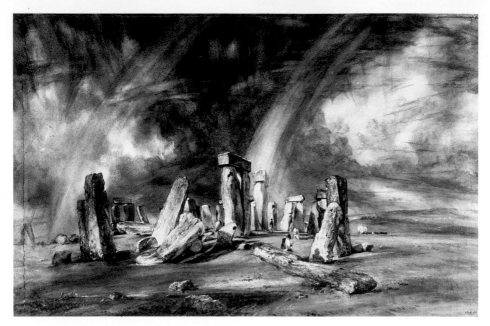

159 *Stonehenge*, 1836

161 *Jacques and the Wounded Stag*, c. 1835

160 *Poppies*, July 1832

Late Constable

After *Dedham Vale* Constable's work showed marked variety. Maria Constable, exhausted with pregnancy and tuberculosis, died in late November 1828, and this, as we saw, devastated her husband. And if his landscapes comprised a history of her husband's affections, his own places henceforward became distanced, and lonelier. A 'natural painture' had had to fluctuate, most dramatically between the descriptive and the evocative, before and after 1822, because what it was possible to perceive as 'nature' was extremely unstable, and as we shall see, Maria's death affected this perception.

Constable's later work is difficult to categorize. He made slavish copies after Greuze and dramatic watercolours of Stonehenge. There are variants of *Jaques and the Wounded Stag* for a book–illustration (Constable exhibited a painting of the subject derived from a composition by Sir George Beaumont in 1832), and careful oil studies of poppies. Constable seemed to favour pencil, ink, or watercolour, and often found landscape-subjects in places where he went to see people. He visited a new friend, the brewer George Constable of Arundel, in 1834 and 1835, taking in Petworth, where Leslie also was in 1834. In 1833 he sent his two eldest sons to school in Folkestone, where he drew close and distant views of the harbour, here developing the old technique of establishing lines and masses with pencil before colouring in watercolour. The deep blues below the cliff and varied brightness of the sky recreate the patchy illumination of the sun through cloud, which the flags show to be shifting with a stiff breeze. If some Sussex drawings seem, in their discipline and concern with representation, like far earlier work, in others the pencil moved almost randomly. Among the various studies made at Cowdray House in 1834, this exterior with its historical note establishes the chiaroscuro in graphite and colours in broad washes, in a schematic rendering where masonry is distinguished against the blue sky by a rose wash veering to brown, and some black boosting the pencilled shadow. Sunlit ground appears yellow.

8, 159
161
160
163
166

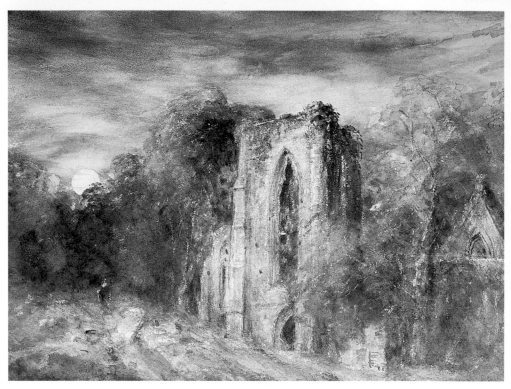

162 *Netley Abbey by Moonlight, c.* 1833

163 *Folkestone, the Harbour,* 1833

164 *Design for Gray's 'Elegy', Stanza V*, 1833

165 (below) *Landscape with Trees and Cattle*, 1832?

Constable had developed into a virtuoso watercolourist. *Netley Abbey by Moonlight* brilliantly fixes its effect, working the Abbey and 162
its surrounds in deep blue blots, achieving definition through highlighting. Leslie Parris noted its basis in a honeymoon drawing of 1816, which he suggests has been metamorphosed into an image relating to illustrations to Gray's *Elegy*, to become 'an image of melancholy'. It also links into a web of imagery deployed by Constable over a long period of time: Gray was first acknowledged in 1806; Constable was illustrating the *Elegy* in 1833. The watercolour 164
drawing of blots and patches with some very pure vermilions and 165

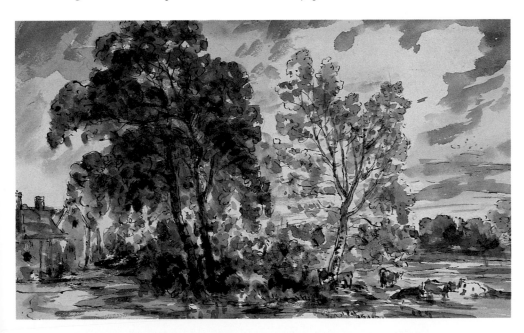

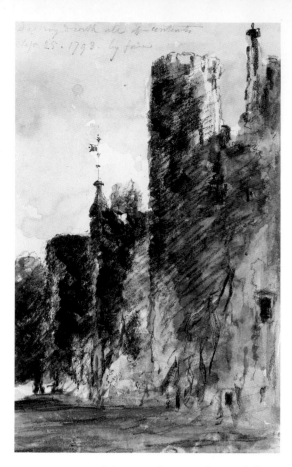

166 *Cowdray House*, 1834.
Inscribed 'Destroyed with
all of its contents Sepr 25'

white superimposed on a delicate ink underdrawing relates to a study
of Willy Lott's farm of 1802, and to variants of the theme of the 1830s.
Both a highly finished watercolour version of *A Farmhouse near the*
Water's Edge and the *Stoke-by-Nayland* with which it was probably
exhibited at the 1832 Royal Academy connect with reworkings of old
themes, and elaborate these watercolour techniques.

There was a retrospective character, too, in much of the work
which was exhibited (and certainly in David Lucas's series of
mezzotints of Constable's paintings, to be published as *English*
Landscape, which was begun in 1829). Even though the *Salisbury*
Cathedral from the Meadows exhibited in 1831 evolved from study of
1829, it looked back, as we shall see, to earlier Salisbury paintings. The
Helmingham Dell in the 1830 Royal Academy was the earlier painting,

167
168

173, 175

183

151

174

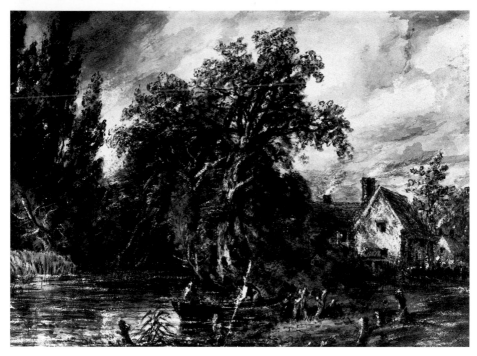

167 *A Farmhouse near the Water's Edge, c.* 1832

168 *Stoke-by-Nayland,* 1832?

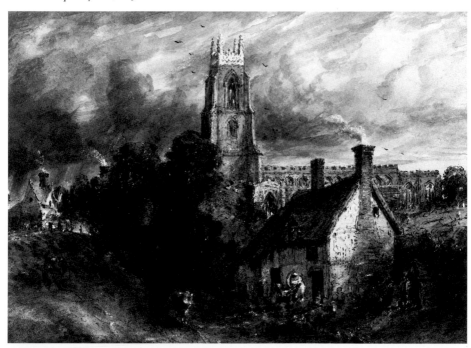

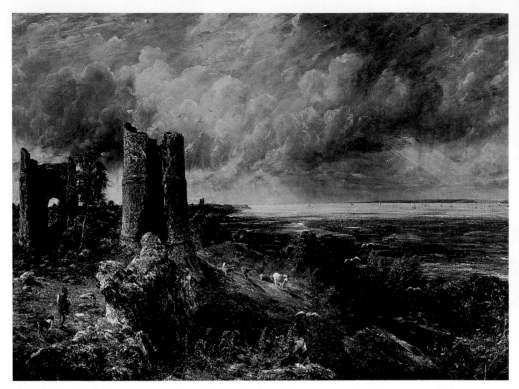

169 *Hadleigh Castle. The Mouth of the Thames – morning after a stormy night*, 1829

171　　back in Constable's hands, and *Waterloo Bridge* had been meant for
　　　exhibition well before 1832. Constable exhibited an unfinished
75　　picture of *c.* 1815, but now 'licked up . . . into a pretty look', in the 1833
　　　Royal Academy together with *Englefield House. Dedham Vale*
　　　reappeared in the British Institution in 1834, when Royal Academy
172　　exhibits were *Old Sarum*, a recent study of trees at Hampstead, and
189　　two equally recent illustrations to Gray. *The Valley Farm*, a single
55　　exhibit of 1835, is based on oil sketches and drawings of *c.* 1812.
169　　　　*Hadleigh Castle. The Mouth of the Thames – morning after a stormy*
64　　*night* is based on a drawing of 1814 and was exhibited in 1829. In 1832
　　　Constable would change the mezzotint of *The Glebe Farm* into a ruin
173, 186　scene called *Castle Acre Priory* to avail himself of an opportunity to
　　　include in *English Landscape* 'a symbol of myself, and of the "Work"
　　　which I have projected'. *Hadleigh Castle* probably anticipated this

176

projection of mental state on to architectural collapse, as Constable mourned Maria. In 1814 the sea-shore had had a 'melancholy grandeur', and on sending a proof of the mezzotint of *Weymouth Bay* to Mrs Leslie in 1830 Constable wrote that:

I shall now to give value to the fragment I send you, apply to it the lines of Wordsworth
 . . . 'That sea in anger
 'and that dismal shoar'.

I think of 'Wordsworth' for on that spot, perished his brother in the wreck of the Abergavenny.

He was quoting from *Elegiac Stanzas suggested by a Picture of Peele Castle in a Storm, painted by Sir George Beaumont,* in which the glowering skies and violent seas of Beaumont's picture (exhibited in the 1806 Royal Academy) recall the shipwreck and drowning of Wordsworth's brother. Constable was mourning a wife. The ruin (if already a 'symbol of myself') and lonely shepherd (which would lend poignancy to the present condition of Old Sarum in paintings and

170 Sketch for *Hadleigh Castle, c.* 1828–9

mezzotint) remind us of the impermanency of all human endeavour.

169 It is tempting to see the violence of the handling of *Hadleigh Castle* as motivated by grief (although it was noticeably clarified from the large
170 study in the Tate Gallery). The shepherd with the dog from *The*
142 *Cornfield* and a character with three cows emphasize the bleakness of their surroundings. The picture had a moderately favourable reception, the *London Magazine* objecting to 'that accursed bespattering with *blanc d'argent* – or whitewash-splashing as Mr. Turner will have it', but still considering it 'excellent', and finding that Constable, 'as he goes on, somehow or other ... contrives to improve; his effects are more vigorous and masterly than ever'.

Although there is a beguiling autobiographical content to the painting, this should not be stressed to overwhelm it. Louis Hawes placed *Hadleigh Castle* within a tradition of painting ruined castles (Hadleigh was associated with Edward III) formulated by Richard Wilson and developed by Turner, which exhibited them as the origins of those processes which created the present. It celebrated the virtues of those who had formed the nation as it now was, while the ruins themselves were a warning to maintain that stoic moral integrity necessary to conserve the political and cultural heritage. Constable turned this ethos (of which, as the letterpress to the mezzotints of *Old Sarum* and *Stoke-by-Neyland* demonstrated, he was well aware) to a new end.

171 *The Opening of Waterloo Bridge.* Exhibited 1832

172 *Old Sarum*, 1834

Turner's *Dunstanburgh Castle* (the inspiration for Beaumont's *Peele Castle*) had been shown in 1798 with a passage from Thomson's *Summer* which Constable abbreviated and misquoted in 1829 (turning a 'blue' into a 'dim' horizon):

> The desert joys
> Wildly, through all his melancholy bounds
> Rude ruins glitter; and the briny deep,
> Seen from some pointed promontory's top,
> Far to the dim horizon's utmost verge
> Restless, reflects a floating gleam.

This came from a hymn to the sun and its light, which was what made the desert joy wildly, for 'The very dead creation, from thy touch/ Assumes a mimic life.' Light invested even the lifeless with fake vitality: without this there would be nothing. In *Hadleigh Castle* Constable reduced the principles of illusion to chiaroscuro. He also declined one possible presentation of his subject, for this was the River Thames, that great artery by which Britannia communicated with and exercised government over its Empire. In 1808, with *Purfleet and the Essex Shore, The Confluence of the Thames and the Medway*, and

Sheerness as seen from the Nore, Turner had painted this same estuary as the theatre in which the economic and military relation between Britain and the ocean was acted out. Constable's shipping is almost irrelevant, material of the 'dead creation' given 'mimic life' through sunlight. *Hadleigh Castle* demands our awareness of the ethos of ruin-painting, and, on contemplating what lessons the past has for the present, we realize that, disastrously, there has been a radical break in that continuum.

Constable's nature was now to be expressed essentially in terms of chiaroscuro, a concern which was to be developed particularly in the mezzotints – Lucas began a large plate based mainly on the Tate *Hadleigh* in 1829. In the Introduction to *English Landscape* Constable wrote that his intention had been 'to arrest the more abrupt and transient appearances of the CHIAR'OSCURO IN NATURE', and '"to give to one brief moment caught from fleeting time", a lasting and sober existence'. Chiaroscuro, subject of Academic lectures by Barry, Fuseli and Opie, was 'one of the most efficient principles' of 'the Art', and, in 1835, Constable defined it as 'a power capable in itself, alone, of imparting Expression, Taste, and Sentiment'. It contained all nature, and the task of the painter was to hold it.

From 1833 the lectures Constable gave at Hampstead and elsewhere were used to articulate his most recent theories on landscape. He suggested that landscape was capable of conveying emotions comparable to those inspired by history painting, and could therefore become its equal: he wrote of 'the Art', to minimize distinctions between genres. *St Peter Martyr* was a 'powerful combination of Landscape & History enhancing each other', and Fuseli was cited to suggest that Titian '"considered the *Elements* = the *Trees* – the *Sky*" = but as the instruments of Pathos'. This ideal sympathy between landscape and history (as in *The Cenotaph*) could lead to an equality. But because the actual elements of landscape were unchanging, paintings based on them were preserved from alteration of their content by changing historical circumstances. A landscapist could produce works unencumbered by the particularities of time and place.

Very few appeared to share Constable's insight. After a visit from the connoisseur and collector W.F. Wells, also in 1833, Constable was exasperated –

Good God – what a sad thing it is that this lovely art – is so wrested to its own destruction – only used to blind our eyes and senses from seeing the sun shine,

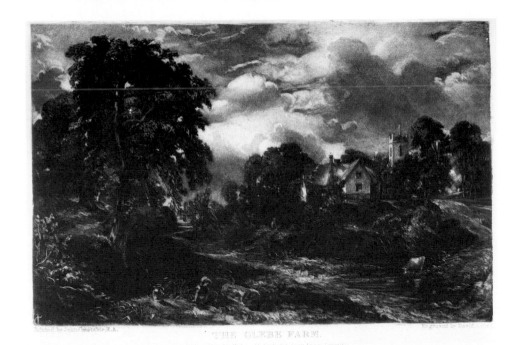

173 *The Glebe Farm*, 1832. Mezzotint by David Lucas after Constable

the feilds bloom, the trees blossom, & to hear the foliage rustle – and old black rubbed-out dirty bits of canvas to take the place of God's own works.

With encouragement from Leslie, to whom he had written this, Constable retrieved some hope:

... your regard for me has at least awakened me to beleive in the possibility that I may yet make some impression with my 'light' – my 'dews' – my 'breezes' – my *bloom* and my *freshness* – no one of which has been perfected on the canvas of any painter in the world.

These were the essences of all landscape. When Ruskin belittled Constable as perceiving 'in a landscape that the grass is wet, the meadows flat, and the boughs shady; that is to say, about as much as, I suppose, might in general be apprehended, between them, by an intelligent fawn and a skylark', the artist might well have taken this as a compliment.

Constable's position can seem peripheral if his late paintings are compared with other British art of the 1830s. Turner went his own

way: 'nothing can touch him, he is in the clouds', wrote Constable in 1832. Artists he himself influenced – Lee, Creswick or Watts – took over only his greenness and humble subjects. His own paintings were less felicitously handled and brilliantly coloured than those of Mulready, Landseer, Etty or Leslie, and this isolation would exacerbate the incomprehension of the true nature of his landscape, as Constable imagined it to be. The lectures, partly meant to rehabilitate his art in tradition, were a crucial enterprise. So were the mezzotints.

Constable came to assume exclusive claims on the engraver Lucas. Their correspondence exposes the wild fluctuations in the painter's mood (in phases of despair he would subject Lucas to intolerable abuse), and his sense of the prints being his creation but achieved through the agency of the mezzotinter. They supply an overview of Constable's art different from that provided by the plates in this book, illustrating the range of his terrain and the variety of his interests, from a vignette of a corner of Hampstead Heath to a plate after *A View on the Stour near Dedham*. The Picturesque of the mid-1820s was represented by *Helmingham Dell* or *The Glebe Farm*; and the only noticeable omissions were mezzotints after the later canal scenes, or pictures like *Flatford Mill*. The prints equalized very different works by standardizing medium and scale, and Constable's personal retrospect imposes a unity on his *œuvre*, transmitting a sense of homogeneity which had become bedded into Constable's attitudes.

Subject had ceased to matter. *Englefield House* was 'a picture of a summer morning, *including a house*', to contradict the imagery of a comparable early work like *Wivenhoe Park*, and annoy the patron. When in 1835 Constable embarked on the extraordinary *Stoke-by-Nayland* (Art Institute, Chicago), he conceived it as 'summer morning? July or August, at eight or nine o'clock'. Lucas based the print of the subject on Suffolk oil sketches, with the fine sepia drawing which introduced the important rainbow arching over the church, a transitional stage to monochrome. That later watercolour seems equally to be a working-out of the subject towards its eventual manifestation in oil.

In the letterpress to the print Constable not only laid out his impressive knowledge of Newtonian optics, as they pertained to rainbows, but, by quoting from Thomson's *Summer*: 'Through the lighten'd air/ A higher lustre and a clearer calm/ Diffusive tremble', and calling the bow a 'mild arch of promise', confirmed its role as the

portent of the end of storms. He wrote how, to see the wool churches of East Anglia, could not 'fail to impress the mind of the stranger with the mingled emotions of melancholy and admiration . . . The venerable grandeur of these religious edifices, with the charm that the mellowing hand of time hath cast over them, gives them an aspect of extreme solemnity and pathos; they stand lasting and impressive monuments of the power and munificence of our Ecclesiastical Government.' This mezzotint (distant in intention from the later 175 painting, which was a field for transmitting the universal effects of colour and chiaroscuro) served, in 1830, to demonstrate the physics of meteorology in an antiquarian illustration. But Constable was less guileless than he sounded, for by 1830 the old Ecclesiastical Government had been destroyed, and it is those who see the prints who should experience those 'mingled emotions', and for the loss of what Stoke

174 *Stoke-by-Nayland, c.* 1829

175 *Stoke-by-Nayland*, 1830, mezzotint by David Lucas after Constable

STOKE BY NAYLAND, SUFFOLK.

176 *Salisbury Plain from Old Sarum*, 18 July 1829

Opposite:
177 *Old Sarum*, 1829?

178 *Watermeadows near Salisbury*, 1829

Church represented; the rainbow impressing that it was through Established religion that salvation was to be gained.

183 The most important project of Constable's later years, *Salisbury Cathedral from the Meadows*, also juxtaposed a rainbow with a church. Constable, wrote Leslie, felt that this painting 'would probably in future be considered his greatest; for if among his smaller works there were many of more perfection of finish, this he considered as conveying the fullest impression of the compass of his art'. It was unusual now, in originating from recent prolific study, at Salisbury on a holiday of July 1829, when Constable pictured various motifs in various techniques. A view out over Fisher's garden manifests a

176 controlled handling of paint, while a vista of Salisbury Plain from Old Sarum deployed that nervous expressive calligraphy which we noticed in work of 1835; a view towards Old Sarum, with shepherd, dog and flock in the foreground, is far more controlled. Since *Hadleigh Castle* had been Constable's previous Royal Academy exhibit, the Hanging Committee can be forgiven for failing to recognize his

178 authorship of *Watermeadows near Salisbury*, which they rejected as 'a nasty green thing' in 1830.

 Salisbury Cathedral from the Meadows was projected during the holiday with John Fisher who was decidedly enthusiastic about it in early August 1829. 'I am quite sure', he wrote, 'the 'Church under a cloud'' is the best subject you can take. It will be an amazing advantage to go every day & look afresh at your material drawn from nature herself.' However, the painting took until 1831 to finish, and even then Constable worked further on it in 1834 and 1835.

184

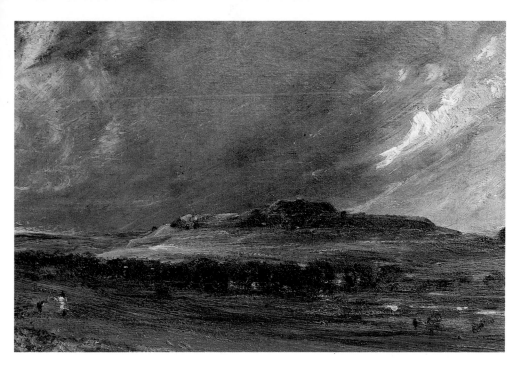

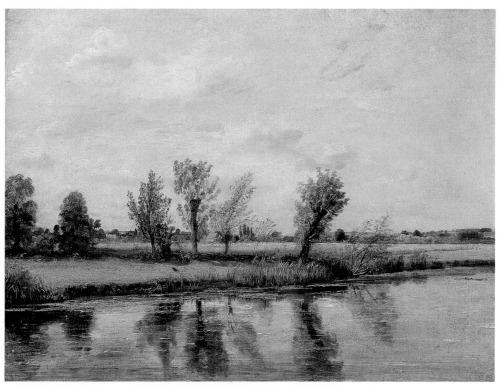

179 *Salisbury Cathedral from the Meadows,* 23 November 1829

180 *Sketch of Salisbury Cathedral from the Meadows,* 1829–30

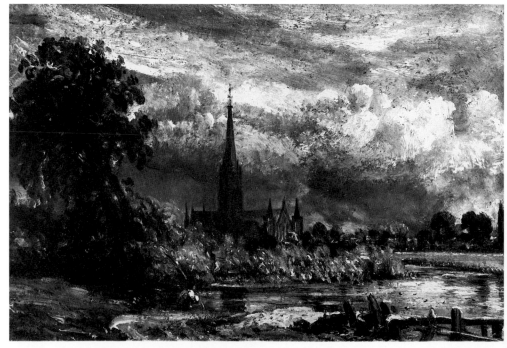

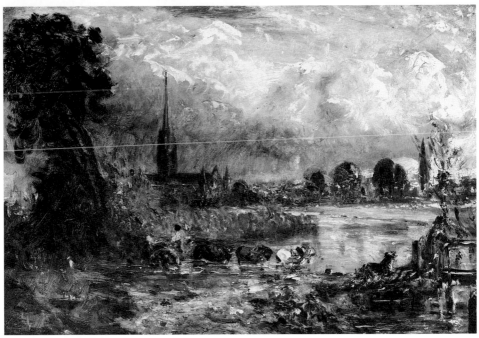

181 Study for *Salisbury Cathedral from the Meadows*, 1830–1

182 Study for *Salisbury Cathedral from the Meadows*, 1830 1

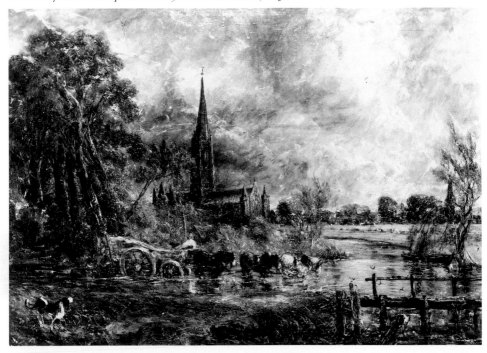

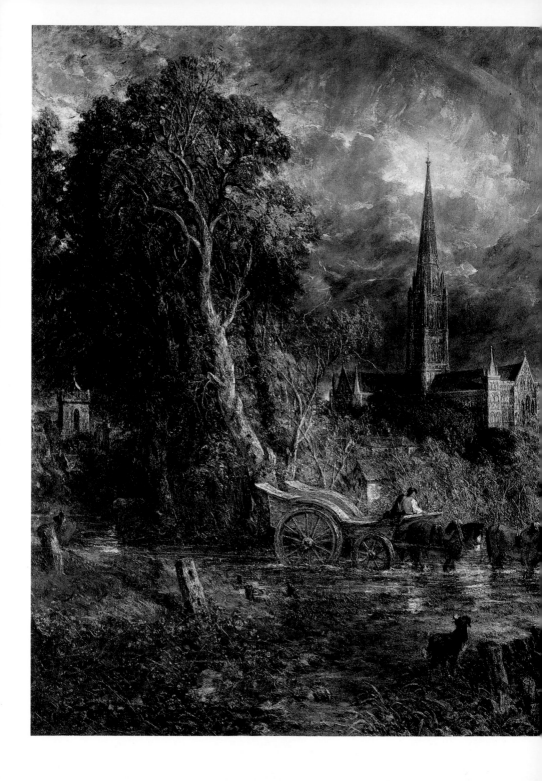

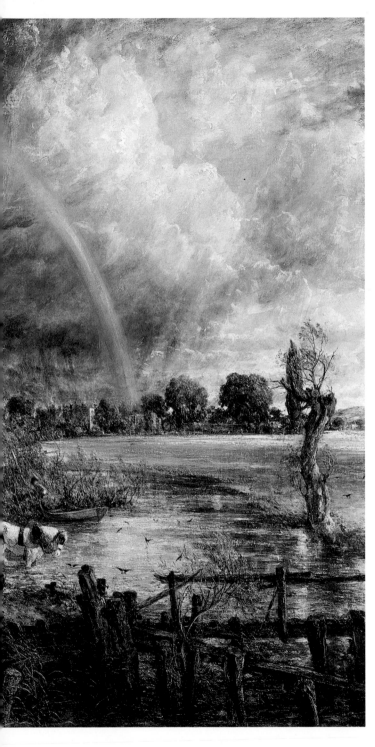

183 *Salisbury Cathedral from the Meadows*. Exhibited 1831

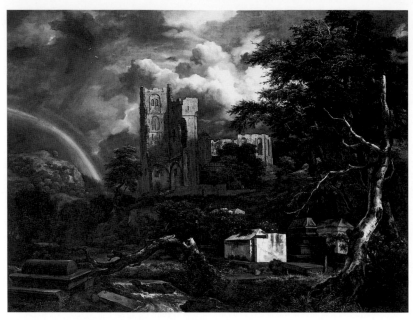

184 J. van Ruisdael, *The Cemetery*, 1655–60

Lucas made two mezzotints, one from an oil sketch (with a double rainbow added), one, unfinished at Constable's death, from the
179 painting. Drawings of 1829 had studied the cathedral from various points. (Ian Fleming-Williams spotted that one introduces the rainbow to the right of the church, and this relationship is very similar
184 to Ruisdael's ruins and rainbow in *The Cemetery*.) Constable may have made oil sketches in combination with drawings, on the spot, before December 1830. A later oil study removes the fisherman but adapts
181 the cart and horses from another drawing, and introduces a figure with dog which echoes a sketch of Fisher and his dogs, perhaps to introduce his friend less symbolically (than as the 'fisher') into the
125 composition, as Bishop and Mrs Fisher appeared in *Salisbury Cathedral from the Bishop's Grounds*. This synthesis evolved in the full-scale study, with the cloud now stormy rather than heralding the passage of a
182 front, Fisher removed, and his dog shifted to the left. The West Front of the Cathedral retains, as John Gage observed, the architecturally inexact form of the earlier study, but the colour has become subdued and its range less wide. A boat has been introduced to the right.

190

This painting is very uneven in quality, particularly in drawing. Nevertheless, the sky conforms with those of other large-scale studies, and the handling with that in Constable's private work of this period. Constable's later work on the exhibited canvas means that we do not see what greeted the gaze of exhibition visitors in 1831, when the excessive use of white came in for some censure. The *New Monthly Magazine* thought the clouds too purple, which fits with their being painted with madders and blues. Constable's guess that they would become less garish with time is evidently correct. Even with this colouration subdued, the painting has some startling effects, particularly in terms of standards of scale. We must understand the buildings in that vermicular undergrowth as houses, which makes the wagon, drover and horses, man in boat, and cathedral, proportionately gigantic, and further destablizes the illusionism of the painting. 183

Moreover, Constable has inserted Stour Valley motifs in what appears to be a topographically descriptive Salisbury landscape. The grouping of woman, wagon, dog (the collie from *The Cornfield*), man in punt, and the plan of the river, derive from *The Hay Wain*. The bridge and spars recall the later canal scenes, and from *The Leaping Horse* came the polled willow and giant elm (the latter having originated in *Flatford Mill*). As we saw, framing a church with a rainbow was tried out in the mezzotint of *Stoke-by-Nayland*. 142 109 136 77 175

Constable knew the physics of rainbows, and Paul Schweizer has shown the Salisbury bow to be optically impossible and therefore deliberately inserted. While its ending at Fisher's house, Leydenhall, may refer to the 'unalloyed' quality of their friendship, it also contributes to Constable's iconography. It arches over Constable's old symbol for the Church itself, in front of which are images from both the georgic and picturesque variants of the Stour Valley imagery. 'The Church under a cloud' contained an element of political allegory, for the danger to the Church avoided in 1823 had now come to pass with the repeal of the Test and Corporation Acts and the Emancipation of Catholics. The Reform Bill of 1831 was understood by some to climax this destruction by putting its administration with Dissenters (a threat made more ominous by the July Revolution of 1830 in France, and the 'Swing' riots, rural unrest which swept through southern Britain in 1830, affecting Wiltshire particularly badly in late November). Constable in October 1831 thought Reform a 'tremendous attack on the constitution of this country' which would

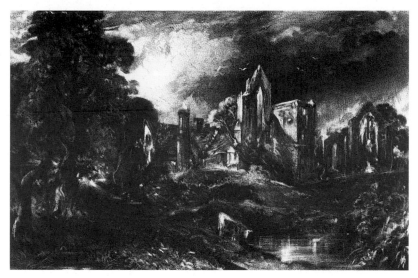

186 *Castle Acre Priory*, 1832. Mezzotint by David Lucas after Constable

only 'give the government into the hands of the rabble and dregs of the people, and the devil's agents on earth, the agitators'. In 1830 Lucas published a mezzotint after the oil study of *Old Sarum*, for Constable a 177 'desolation', observed only by a shepherd with his dog, which Lawrence said he ought to dedicate to the House of Commons. Old Sarum, for which a tiny electorate returned two Members of Parliament, had been perhaps the rottenest of the rotten boroughs.

Salisbury does not simply represent the embattled Church standing guardian over the emblems of that old England, but embodies other references also. We linked *The Cemetery* to an earlier drawing, and it is 184 tantalising to wonder how far this Ruisdael affected Constable's visualization. When the elegaic *Glebe Farm* became *Castle Acre Priory*, 153, 186 the architecture appeared a Gothic variant of Ruisdael's, with an appropriately stormy sky. For Constable in the 1830s weather communicated mood: writing to Leslie while again working on *Salisbury* in 1834, he complained that 'every gleam of sunshine is blighted to me in the art at least. Can it therefore be wondered at that I paint continual storms? . . . still the "darkness" is majestic.' The cathedral and rainbow, by obliquely referring to *The Cemetery*, may place 'old England' in a position equivalent to the tombs.

◀ 185 *A Farmhouse near the Water's Edge*, c. 1834; detail (see Ill. 190)

Later Constable would censure Ruisdael for having painted in *The Cemetery*, which he said, had been called 'An Allegory of the Life of Man', 'ruins to indicate old age, a stream to signify the course of life, and rocks and precipices to shadow forth its dangers. But how are we to discover all this?' Constable's was a rhetorical question. In denying any emblematic potential to landscape he was disclaiming much of his earlier work, and the *Salisbury Cathedral from the Meadows* as it was intended to be seen in 1831; for it changed its meanings, and it is salient that Constable began lecturing only in 1833. In 1831 Constable leavened the political allegory by directing attention to the rainbow in quoting in the Royal Academy catalogue a passage from Thomson's *Summer*, which begins: 'As from the face of heaven . . .' and ends 'nature smiles reviv'd', to show the bow to offer the same hope as it had offered to Noah. There may be a connection with a drawing of a cloud formation like that about the cathedral's spire, under which Constable copied Robert Bloomfield's account of a night sky from 'Winter' in *The Farmer's Boy*, which concluded that the clouds, '. . . to the raptured mind – aloud proclaim/ Their mighty shepherd's everlasting name.' Hope might be discovered in religious contemplation. Yet that passage from Thomson was ambiguous, for it follows the tragedy of Amelia, who, struck by lightning, ends a 'blackened corse' in the arms of her lover, Celadon. As Edward Harwood has suggested, this may refer more immediately to the death of Maria Constable. The content of the picture in 1831 may appear increasingly involved; but in 1833 Constable supplanted 'historical' landscape with landscape which was at one with history painting in 'the Art'.

In January 1832 he wrote: 'My limited and abstracted art is to be found under every hedge, and in every lane, and therefore nobody thinks it worth picking up.' He was keenly aware of both his own isolation and the deceptive simplicity of what he was trying to paint – 'still the trees and clouds all ask me to do something like them – and that is no small reward for a life of labor'. There was little planning in the pictures sent for exhibition. When *Waterloo Bridge* reached the Academy in 1832, the use of the palette knife came in for censure, although some admired it, and Constable probably exhibited the canvas (the earlier rationale for which no longer held) because rheumatism earlier in 1832 had stopped him painting, and this canvas was already finished enough to require a minimum of work. In 1834

171

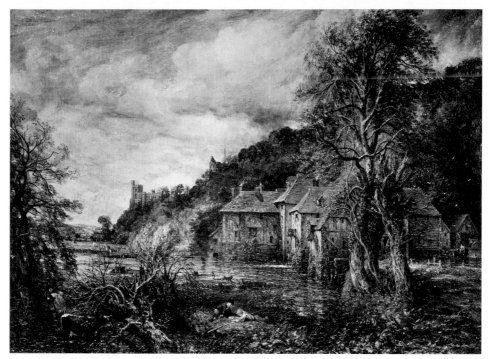

187 *Arundel Mill and Castle.* Exhibited 1837

he had 'difficulty' in finding 'a subject fit for the largest of my sizes', but cared not what that subject was. His attitude towards subjects can appear to have become arbitrary. In 1836 *The Cenotaph*, now a sinister 21 and ambiguous tribute to the Academy and its artistic pedigree, did matter to him. *Stonehenge* was a watercolour of an unexceptionable 159 subject which dovetails into Constable's more private concerns through the inclusion of the rainbow. When, in 1834, he was struck by the beauty of Arundel Castle, he wished it might influence his 187 painting in future, 'for I have too much preferred the picturesque to the beautifull – which I hope will account for the *broken ruggedness of my style*'. The painting of this scene, on which he was working when he died, remains, despite these sentiments, picturesque.

Constable told George Constable of Arundel in December 1833 that he was 'unwilling to part' with a version of *Salisbury Cathedral from the Bishop's Grounds* because it would be too costly, and it was one of his 'standard picture – they being all points with me in my practice,

and will much regulate my future productions, should I do any more large works'. His present art needed his old paintings, as *Salisbury Cathedral from the Meadows* had done. The canvas called *A Cottage at East Bergholt* reworks, in the cottage, cornfield and donkey, the earlier *A Cottage in a Cornfield*, but adds the windmill and rainbow from an 1812 oil sketch (which in turn connects with that late *Hampstead Heath*). The handling is expressionist, with an emphasis on patches and spots of pure colour. The rainbow figured repeatedly in Constable's work, and when, in 1837, he was deeply involved in creating the second *Salisbury* mezzotint, he called the bow 'the *subject* of the picture'. In *Table Talk* Hazlitt wrote: 'Rainbows, showers, partial gleams of sunshine, moon-light, are the means with which Rubens produces his most gorgeous and enchanting effects', and Constable expanded on this in his third lecture:

188
75–6

141

Rubens delighted in phenomena; – rainbows upon a stormy sky – bursts of sunshine – moonlight – meteors – and impetuous torrents mingling their sound with wind and waves.

188 *A Cottage at East Bergholt, c. 1834–5*

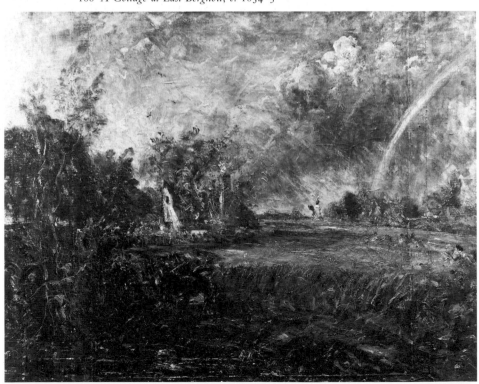

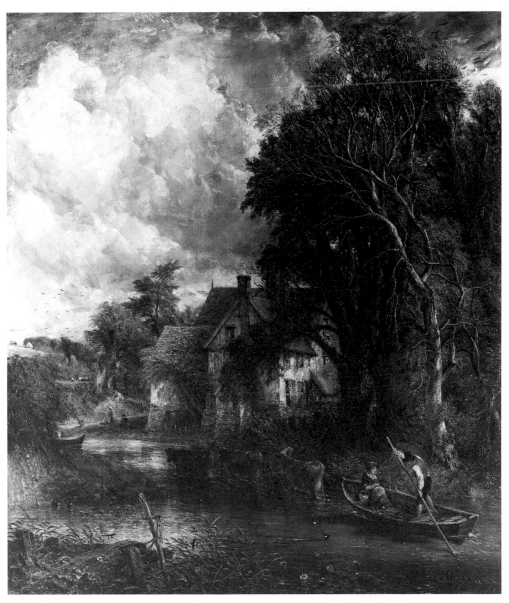

189 *The Valley Farm*, 1835

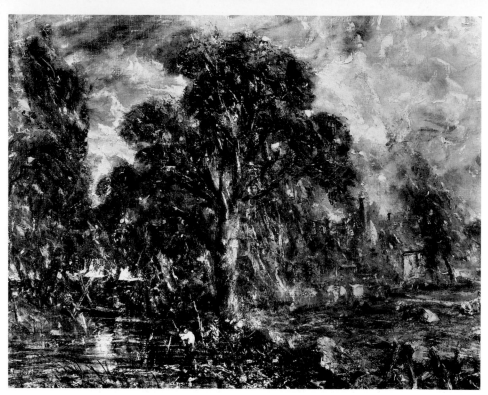

190 *A Farmhouse near the Water's Edge, c.* 1834 (see also Ill. 185)

By the rainbow of Rubens I do not allude to a particular picture, for Rubens often introduced it; I mean, indeed, more than the rainbow itself, I mean dewy light and freshness, the departing shower, with the exhilaration of the returning sun, effects which Rubens, more than any other painter, has perfected on canvas.

These were the same things Constable aimed to communicate himself, sanctioned through the example of an Old Master. The problem remained of how to communicate them.

189 In *The Valley Farm* there had been such spotting with white that comparisons with snow-scenes were made again. (The further deterioration of the pigments has made the painting dark and depressive.) It is significant as a last effort at reconstituting a picturesque Stour valley. This was Willy Lott's farm, the 'old farm', so important in several earlier landscapes, pictured as in 1812. The

foreground spars recall similar lumber in *The White Horse*, where,
too, cattle waded; the ubiquitous ferry came from *The Mill Stream*, of
which this was a different view. *Frazer's Magazine* wrote that the
painting was 'more remarkable for spirit and sparkle than for breadth;
it has brilliancy, but it also has too much glitter . . . and although his
skies are too literally "pure marble air", he at the same time makes us
aware of the fresh and refreshing breeze'. The praise was for the
natural effects suggested, not for what the motif was. *The Valley Farm*
had been realized with a struggle, and again Constable was beaten by
problems of relative scaling of details. Willy Lott's farm, from being
neat and whitewashed, turns into a picturesque pile.

This was Constable attempting to paint for public exhibition. *The
Valley Farm* also connects with watercolour paintings and 165, 167
unexhibitable oils. One (in the Victoria and Albert Museum) included
the boat, but another, illustrated, replaces it with a figure. The
ingredients of the landscape – water, principal trees, and a building –
recur to suggest that we may have another example of improvisation
on a theme, as had happened with the later canal scenes. The brilliant
colouring and expressive handing develop an abstraction of light,
atmosphere and colour which, being ubiquitous, could be realized on
this compositional armature, itself refined out of his own paintings.
(These works might equate with Turner's 'colour beginnings', for
specks of pure colour are still visible beneath later painting on the
unfinished *Arundel Mill and Castle*). 'We exist but in a Landscape,'
said Constable, in a lecture at Hampstead in 1836, 'and we are but
the creatures of a landscape.' The moral character of painting still
concerned him, for he regretted how few there were who seemed 'to
be aware' of 'the beauty of the Paradise in which we are placed', but
the problem now was with finding others who could understand and
share his vision.

Perspectives

We take the history of art as the history of notable practitioners so much for granted that we can forget that, while such a history is valuable, it is not necessarily the case that our judgment of the artists' stature was shared by their contemporaries, or that what they produced was somehow insulated from the more general practice of art. As the forms of Constable's landscapes were directed by his own outlook on the world in a wider sense, so, too, was he but one of many painters who were enjoying varying degrees of commercial or critical success at this period – although, of course, we require a close knowledge of Constable and his work before we can understand how it fits with the more general history of painters and their paintings in early nineteenth-century Britain.

Constable might have been eccentric in some ways – in his choice of landscape sites, for instance – but in others his work fits with what his contemporaries were doing. Enough of his correspondence has been quoted to indicate his awareness and perhaps even jealousy of William Collins in the 1820s, for instance; but we have also seen how his taking up oil sketching from 1808 was a move which tallied with what a number of painters were doing. Even the fact that his paintings of the 1820s are so immediately distinguishable from those of other artists accords with a general lack of homogeneity in British painting notable during this decade: to stress the individuality of your work might have been one way of attracting attention in that vital arena, the public exhibition. There were other ways in which Constable was not isolated. His preoccupation with chiaroscuro, for instance, in translating the polychrome of oil paintings into the monochrome of prints was common to others: Barry had discussed it, Thomas Phillips lectured about it, and Turner was profoundly occupied with the problem. Turner was as concerned as Constable to produce the morally serious art that Reynolds had insisted that British artists should do, and to justify doing this through landscape rather than through history painting.

To do more than mention where Constable's practices were shared by others must be outside the scope of a short monograph, but we can at least acknowledge the existence of such connections. We must also be aware that the account we are able to give of Constable may not tally with the way that contemporaries perceived the man and his work, and that the history of the development of a reputation is also something to be taken into account, for it may help us to understand what we notice from our vantage point. It will have been apparent that Constable's contemporary reputation, for instance, took time to develop, but was well established by the 1820s – so that by 1827 *The Times* was calling him 'unquestionably the first landscape painter of the day', while in 1828 the *Quarterly Review* noticed that 'the English School of Landscape Painting has come to be of the first rank', and listed its luminaries as 'Turner, Constable, Callcott, Thomson, Williams, Copley Fielding, and others whom we might name even with these masters'.

Robert Hunt of *The Examiner* (whom Constable may never have read, for he would have had no truck with the paper's radical politics) was consistent in his enthusiasm for the artist, whom he noticed relatively early in his career. He obviously looked very closely, for instance, at *A Water-Mill* in the 1812 Royal Academy: 53

> Mr. CONSTABLE has much originality and vigour of style, but bordering perhaps on a little crudeness of effect. I say perhaps, as it is doubtful whether if his general tone of colour was less cold, green and grey and his masses of light and shade divided by a number of strong touches of both, he would not considerably diminish that originality and vigour so peculiar to himself.

This shows a willingness to understand what the artist was trying to communicate, and to make allowances for the techniques that he used. Hunt always was prepared to study Constable's work as closely as this, and it is from his writings, for instance, that we discover that *The Hay* 109 *Wain* underwent repainting, in order to tone down 'certain catching lights', between its exhibition in the Royal Academy in 1821 and the British Institution in 1822.

During the 1810s Hunt agreed with critics who complained about Constable's want of finish. In 1815 he felt that even though there was 'much sparkling sunlight, and a general character of truth', it was unfortunate that 'Mr. CONSTABLE's pencil is still so coarsely

sketchy', agreeing with another critic who approved the 'constant reference to common nature, seen in the freshness of his trees and his colouring in general', but regretted that 'his performances, from want of finish, are rather sketches than pictures'. This was a serious censure. We discover from Reynolds's eighth *Discourse* that sketchiness was tolerable in works intended to stimulate the imagination in private contemplation, but not allowable in a picture meant for public exhibition. In the opinions of some, Constable had corrected the failing by 1816 when the *Repository of Arts* noticed that from 'entire carelessness' he had 'passed to the other extreme and now displays the most laboured finish', which, by 1818, was what the critic of the *Literary Gazette* had come to expect, for, in noticing the *Breaking up of a Shower* at the Royal Academy he (presumably) was struck by a 'remarkably sweet production. The handling remarkably free considering the apparent minuteness of this artist's usual manner.'

It was this same critic who was among the first to wish that Constable's painting could be compared with its model: 'We remember that it is true to nature and only wish we had something of the same showery effect outside in order to institute the comparison anew. We are sure Mr. Constable would not suffer from it.' Robert Hunt took up this theme again in 1823 when commending *Salisbury Cathedral* for being 'so preeminent in that "prime cheerer, light", that were many of the other landscapes similar, the mind would not be so conscious of the real over the mimic light on entering into the open air from an exhibition room'. With this assessment of his 'naturalism' went a perception that Constable was the quintessentially English painter. The *London Magazine* reviewing *A Boat Passing a Lock* in 1824 observed: 'the character of Mr. Constable's style is peculiarly English', and for the *Literary Chronicle* in 1825 *The Leaping Horse* was 'a charming specimen of that fresh, verdant scenery so peculiar to this country'. He kept this label into the 1830s.

The point should be made that there are real limits to what this criticism can tell us. Leslie thought the paintings of around 1817 to be 'perfect', indeed 'Constable's art was . . . perhaps never so perfect, as at this period of his life'. This agrees so much with our own perception of these works that we might be surprised that so acute a critic as Robert Hunt could have considered some of them 'coarsely sketchy', and discover crudity where we might not. In 1817 he commented on the 'strong resemblance to Nature's atmosphere and tints, but no nice

touches of her finishing hand' in *Flatford Mill* and *Wivenhoe Park*. 77, 83

Critical judgments ask to be taken with a pinch of salt. To some Constable was the supreme naturalist, but the *New Monthly Magazine* had never seen 'anything more true to nature . . . the water, the vessel, the distances are all perfect nature' than Callcott's Royal Academy exhibit of 1818. In 1824 it was Collins who showed pictures 'as true and sweet as nature herself', although as 'a pure representation of external objects under a certain aspect', the same critic thought that Callcott's *View of Rochester*, also in the exhibition, could 'hardly be surpassed'. From his paintings and letters we can make an informed guess at what Constable meant by 'nature' at various times of his life – but this is not to say that he would have concurred in his definition with the critics, nor they with one another. The terminology of criticism was unsophisticated. 'Natural' was a handy (and relatively safe) adjective to apply in praise of a landscape painting. If Constable was 'unquestionably the first landscape painter of the day' for *The Times* in 1827, in 1825 the *Monthly Magazine* had felt that in finding a landscapist to rival Claude it would be Glover and Hofland 'whose names will shed a lasting lustre over the English school', and for other critics in other years it might be Callcott, Collins or Turner who would be held up as the champion British landscape painter. And none of the critics seems to have been at all conscious of the high moral seriousness of Constable's landscape.

We can begin to understand something of the frustration Constable would vent in the 1820s. Complaining in December 1822 of the continuing failure to be elected to the Royal Academy he grumbled: 'I have nothing to help me but my stark naked merit, and although that (as I am told) far exceeds all the other candidates – it is not heavy enough.' By 1824, when he had been enjoying some success, he was writing to John Fisher:

I do hope that my exertions may at last turn towards popularity – 'tis you that have too long held my head above water. Although I have a good deal of the devil in me I think I should have been broken hearted before this time but for you.

Constable's real desperation comes out through the references to Dr Johnson's famous definition of a patron as 'one who looks with unconcern on a man struggling for life in the water, and, when he has reached ground, encumbers him with help'. Fisher alone had tried to

save Constable from this metaphorical drowning. The moods fluctuated. 'My reputation at home among my brother artists [is] dayly gaining ground, & I deeply feel the honour of having found an original style & independent of him who would be Lord over all – I mean Turner,' he wrote in early 1825. Later this year even Fisher was failing to help the artist as he floundered:

It is easy for a bye stander like you to watch one struggling in the water and then say your difficulties are only imaginary. I have a great part to perform & you a much greater, but with only this difference. You are removed from the ills of life – you are placed almost beyond circumstances. My master the publick is hard, cruel & unrelenting, making no allowance for a back-sliding. The publick is always more against than for us, in both our lots, but then there is this difference. Your own profession closes in and protects you, mine rejoices in the opportunity of ridding itself of a member who is sure to be in somebody's way or another.

Here we see the anxiety of the 'independent' producer (his private income did supply a financial cushion) directed against the institutional protection clergymen enjoyed. His conviction that he was engaged in a genuine struggle tallies with what W.J. Fox would observe of the middle classes in 1835: 'we note an almost universal unfixedness of position. Every man is either rising or falling or hoping that he shall rise, or fearing that he shall sink.'

There are, however, problems in assessing Constable's contemporary reputation. In the first (1843) edition of his *Memoirs* Leslie justified the book as being of interest merely in showing 'the adventures of the *mind* of so original a painter as John Constable'. The biography, indeed, is principally a compendium of Constable's correspondence, often transcribed to censor evidence of the artist's less attractive personality traits. It does, however, seem extraordinary, from what we have seen, that Leslie could have assumed a public indifference to Constable's *art*: the artist had won medals in France; he was a Royal Academician. Yet the Academical honours were a long time coming, and this might signify only qualified admiration on the part of the artistic establishment. Furthermore, some considered that Constable never was a true professional, but only an amateur with pretensions. In 1835 the *Morning Post* mentioned him as 'an amateur painter', and Henry Trimmer, who knew Constable in his later life, wrote 'I doubt if he ever supported himself by his profession; but he painted simply for fame, and not for remuneration', and also noted

that the artist enjoyed 'easy circumstances' (brought about by inheriting money from Maria's father in 1828).

Constable also stood apart by not conducting his practice in the way that many other landscape painters did. Turner's ventures covered the range of ways that they could make a living. He sold oil paintings for large sums, and on commission. He made and sold watercolours. He carried on a thriving production of topographical prints for the engravers, and published prints after his own work, and in the *Liber Studiorum*. Others may have been less successful, but they nevertheless applied themselves to the same sorts of projects. Constable had to wait a long time before his pictures fetched good prices, and even then, sales were a matter of luck. He gained a reputation for being difficult with patrons, and is reputed to have told another artist, 'when he was successful with a picture and it pleased him he was unwilling to part with it, and that when they were inferior he did not like to part with them'. He did very little work specifically for the engravers. A planned series of prints after his Brighton beach drawings came to nothing. When eventually he published a collection of mezzotints by David Lucas after his own work as *English Landscape*, this was a commercial disaster. He also, as we have seen, painted the regions other artists chose, on the whole, to ignore.

But there is evidence that Constable's reputation was affected by the ways in which people reacted to his personality. In their *Century of British Painters* the Redgraves made this criticism of Leslie's *Memoirs*:

Constable has been most fortunate in his biographer, but Leslie has painted him *couleur de rose*, and transfused his own kind and simple spirit into the biography. The landscape painter, though of a manly nature, was eminently sarcastic, and very clever at saying the bitterest things in a witty manner. This had no doubt been increased by the neglect with which the would-be connoisseurs had treated his art, and by the sneers of commonplace critics.

There is evidence that much as Constable was liked by many, he was disliked with the same intensity by others. He had a reputation for coarseness (in 1825 he described Collins's Royal Academy exhibit as 'like a large cow-turd'), and was periodically rumoured to have been slanderous about senior artists. He also had a tendency to gossip, sometimes maliciously, often on fairly slight evidence.

Preferment in the Royal Academy was not dependent on talent alone: Farington is notorious for having fixed elections, and it was

certainly at least partially his influence which obtained Constable his Associateship in 1819. With Farington's death Constable lost a powerful friend, and we have to entertain the possibility that it was because he lacked the grace and dishonesty necessary for the deft manipulation of institutional politics that his peers preferred not to acknowledge his real achievements in landscape until 1829.

By this time Constable was coming in for fairly savage attacks in the press. While the *New Monthly Magazine* thought that *Hadleigh Castle* represented 'the very best of his very peculiar style' in 1829, the *Morning Chronicle* considered the painting had 'the appearance of being scattered over, whilst the colouring was fresh, with a huge quantity of chopped hay. It is an execrable taste.' By 1830 the critic of the *Morning Chronicle* was prepared to attack the man through his work when he observed that 'Effect ... is the idol of Constable, both in his painting and himself, and both would be respected with less coarseness', taking up a particularly malevolent species of criticism which had been initiated in the *London Magazine* in 1825.

Reviewing the loan exhibition of modern British masters at the British Institution, its critic had complained of Constable's

peculiar affection for the dullest of subjects ... Not one inch of repose is to be found anywhere. Plants, foliage, sky, timber, stone – everything – are all contending for individual notice; and all curled up and insipid and powdered with white as if he had employed a dredging box in dusting a bed of cabbages or carrots. If we did not consider him hopeless, we should have been more particular, but this is a hand that cannot mend. There is no mind to guide it.

To perceive Constable's paintings as the least exciting sort of still-life was a calculated insult, for it was to deny them any elevating content. While it might be hard to find 'one inch of repose' in Constable's most *recent* canal scenes, *A Boat Passing a Lock* or *The Leaping Horse*, the earlier landscapes which were actually on show, *The White Horse* and *Stratford Mill*, were comparatively restrained in handling and varied in composition. Presumably it was the same critic who returned to the attack in 1828, on the exhibition at the British Institution in February of *The Chain Pier, Brighton*:

This is one of numberless productions by the same artist, under which it might be written, '*Nature done in white lead, opal, or prussian blue*'. The end is perfectly answered; why the means should be intruded like an eye-sore, we do not understand. It is like keeping up the scaffolding after the house is built. It is evident that Mr. Constable's landscapes are *like* nature; it is still more

evident that they *are* paint. There is no attempt made to conceal art. It is a love of the material vehicle, or a pride in slovenliness and crudity, as the indispensable characteristics of national art; as some orators retain their provincial dialect, not to seem affected. We have said enough of this; but small objections are of weight in small matters.

Lack of finish, improper in an exhibition work, is condemned as a social affront (one wonders how much of Constable's Suffolk accent lingered). A 'love of the material vehicle' displays an improper ostentation such as the man of taste should not tolerate, an ostentation which now appears, unfortunately, to be a characteristic of 'national' art. We are asked to know the man through his paintings, and that these works should not grace the walls of a national institution would, it is inferred, be preferable.

The odd thing is, that it is very hard to identify any 'national' or even 'establishment' art, unless one considers under this heading the kind of painting liked by George IV. The king had patronised the genre painters Wilkie and Bird (who both in the 1810s painted to a high degree of 'finish'), and in 1825 paid William Collins 300 guineas for *Prawn Fishers at Hastings*. This was far more glossy in its finish than Constable's *Chain Pier*, and had, typically for Collins, a sentimental subject. Dominic Colnaghi published an engraving after *The Chain Pier* in 1829. Such prints are rare enough, for Constable, to single out this painting as relatively 'important'. Indeed it might have constituted a response to the King's purchase of *Prawn Fishers*, for it portrayed a resort created by him but to which, in August 1824, Constable had reacted with distaste, writing that 'Brighton is the receptacle of the fashion and offscouring of London ... the beach is only Piccadilly ... by the sea-side ... there is nothing here for a painter but the breakers – & sky.'

If we inspect the surface of *The Chain Pier* it is neither slovenly nor crude, and it did not appear thus to Robert Hunt, always alert to any sketchiness in Constable's work. We must entertain the possibility that that the review in the *London Magazine* had set out deliberately to be professionally damaging to Constable. While the exhibition was in progress he was canvassing for votes for the Academy elections, and had actually been visiting the British Institution when he was 'pounced upon' and lectured, first by Martin Archer Shee, and then Thomas Phillips – 'I have heard so much of the higher walks of the art, that I am quite sick.'

154

The two portraitists were, on the instigation of Lawrence, pushing for the claims of William Etty, and it was Lawrence, after Constable was successful in his election, who made it clear that he thought Constable's art, if not Constable himself, undeserving of the honour. Lawrence set Shee on to Constable in 1828, and Shee advised Allan Cunningham to apply for some duly-given information on Thomas Gainsborough in 1829. Ian Fleming-Williams has written of Cunningham's long association with the *London Magazine*, and one must entertain the possibility that either he wrote those reviews, or he acted as a means by which opinions could be transmitted to the reviewer. For the time being we cannot be certain: but we can accept that, while we are able to lay out a history of Constable's painting, this is only a partial story, and what we observe will have been affected by matters about which we as yet do not know.

The final impression, perhaps, is of a life of artistic struggle, which, we can now see, was directed towards the creation of an art for posterity. This art changed as it did through Constable having to accommodate his landscape to changing circumstances. The terms 'public' and 'private' have been used rather loosely through this book to distinguish pictures related to concerns which occupied people at large from those which were personal to the artist. An oil sketch of Willy Lott's farm could not pretend to the level of complexity of *The Hay Wain*, and exhibition visitors should have been able to respond to the elevated content of the latter, for Constable had selected and presented his imagery in such a way as supposed common values to exist among the liberal and cultivated classes which comprised the audience for such pictures. One theme of Constable's development is the breakdown of the distinctions between public and private. In the 1810s drawings could be finished enough to be exhibited, but were mainly used to prepare for easel paintings, which, becoming increasingly large, presented a local landscape of a general morally elevating character. By the time of *The Leaping Horse* such distinctions had vanished, and in the 1830s there was an apparent equality in the spheres of the various media.

By 1825, as well, Constable was offering very few clues as to the real nature of his art. Like *The Hay Wain*, *The Leaping Horse* was concerned with ethical, political values, with presenting an exemplar, but we would not know this without the information offered by the artist himself, and without his letters we would certainly be ignorant

of his concerns with synaesthesia. It is perhaps here that we might make a connection with Wordsworth. The artist retires to the edge of society; individual perceptions supplant those previously arrived at through a consensus in that part of society most naturally interested in the liberal arts. For Constable in the 1830s, any such consensus had become a chimaera. Turner was in a comparable position, and just as Constable's biographer Leslie seemed unaware of the ways in which Constable and his work did connect with other aspects of contemporary culture, so Ruskin in the earliest of his writings on Turner produced a floridly descriptive criticism which showed no consciousness of important aspects of Turner's art of which we have subsequently become aware. Broadly, Ruskin could not be completely aware of the nature of his subject because of changes which had taken place within British society which distanced him from the world of Turner. The patrons Constable attracted in the 1830s, the businessmen Vernon or Sheepshanks, were people of a very different character from rural landowners like the Godfreys or the Rebows. One of the most pressing problems for Constable was the struggle to adapt his ideals and his art to a nation in the throes of an unprecedented social and political transformation. What appeared the demolition of an England he had valued and loved (although the aristocracy was to retain effective power for many years after reform) had left, under radical influence, a place which was inherently hostile, and in which ethics of Constable's kind appeared no longer to have any place. The result must have been an increasing alienation.

But Constable was not the only painter to have been subjected to these pressures. What has been outlined above is an intricate and complicated episode in history, where the connections wait to be made between the works of fine and other artists, and between artists and writers, and in which we need to know about a great many more aspects of culture in the general sense. Then the sharp relief into which Constable is thrown by a book of this kind may assimilate itself into a more complete historical plan.

Acknowledgements

While writing this book I have had occasion to feel grateful to very many people. Although the format of the text prohibits references to the numerous times when I have utilised information which they have published, I owe a very considerable debt to the work of the late R.B. Beckett, Graham Reynolds, Conal Shields, Leslie Parris, and Ian Fleming-Williams. Charles Rhyne has, as ever, been generous in relaying information and responding to queries, as well as proffering some useful suggestions. I should like to thank Louis Hawes and Paul Schweizer for sending me copies of their articles, which I found extremely helpful. Pete Nicholls, Steve Daniels and Sam Smiles read through an early draft of the text and I very much appreciate both their doing this, and the suggestions which they made. Andrew Hemingway was generous in sending me various references, and we should look forward to the publication of the research on art criticism in the press which he has been carrying out. I should like to thank my wife for putting up with me and the summer of 1985/6. I enjoyed useful conversations with Peter Funnell and learned a great deal from talking with Gary Bowie, Nick Burns, Caroline Geary and Nick Leigh. I found the recent publications of John Murdoch very helpful. Elizabeth Fairman was kind enough to direct me towards texts of which I would have remained ignorant, and Andrew Charlesworth made some salient criticism of my previous work on Constable.

I should like to thank, amongst others, Constance-Anne Parker, Brian Seymour, T. Monk, D. Solkin, Charles Parker, Malcolm Cormack, Loveday Gee, Robert Gee, M. Davis, McKinley Morganfield, H. P. Bulmer, Martin Postle, Patrick Noon, E. P. Rosenthal and John Barrell. I regret that we were not granted its owners' permission to reproduce *Stratford Mill* of 1820. Some of the research for the book was carried out with the generous assistance of funding from the British Academy, and some when I enjoyed a Visiting Fellowship at the Yale Center for British Art.

Selected Bibliography

Catalogues

Graham Reynolds's two volume catalogue raisonné, *The Later Paintings and Drawings of John Constable* (New Haven and London, 1984) follows on from his pioneering *Catalogue of the Constable Collection in the Victoria and Albert Museum* (2nd edn., London, 1973). The companion volumes, dealing with Constable's art before 1817, by Charles Rhyne, are in preparation. The only previous catalogue raisonné has been Robert Hoozee's *L'Opera completa di Constable* (Milan, 1979). Among the more limited catalogues, the one prepared by Leslie Parris, Ian Fleming-Williams and Conal Shields, for the 1976 Tate Gallery, London, bicentenary exhibition, *Constable: Paintings, Watercolours & Drawings*, remains very useful. More particularized catalogues to be recommended include Leslie Parris's *The Tate Gallery Constable Collection* (London, 1981); Leslie Parris and Conal Shields, *Constable: the Art of Nature* (Tate Gallery, London, 1971), Reg Gadney, *John Constable, 1776–1837. A Catalogue of Drawings and Watercolours* (Fitzwilliam Museum, Cambridge, 1976); and Graham Reynolds, *Constable's England* (Metropolitan Museum of Art, New York, 1983).

Documents

Constable is extremely well documented. The excellence of R.B. Beckett's editing of the first six volumes of *John Constable's Correspondence*, and *John Constable's Discourses* (Suffolk Records Society, Ipswich, 1962–70) was admirably maintained by Leslie Parris, Ian Fleming-Williams and Conal Shields in *John Constable: Further Documents and Correspondence* (Suffolk Records Society, Ipswich, and Tate Gallery, London, 1975).

Biographies and Other Studies

The foremost biography remains C. R. Leslie, *Memoirs of the Life of John Constable* (ed. J. Mayne, London, 1951). Others to be consulted include Freda Constable, *John Constable, 1776–1837: A Biography* (Lavenham, 1975) and Reg Gadney, *Constable and his World* (London and New York, 1976). Among the general studies of Constable's painting are Graham Reynolds, *Constable, the Natural Painter* (London, 1965), Basil Taylor, *Constable. Paintings, Drawings & Watercolours* (2nd edn., London, 1975), John Sunderland, *Constable* (2nd edn., Oxford, 1980), the Tate Gallery booklet *John Constable* by Leslie Parris and Conal Shields (1985), and my own *Constable. The Painter and his Landscape* (New Haven and London, 1983), and Malcolm Cormack's *John Constable* (Oxford, 1986). Among more particularized studies to be recommended are Ian Fleming-Williams, *Constable Landscape Watercolours & Drawings* (Tate Gallery, London, 1976); C. A. Brooks and A. Smart, *Constable and his Country* (London, 1976); and K. Badt, *John Constable's Clouds* (Lon-

don, 1950), which has recently been supplemented by J. Thornes, 'The weather dating of John Constable's Clouds', *Weather* 34 (1979), pp. 308–15, and 'Constable's Clouds', Burlington Magazine CXXI (1979), pp. 679–704), The mezzotints were discussed by A. Shirley in *The Published Mezzotints of D. Lucas after John Constable R.A.* (Oxford, 1930), and by Andrew Wilton in *Constable's 'English Landscape Scenery'* (British Museum, London, 1979), while David Hill has brought out a further book on them (same title, London) in 1985. Constable and British Antiquity formed the theme of L. Hawes, *Constable's Stonehenge* (London, 1975). In *The Discovery of Constable*, (London, 1984) Ian Fleming-Williams and Leslie Parris discuss the history of Constable's reputation and problems of Constable connoisseurship. There is a useful chapter on Constable in John Barrell, *The Dark Side of the Landscape* (Cambridge, 1980). Also to be recommended is the chapter on Constable in Ann Bermingham's distinguished *Landscape and Ideology* (University of California Press, 1986).

Articles

There are plenty of articles on Constable. Recent ones of interest include P.D. Schweizer, 'John Constable and the Anglican Church Establishment', *Artibusa et Historiae* 5 (III), Venice–Vienna 1982, pp. 125–39, and 'John Constable, Rainbow Science and English Color Theory', *Art Bulletin* LXIV (September 1982), pp. 424–55; L. Hawes, 'Constable's Hadleigh Castle and British Romantic Ruin Painting', *Art Bulletin* LXV (September 1983), pp. 455–70, and S. Boulton, 'Church under a Cloud: Constable and Salisbury', *Turner Studies* 3 2 (Winter 1984), pp. 29–44.

The Artistic Background

General information about the relationships between artists are to be found in W. T. Whitley, *Art in England* (2 vols, Cambridge, 1928, 1930), J. Farington, *Diary* (16 vols, New Haven and London, 1978–84), and T. Fawcett, *The Rise of English Provincial Art* (Oxford 1974). Studies in British landscape painting include L. Parris, *Landscape in Britain c.1750–1850* (exhibition catalogue, Tate Gallery, London, 1973), Luke Herrmann, *British Landscape Painting of the Eighteenth Century* (London, 1973), M. Rosenthal, *British Landscape Painting* (Oxford, 1982), and L. Hawes, *Presences of Nature. British Landscape 1780–1830* (exhibition catalogue, Yale Center for British Art, New Haven, 1982). Publications which focus more on watercolour are C. White, *English Landscape 1630–1850* (exhibition catalogue, Yale Center for British Art, New Haven 1977); Andrew Wilton, *British Watercolours 1750–1850* (Oxford, 1977); Michael Clark, *The Tempting Prospect* (British Museum, London, 1981); Jane Bayard, *Works of Splendor and Imagination. The Exhibition Watercolour* (exhibition catalogue, Yale Center for British Art, New Haven, 1981); and Lindsay Stainton, *British Landscape Watercolours 1660–1860* (exhibition catalogue, British Museum, London, 1985).

Studies of individual artists vary in quality. The Turner literature is enormous and growing unstoppably. There is a useful bibliography in M. Butlin and E. Joll, *The Paintings of J. M. W. Turner* (2nd edn., New Haven and London, 1984). J. Gage, *Colour in Turner. Poetry in Truth* (London, 1969), and Jack Lindsay, *J. M. W. Turner. His Life and Work* (London, 1966) are the best introductions. For Collins there is W. Wilkie Collins, *Memoirs of the Life of William Collins, R.A.* (2 vols, London, 1848), and for Callcott, D. B. Brown, *Augustus Wall Callcott* (exhibition catalogue, Tate Gallery, London, 1981). Works on other artists include M. Rajnai (ed.), *John Sell Cotman 1782–1842* (London, 1982) which has a handy bibliography, S. Wildman *et al.*, *David Cox 1783–1859* (exhibition catalogue, Birmingham Museums and Art Gallery, 1983), K. Crouan, *John Linnell* (exhibition catalogue, Fitzwilliam Museum, Cambridge, 1982), and C. M. Kauffman, *John Varley (1778–1842)* (London, 1984).

Oil sketching was the subject of John Gage, *A Decade of English Naturalism 1810–1820* (exhibition catalogue, Norwich Castle Museum, Norwich and London, 1969) and Philip Conisbee, *Painting from Nature* (exhibition catalogue, Arts Council, London, 1981). For topics related to the theme of British landscape paintings there remains, still to be superseded, Christopher Hussey, *The Picturesque* (London, 1927, repr, 1967), which touches with themes dealt with by Peter Bicknell, *Beauty Horror and Immensity: Picturesque Landscape in Britain 1750–1850* (exhibition catalogue, Fitzwilliam Museum, Cambridge, 1981). For other attitudes to landscape, John Barrell, *The Idea of Landscape and the Sense of Place* (Cambridge, 1972), is recommended. For the connoisseurs, see Peter Fullerton, 'Patronage and Pedagogy: The British Institution in the Early Nineteenth Century', *Art History* 5. 1 (March 1982), pp. 59–72, and Nicholas Penny, Michael Clark (eds), *The Arrogant Connoisseur: Richard Payne Knight 1751–1824* (exhibition catalogue, Manchester University Press, 1982).

List of Illustrations

All works are by John Constable (1776–1837) unless otherwise stated. Dimensions are given in centimetres and inches, height before width.

Abbreviations

BM British Museum, Department of Prints and Drawings
NG National Gallery, London
TG Tate Gallery, London
VAM Victoria and Albert Museum, London
YCBA Yale Center for British Art, Paul Mellon Collection

Frontispiece: *Fir Trees at Hampstead*, 1820. Pencil 23.3 × 16 (9⅛ × 6¼) VAM.
1 'Constable Country' from the 1805 Ordnance Survey Map.
2 Claude (1600–82), *Landscape with Hagar and the Angel*, 1646. Oil on canvas 52.7 × 43.8 (20¾ × 17¼). NG.
3 *Susannah Lloyd*, 1806. Oil on canvas 64.5 × 50.2 (23⅝ × 19¾). TG.
4 *Malvern Hall*, 1809. Oil on canvas 51.4 × 76.8 (20¼ × 30¼). TG.
5 *Christ Blessing the Sacraments, c.* 1809 Oil on canvas 116.8 × 94.6 (46 × 37¼). Nayland Church, Suffolk. Photo Courtauld Institute of Art, London.
6 *Rear-Admiral Thomas Western, c.* 1813. Oil on canvas 76.2 × 63.5 (30 × 25). Collection of Alexander Kardo-Sessoeff.
7 *The Risen Christ*, 1822. Oil on canvas 160 × 127 (63 × 50). All Saints Church, Feering, Essex.
8 *Girl with Doves*, after Greuze, 1831. Oil on canvas 72.4 × 60.3 (28½ × 23¾). Private Collection.
9 *Christ's Charge to Peter*, copy after Dorigny's engraving after Raphael, 1795. Pen and wash 48.9 × 74.7 (19¼ × 29⅜). The Minories, Colchester.
10 *A Ruined Cottage at Capel, Suffolk*, 1796. Pen and ink 18.1 × 29.9 (7⅛ × 11¾). VAM.
11 *A Dell*, 1796. Pen and wash 40.6 × 45.7 (16 × 18). Forty Hall Museum, London Borough of Enfield.
12 *A Cottage among Trees, c.* 1798–9. Pencil and grey wash 30.2 × 36.6 (11⅞ × 14⅜). YCBA.
13 *East Bergholt Church from the South West, c.* 1796–9. Pen and watercolour 25.8 × 39.7 (10⅛ × 15⅝). VAM.
14 *Academy study, c.* 1800. Black and white chalk on brown paper 55.5 × 43.8 (21¾ × 17¼). VAM.
15 *Female figure study*, 1820. Pencil 17.8 × 11 (7 × 4⅜). Colchester Borough Council, on loan to the Minories, Colchester.
16 *The Stour Valley with Stratford Bridge*, 1800. Pen and watercolour 34.3 × 52.1 (13½ × 20½). VAM

17 *Helmingham Dell*, 1800. Pencil, pen and grey wash 53.3 × 66.4 (21 × 26⅛). The Clonterbrook Trustees.
18 *Dovedale*, 1801. Black and white chalk on blue paper 28.2 × 35.2 (11⅛ × 13⅞). The Royal Museum of Fine Arts, Copenhagen, Department of Prints and Drawings.
19 *The Entrance to the Village of Edensor*, 1801. Pen and sepia wash 17.5 × 26.4 (6⅞ × 10⅜). VAM.
20 Copy after Girtin's *Guisborough Priory, c.* 1800. Pencil 15.2 × 22.9 (6 × 9). VAM.
21 *The Cenotaph*, 1836. Oil on canvas 132.1 × 108.6 (52 × 42¾). NG.
22 *The Stour Valley*, 1802. Oil on canvas 33.3 × 41.6 (13⅛ × 16⅜). YCBA.
23 Detail of 22.
24 *Dedham Vale*, 1802. Oil on canvas 43.5 × 34.4 (17⅛ × 13½). VAM.
25 *Mill on the Banks of the Stour*, 1802. Black chalk, charcoal and traces of red chalk 24 × 29.8 (9½ × 11¾). VAM.
26 *Landguard Fort near Felixstowe*, 1803? Watercolour 16.5 × 32 (6½ × 12⅝). Private Collection.
27 *A Wooded Landscape, c.* 1805. Black chalk, stump, some white chalk 34.5 × 51.2 (13⅝ × 20⅛). YCBA.
28 *Dedham Vale, c.* 1805. Pencil and watercolour 17.1 × 27.6 (6¾ × 10⅞). VAM.
29 *Shipping in the Thames*, 1803. Pencil, grey wash and watercolour 19 × 32 (7½ × 12⅝). VAM.
30 *The Stour Estuary*, 1804. Oil on canvas 22 × 34.5 (8⅝ × 13⅝). Beecroft Art Gallery (Southend-on-Sea Museums Service).
31 *Landscape with Cows and Trees*, 1803 Pencil and watercolour 19 × 23 (7½ × 9⅛). VAM.
32 *Ruins of St Botolph's Priory, Colchester, c.* 1803–7. Black chalk with some brown chalk. 43.6 × 35.9 (17⅛ × 14⅛). VAM.
33 *Laura Hobson of Markfield*, 1806. Pencil 10.6 × 8.2 (4⅛ × 3¼). BM.
34 *Joshua and Laura*, 1806. Pencil 8.3 × 10 (3¼ × 3⅞). BM.
35 *His Majesty's Ship Victory, Capt. E. Harvey, in the memorable battle of Trafalgar, between two French Ships of the Line*, 1806. Watercolour

51.8 × 73.4 (20¾ × 28⅞). VAM.
36 *A Bridge, Borrowdale*, 1806. Pencil and watercolour 19 × 27 (7½ × 10⅝). VAM
37 Sir George Beaumont (1753–1827), *Landscape with a Bridge*. Pencil 15 × 20 (5⅞ × 7⅞). YCBA, Gift of Charles Rhyne.
38 *A Waterfall*, 1806. Pencil and watercolour 26.4 × 19.9 (10⅜ × 7⅞). BM.
39 Joseph Wright of Derby (1734–97), *Rydal Waterfall*, 1795. Oil on canvas 57.2 × 76.2 (22½ × 30). Derby Art Gallery.
40 *A Lane near East Bergholt with a Man Resting*, 1809. Oil 21.6 × 32.7 (8½ × 12⅞) on board. Private Collection.
41 *Langdale Pikes from Elterwater*, 1806. Pencil 24.1 × 38.1 (9½ × 15). Private Collection.
42 *Langdale Pikes*, 1806. Pencil and watercolour 16.5 × 30.5 (6½ × 12).Philadelphia Museum of Art: Given by Boies Penrose.
43 *View towards East Bergholt Rectory*, 1808. Oil on board 16.3 × 25.1 (6⅜ × 9⅞). Fitzwilliam Museum, Cambridge.
44 *View towards East Bergholt Rectory*, 1810. Oil on canvas laid on panel 15.3 × 24.5 (6 × 9⅝). John G. Johnson Collection, Philadelphia.
45 *A Church Porch*, exh. 1810? Oil on canvas 44.4 × 35.9 (17½ × 14⅛). TG.
46 *East Bergholt Church*, 1811. Watercolour 39.6 × 59.9 (15⅝ × 23⅝). Lady Lever Art Gallery, Port Sunlight.
47 *A Lane in Suffolk, c.* 1810–11. Oil on paper laid on canvas 22.2 × 19.7 (8¾ × 7¾). YCBA.
48 *Dedham Vale, Morning*, 1811. Oil on canvas 78.7 × 129.5 (31 × 51). W. H. Proby, Elton Hall Collection.
49 *Stourhead*, 1811. Pencil 8.6 × 14.9 (3⅜ × 5⅞). Courtesy of the Fogg Art Museum, Harvard University. Bequest of Grenville L. Winthrop.
50 *Salisbury Cathedral from the South West*, 1811. Black and white chalk on grey paper 19.3 × 29.8 (7⅝ × 11¾). VAM.
51 *Stratford Mill*, 1811. Oil ﾟon panel 18.4 × 14.2 (7¼ × 5⅝). Private Collection.
52 *Flatford Mill from the Lock, c.* 1810–11. Oil on paper laid on canvas 26 × 35.6 (10¼ × 14). Royal Academy of Arts, London.
53 *A Water-Mill*, 1812. Oil on canvas

66 × 92.7 (26 × 36½). Washington D.C. The Corcoran Gallery of Art, anonymous loan.

54 *Dedham from Langham, c.* 1812. Pencil 32 × 66.7 (12⅝ × 26¼). The Royal Museum of Fine Arts, Copenhagen, Department of Prints and Drawings.

55 *Willy Lott's Farm, c.* 1812. Pencil 20 × 28.6 (7⅞ × 11¼). Witt Collection, Courtauld Institute of Art, London.

56 *Dedham from Langham,* 1812. Oil on canvas 19 × 32 (7½ × 12⅝). Ashmolean Museum, Oxford.

57 *Landscape, Boys Fishing,* 1813. Oil on canvas 101.6 × 125.7 (40 × 49½). Courtesy of the National Trust (Fairhaven Collection, Anglesey Abbey).

58 Sketchbook, 1813. A ploughman. Pencil 8.9 × 12.1 (3½ × 4¾). VAM.

59 Sketchbook, 1813. A horse and barges. Pencil 8.9 × 12.1 (3½ × 4¾). VAM.

60 Sketchbook, 1813. A post, a mill. Pencil 8.9 × 12.1 (3½ × 4¾). VAM.

61 *The Mill Stream, c.* 1810–13. Oil on board 20.9 × 29.2 (8¼ × 11½). TG.

62 *The Mill Stream, c.* 1814. Oil on canvas 71.1 × 91.4 (28 × 36). Ipswich Museums and Galleries.

63 *Landscape, Ploughing Scene in Suffolk,* 1814. Oil on canvas 51.4 × 76.8 (20¼ × 30¼). Private Collection.

64 *Hadleigh Castle, near Southend,* 1814. Pencil 8.3 × 11.2 (3¼ × 4⅜). VAM

65 *View of Dedham,* 1814. Oil on canvas 55.5 × 77.8 (21⅞ × 30⅝). Courtesy Museum of Fine Arts, Boston, Warren Collection.

66 Sketch for *View of Dedham,* 1814. Oil on canvas 39.4 × 55.9 (15½ × 22). Leeds City Art Gallery.

67 Sketchbook, 1814. Labourers. Pencil 8 × 10.8 (3⅛ × 4¼). VAM.

68 Sketchbook, 1814. Dedham Vale. Pencil 8 × 10.8 (3⅛ × 4¼). VAM

69 Detail of 65.

70 *View over Golding Constable's Farm,* 1814. Pencil 30.2 × 45.1 (11⅞ × 17¾). VAM

71 Sketchbook, 1814. Study for *Boat Building.* Pencil 8 × 10.8 (3⅛ × 4¼). VAM.

72 *Boat Building,* 1814. Oil on canvas 50.8 × 61.6 (20 × 24¼). VAM.

73 *Golding Constable's Flower Garden,* 1815. Oil on canvas 33 × 50.8 (13 × 20). Ipswich Museums and Galleries.

74 *Golding Constable's Kitchen Garden,* 1815. Oil on canvas 33 × 50.8 (13 × 20). Ipswich Museums and Galleries.

75 *A Cottage in a Cornfield,* 1815? and 1833. Oil on canvas 62.2 × 51.4 (24½ × 20¼). VAM.

76 *A Cottage in a Cornfield,* 1815–7. Oil on canvas 30.5 × 50.8 (12 × 20). National Museum of Wales, Cardiff.

77 *Flatford Mill,* 1816–17. Oil on canvas 101.6 × 127 (40 × 50). TG.

78 Detail of 77.

79 Detail of 82.

80 *Gleaners, c.* 1815. Pencil 10.2 × 7.8 (4 × 3). Musée du Louvre, Cabinet des Dessins, Photo Réunion des Musées Nationaux.

81 *Woodbridge,* 1815. Pencil 10.8 × 15.9 (4¼ × 6¼). Ipswich Museums and Galleries.

82 *Dedham Mill, c.* 1815. Oil on canvas 15.6 × 28.6 (6⅛ × 11¼). John G. Johnson Collection, Philadelphia.

83 *Wivenhoe Park,* 1816. Oil on canvas 56.1 × 101.2 (22⅛ × 39⅞). Washington D.C., National Gallery of Art, Widener Collection.

84 *Weymouth Bay from the Downs,* 1816. Pencil 17.4 × 31.1 (6⅞ × 12¼). Whitworth Art Gallery, University of Manchester.

85 *Weymouth Bay,* 1816? Oil on millboard 20.3 × 23.5 (8 × 9¼). VAM.

86 *Weymouth Bay,* exh. 1819? Oil on canvas 88.3 × 111.8 (34¾ × 44). Musée du Louvre. Photo Giraudon.

87 *Mrs Edwards,* 1818? Oil on canvas 75.8 × 63.5 (29⅞ × 25). Museum of Art, Rhode Island School of Design, Providence.

88 *Cottage and Road at East Bergholt,* 1817. Pencil 11.4 × 18.8 (4½ × 7⅜). VAM.

89 *Elm Trees in Old Hall Park, East Bergholt,* 1817. Pencil with slight grey and white washes 59 × 49.5 (23¼ × 19½). VAM.

90 *Richmond Bridge with Barges on the Thames,* 1818. Pencil 10.2 × 13.3 (4 × 5¼). VAM.

91 *Fulham Church,* 1818. Pencil 29.8 × 44.5 (11¾ × 17½). VAM.

92 *Waterloo Bridge from the Left Bank of the Thames,* 1817? Pencil 11.2 × 17.8 (4⅜ × 7). Museum of Art, Rhode Island School of Design, Providence, Anonymous Gift.

93 Sketch for *The Opening of Waterloo Bridge seen from The Whitehall Stairs, June 18th 1817,* 1819–25. Oil on millboard 29.2 × 48.3 (11½ × 19). VAM.

94 *A Child Being Nursed, c.* 1818. Pen, ink and brush 18.2 × 11.2 (7⅛ × 4⅜). BM.

95 *The White Horse,* 1819. Oil on canvas 131.4 × 188.3 (51¾ × 74⅛). Frick Collection, New York.

96 Sketchbook, 1814. Willie Lott's Farm. Pencil 8 × 10.8 (3⅛ × 4¼). VAM.

97 *Branch Hill Pond,* 1819. Oil on canvas 25.4 × 30.1 (10 × 11⅞). VAM.

98 Hampstead: *Stormy Sunset,* 1820. Oil on paper on card 12.7 × 17.1 (5 × 6¾). VAM.

99 Sketchbook used in 1819. Quarrying on Hampstead Heath. Pencil 6.6 × 9.1 (2⅝ × 3⅝). BM.

100 Thomas Hofland, *Harrow from Hampstead,* 1815? Oil on board 25.4 × 34.9 (10 × 13¾). Private Collection.

101 *A Sandbank at Hampstead,* 1820–2. Oil on canvas 21.6 × 25.4 (8½ × 10). TG.

102 *Harwich Lighthouse,* 1820? Oil on canvas 33 × 50.8 (13 × 20). YCBA.

103 *Dedham Lock and Mill,* exh. 1820? Oil on canvas 54.6 × 77.5 (21½ × 30½). Currier Gallery of Art, Manchester, New Hampshire.

104 *Dedham Lock and Mill,* exh. 1819? Oil on canvas 71.1 × 90.2 (28 × 35½). Private Collection on loan to the Fitzwilliam Museum, Cambridge.

105 Full-scale sketch for *Stratford Mill,* 1820. Oil on canvas 130.8 × 184.2 (51½ × 72½). YCBA Paul Mellon Fund.

106 *Salisbury from the South,* 1820? Oil on canvas 35.5 × 51.1 (14 × 20⅛). Musée du Louvre. Photo Réunion des Musées Nationaux.

107 *Cottage and Trees in the New Forest,* 1820. Pencil 16.3 × 23.9 (6⅜ × 9⅜). VAM.

108 *Hampstead Heath,* 1820–1. Oil on canvas 53.3 × 77.5 (21 × 30½). VAM.

109 *The Hay Wain,* 1821. Oil on canvas 130.2 × 185.4 (51¼ × 73). NG.

110 Full-scale sketch for *The Hay Wain,* 1820–1. Oil on canvas 137.2 × 188 (54 × 74). VAM.

111 Detail of 109.

112 *Spring, East Bergholt Common,* 1821? Oil on panel 19 × 36.2 (7½ × 14¼). VAM.

113 *Cloud Study,* 1821? Oil on paper mounted on canvas 19.3 × 23.9 (7⅝ × 9⅜). Ipswich Museums and Galleries.

114 *Pond and Cottages, a Storm Approaching,* 1821? Pencil and watercolour 16.8 × 25.8 (6⅝ × 10⅛). BM.

115 *Sky and Trees at Hampstead,* 1821. Oil on paper 24.1 × 29.8 (9½ × 11¾). VAM.

116 *Branch Hill Pond, Evening,* 1821–2. Oil on paper 22.9 × 19 (9 × 7½). VAM.

117 *A Ruin near Abingdon,* 1821. Pencil 17.1 × 26 (6¾ × 10¼). VAM.

118 Detail of 115.

119 *Cloud Study,* 1821. Oil on paper laid on panel 22.2 × 29.2 (8¾ × 11½). YCBA.

120 Sketchbook, 1814. View on the Stour. Pencil 8 × 10.8 (3⅛ × 4¼). VAM.

121 *A View on the Stour near Dedham,* 1822. Oil on canvas 129.5 × 188 (51 × 74). The Henry E. Huntington Library and Art Gallery, San Marino.

122 *A View on the Stour near Dedham,* 1821–2. Oil on canvas 129.5 × 185.4 (51 × 73). Egham, Royal Holloway College.

123 *Cumulus Clouds,* 1822. Oil on paper laid on canvas 30.5 × 50.8 (12 × 20). YCBA.

124 *Cirrus Clouds,* 1822? Oil on paper 11.4 × 17.8 (4½ × 7). VAM.

125 *Salisbury Cathedral from the Bishop's Grounds,* 1823. Oil on canvas 87.6 × 111.8 (34½ × 44). VAM.

126 *Yarmouth Jetty,* 1822. Oil on canvas 31.8 × 50.8 (12½ × 20). Private Collection.

127 John Crome (1768–1821), *Yarmouth Jetty, c.* 1808–9. Oil on canvas 44.7 × 58.4 (17⅝ × 23). Norwich, Castle Museum.

128 *Cenotaph to Sir Joshua Reynolds in the Grounds of Coleorton Hall,* 1823. Pencil and grey wash 26 × 18.2 (10¼ × 7⅛). VAM.

129 *Landscape with a Windmill,* 1823. Pencil and grey wash 11.2 × 18.2 (4⅜ × 7⅛). Ashmolean Museum, Oxford.

130 *Dedham Lock, c.* 1822–5. Oil on paper laid on canvas 11.4 × 16.5 (4½ × 6½). YCBA.

131 *A Boat Passing a Lock,* 1822–4. Oil on canvas 141.6 × 121.9 (55¾ × 48). Philadelphia Museum of Art: John H. McFadden Collection.

132 *A Boat Passing a Lock,* 1824. Oil on canvas 142.2 × 120.7 (56 × 47½). Walter Morrison Collection, Sudeley Castle, Winchcombe, Gloucestershire.

133 *Beached Vessels at Brighton*, 1824? Pencil, pen and wash 17.8 × 25.4 (7 × 10). The Trustees, The Cecil Higgins Art Gallery, Bedford.
134 Study for *The Leaping Horse*, 1824–5. Pencil and grey wash 20.3 × 30.1 (8 × 11⅞). BM.
135 Full-scale study for *The Leaping Horse*, 1824–5. Oil on canvas 129.5 × 188 (51 × 74). VAM.
136 *The Leaping Horse*, 1824–5. Oil on canvas 142.2 × 187.3 (56 × 73¾). Royal Academy of Arts, London.
137 Detail of 136.
138 *Brighton Beach*, 1824. Oil on paper 12.1 × 29.5 (4¾ × 11⅝). VAM.
139 *Branch Hill Pond, Hampstead*, 1825. Oil on canvas 62.2 × 78.1 (24½ × 30¾). Virginia Museum of Fine Arts, Richmond.
140 *Hampstead Heath, Branch Hill Pond*, 1828. Oil on canvas 60.6 × 78.1 (23⅞ × 30¾). Cleveland Museum of Art, Purchase, Leonard C. Hanna Jr., Bequest.
141 *Hampstead Heath and Rainbow*, 1836. Oil on canvas 50.8 × 76.2 (20 × 30). TG.
142 *The Cornfield*, 1826. Oil on canvas 142.6 × 121.9 (56⅛ × 48). NG.
143 From a sketchbook used at Brighton: a stormy seascape, 1824? Watercolour, page size 8.3 × 11.4 (3¼ × 4½). Musée du Louvre, Cabinet des Dessins. Photo Réunion des Musées Nationaux.
144 *Harwich*, 1825. Pencil 11.4 × 18.4 (4½ × 7¼). BM.
145 *Windmill among Houses with Rainbow*, c. 1824. Oil on paper laid on canvas 21 × 30.4 (8¼ × 12). VAM.
146 *The Sea near Brighton*, 1826. Oil on paper laid on card 17.5 × 23.8 (6⅞ × 9⅜). TG.
147 *Cottages at East Bergholt*, 1827. Pencil 22.5 × 33 (8⅞ × 13). VAM.
148 *A View on the Stour at Flatford*, 1827. Pencil 22.2 × 32.7 (8¾ × 12⅞). National Gallery of Ireland, Dublin.
149 *Netley Abbey, the West End*, 1833. Etching 13.3 × 19 (5¼ × 7½). Philadelphia Museum of Art; Purchased with funds given by Miss Anna W. Ingersoll.
150 A. Waterloo (1608/9–1690), *A Water Mill*. Engraving 28.5 × 22.9 (11¼ × 9). BM.
151 *Helmingham Dell*, 1825–6. Oil on canvas

70.7 × 91.4 (27⅞ × 36). John G. Johnson Collection, Philadelphia.
152 *Gillingham Mill*, 1825. Oil on canvas 50.2 × 60.3 (19¾ × 23¾). YCBA.
153 *The Glebe Farm*, 1827? Oil on canvas 46.4 × 59.7 (18¼ × 23½). Detroit Institute of Arts, Gift of Mrs Joseph B. Schlotman.
154 *The Chain Pier, Brighton*, 1827. Oil on canvas 127 × 182.9 (50 × 72). TG.
155 *The Glebe Farm*, c. 1830. Oil on canvas 64.8 × 95.5 (25½ × 37⅝). TG.
156 Detail of 155.
157 Detail of 158.
158 *Dedham Vale*, 1828. Oil on canvas 145.2 × 121.9 (57⅛ × 48). National Galleries of Scotland, Edinburgh.
159 *Stonehenge*, 1836. Watercolour 38.7 × 59.1 (15¼ × 23¼). VAM.
160 *Poppies*, 1832. Oil on board 38.7 × 21 (15¼ × 8¼). Paul Mellon Collection, Upperville, Virginia.
161 *Jacques and the Wounded Stag*, c. 1835. Pen, ink, pencil and wash 22.2 × 18.2 (8¾ × 7¼). BM.
162 *Netley Abbey by Moonlight*, c. 1833. Watercolour 14.6 × 20 (5¾ × 7¾). BM.
163 *Folkestone, the Harbour*, 1833. Watercolour and pencil 13.1 × 21 (5⅛ × 8¼). Fitzwilliam Museum, Cambridge.
164 Design for Gray's 'Elegy', Stanza V, 1833. Pen, ink and watercolour 11.7 × 17.4 (4⅝ × 6⅞). BM.
165 *Landscape with Trees and Cattle*, 1832? Pen, ink and watercolour 11.2 × 18.8 (4⅜ × 7⅜). BM.
166 *Cowdray House*, 1834. Pencil and watercolour 20.7 × 12.7 (8⅛ × 5). BM.
167 *A Farmhouse near the Water's Edge*, c. 1832. Watercolour 14.6 × 19.7 (5¾ × 7¾). BM.
168 *Stoke-by-Nayland*, 1832? Pen, ink and watercolour 14.6 × 19.7 (5¾ × 7¾). BM.
169 *Hadleigh Castle. The Mouth of the Thames – morning after a stormy night*, 1829. Oil on canvas 122 × 161.9 (48 × 64⅜). YCBA.
170 Sketch for *Hadleigh Castle*, c. 1828–9. Oil on canvas 122.5 × 167.3 (48¼ × 65⅞). TG.
171 *The Opening of Waterloo Bridge*, exh. 1832. Oil on canvas 134.6 × 219.7 (53 × 86½). Private Collection.
172 *Old Sarum*, 1834. Watercolour 30.1 × 48.6 (11⅞ × 19⅛). VAM.

173 *The Glebe Farm*, 1832. Mezzotint 25 × 17.8 (9⅞ × 7). BM.
174 *Stoke-by-Nayland*, c. 1829. Sepia 12.7 × 18.4 (5 × 7¼). BM.
175 *Stoke-by-Nayland*, 1830. Mezzotint 14.3 × 21.8 (5⅝ × 8⅝). BM.
176 *Salisbury Plain from Old Sarum*, 1829. Pencil 23.5 × 33.7 (9¼ × 13¼). YCBA.
177 *Old Sarum*, 1829? Oil on card 14.2 × 21 (5⅝ × 8¼). VAM.
178 *Watermeadows near Salisbury*, 1829. Oil on canvas 45.7 × 55.2 (18 × 21¾). VAM.
179 *Salisbury Cathedral from the Meadows*, 1829. Black chalk and pencil 21.6 × 33 (8½ × 13). Private Collection.
180 *Sketch of Salisbury Cathedral from the Meadows*, 1829–30. Oil on paper mounted on card 18.4 × 27.9 (7¼ × 11). Private Collection.
181 Study for *Salisbury Cathedral from the Meadows*, 1830–1. Oil on canvas 102.6 × 51.2 (40⅜ × 20⅛). TG.
182 Study² for *Salisbury Cathedral from the Meadows*, 1830–1. Oil on canvas 151.8 × 189.9 (59¾ × 74¾). Guildhall Art Gallery, London.
183 *Salisbury Cathedral from the Meadows*, exh. 1831. Oil on canvas 151.8 × 189.9 (59¾ × 74¾). On loan to the National Gallery, London. Reproduced by kind permission of the Lord Ashton-of-Hyde. Photo Bridgeman Art Library.
184 J. van Ruisdael (1628/9–1682), *The Cemetery*, 1655–60. Oil on canvas 142.2 × 189.2 (56 × 74⅜). The Detroit Institute of Arts, Gift of Julius H. Haass, in memory of his brother Dr. Ernest W. Haass.
185 Detail of 190.
186 *Castle Acre Priory*, 1832. Mezzotint 14.4 × 22.4 (5⅝ × 8¾). BM.
187 *Arundel Mill and Castle*, exh. 1837. Oil on canvas 72.4 × 100.3 (28½ × 39½). Toledo, Ohio, Toledo Museum of Art.
188 *A Cottage at East Bergholt*, c. 1834–5. Oil on canvas 87.6 × 113 (34½ × 44½). The Lady Lever Art Gallery, Port Sunlight.
189 *The Valley Farm*, 1835. Oil on canvas 147.3 × 125.7 (58 × 49½). TG.
190 *A Farmhouse near the Water's Edge*, c. 1834. Oil on canvas 62 × 79.1 (24⅜ × 31⅛). The Phillips Collection, Washington D.C.

Index

215